Mothering Outside the Lines

Tales of Boundary-Busting Mamas

Edited by Michelann Parr and BettyAnn Martin

DEMETER

Mothering Outside the Lines:
Tales of Boundary-Busting Mamas
Edited by Michelann Parr and BettyAnn Martin

Copyright © 2023 Demeter Press

Demeter Press
PO Box 197
Coe Hill, Ontario
Canada
K0L 1P0
Tel: 289-383-0134
Email: info@demeterpress.org
Website: www.demeterpress.org

Demeter Press logo based on the sculpture "Demeter" by Maria-Luise Bodirsky www.keramik-atelier.bodirsky.de

Printed and Bound in Canada

Cover design: Michelann Parr
Typesetting: Michelle Pirovich
Proof reading: Jena Woodhouse

Library and Archives Canada Cataloguing in Publication
Title: Mothering outside the lines : tales of boundary busting mamas /
edited by Michelann Parr and BettyAnn Martin.
Names: Parr, Michelann, 1964- editor. | Martin, BettyAnn, 1971- editor.
Description: Includes bibliographical references.
Identifiers: Canadiana 2023048493X | ISBN 9781772584646 (softcover)
Subjects: LCSH: Motherhood. | LCSH: Mothers. | LCSH: Feminism.
Classification: LCC HQ759 .M8846 2023 | DDC 306.874/3—dc23

 The publisher gratefully acknowledges the support of the Government of Canada

for those mothers who blazed a trail,
for those who currently mother outside the lines,
and for those who are empowered to follow their lead...

may you find hope, inspiration, strength, and community
in this collection.

Acknowledgements

We express a deep sense of gratitude to Andrea O'Reilly and Demeter Press for creating a space for women and mothers to write about motherhood and the multitude of social and emotional intersections experienced through mothering in all its forms. In an era of disconnection, alienation, and isolation, it makes sense to return to our experience of mothering as a starting point to redefine strength as a function of compassion, connection, and inspiration.

We acknowledge the power of our writers as they share their stories of struggle, strength, and celebration. The more we share our experiences and connect our stories, the more we know. And when we know differently, we do differently. Through these tales, we come to understand our experiences as a function of time and place, which better positions us to permeate structures and boundaries that no longer serve. We are deeply grateful for the willingness of our writers to step up and share their experiences of empowerment, no matter how difficult.

We also thank our families and children for their encouragement and support in the writing of this book and for the opportunities they offer on a daily basis to know and grow ourselves through motherhood; in our encounters with mothering and being mothered, we find possibilities for personal and relational transformation and healing not just for ourselves but for our children and others who mother.

Finally, we acknowledge those whose stories are as yet un(der)told—silenced out of fear or oppression—whose worth is not diminished by this silence. We see you and acknowledge your experiences, and we hope that collections such as these create space, inspiration, and possibility for you to push through boundaries that often feel rigid and firm.

Foreword

Stories (of) Carrying Forth M/otherworlds from Our Matricentric Carrier Bags

Mairi McDermott

I Dream of M/otherworlds

M/otherworlds:

Worlds

shaped by love, grace, dignity, relationships, and abundance,

rather than scarcity and competition.

Worlds

honouring the inheritances of those whose whispers are like seeds

pushing through

the often-dense hard casings

trying to hold us and our imaginations in (Maracle).

When nurtured,

we hear the whispers, we

add our voices and stories

to worlding better nows and futures for our children and the planet.

If I were to use an analogy to describe Michelann Parr and BettyAnn Martin's edited collection, it is that of a carrier bag (Le Guin)—a container gathering, holding, and making space for matricentric collectives and m/otherworlds. In her essay *The Carrier Bag Theory of Fiction*, Ursula K. Le Guin reminds us that "It is the story that makes the difference" (33); she summons us to tell the stories of livingness; to gather stories with the intention of sharing (rather than accumulation); and of telling stories beyond the masculinized narrative scripts of "the linear, progressive, Time's-(killing)-arrow mode of the Techno-Heroic" (36). Le Guin declares that the stories that make a difference in the world, transgressing the "what is," already exist and have always seeped through what turns out to be more porous boundaries than dominant patriarchal scripts suggest. As the title of this edited collection—*Mothering Outside the Lines: Tales of Boundary-Busting Mamas*—advocates, this is a book about boundary-busting mamas, yet it is not simply about busting the boundaries. Indeed, what it asks of the reader is to embrace the porosity of the boundaries narrated as rigid and firm. What it offers is an unabashed centring of those who mother in the crevices, corners, cracks, and spaces between the lines of the normative storylines circulating with malice to hold us in place. When reading this edited collection, I noted the underpinning call to ask: How do we come to (re)imagine and call forth m/otherworlds—that is worlds shaped for life, abundance, love, and dignity?

The Stories of Our Dreams, or Restorying M/otherworlds

I believe in the generative power of stories (e.g., Le Guin; King; McDermott "Changing the Stories"; Okri). We must be careful with the stories we tell: "It matters what stories we tell to tell other stories with; it matters what concepts we think to think other concepts with" (Haraway 10). When we reach into our carrier bags, what concepts and stories are there for us to hold and what stories, ideas, concepts hold us as we move towards m/otherworlds? The stories we tell—and the stories that go un(der)told or are made illegible amid the cacophony of imperialist white supremacist capitalist patriarchal (hooks) scripts overdetermining what is and what can be—matter. They make a difference in the world. Parr and Martin's assemblage makes legible the vital necessity

to ask how motherhood has been constructed through its polyvocal and multiplicitous voices, experiences, genres, and possibilities. The stories shared across the chapters provide us with tools and maps to (re)orient ourselves towards m/otherworlds. The stories offered become stories to tell our stories with; we are collected in the carrier bag if we want to be.

After reading the variety of ways in which the authors take up, reflect upon, and honour the possibilities of mothering outside the lines—including poetic inquiry, autoethnography, ruminations on intergenerational teachings, and popular culture encounters—I felt the energy and embrace of a matricentric collective carrier bag that holds objects, ideas, identities, relations, and connects us to time and place beyond the here and now. In the poetics of Donna Haraway, "To carry, to wear, any of these bags is to enter into the knotting of capacities to respond, to become with each other in the untold stories we need" (12).

Coming to Defamiliarize Mother*: *Motherhood, *Mothering, and *Motherwork

Through habituated practices and the repetition of dominant stories (and storylines) saturated in competition and scarcity, we may waver, hesitate, or even fear the uncertainty that curiosity breeds. My dreaming of m/otherworlds is full of re-search and curiosity—a method of continually questioning that which I think I know. Guided by Zora Neal Hurston's work, I, too, embrace how "Research is formalized curiosity. It is poking and prying with a purpose" (127). Poking and prying open what is familiar. In a somewhat recent turn in my research, I have added "m/" to my social justice work. I have entered "into the knotting of capacities to respond" (Haraway 12) to a desire to carry forth m/otherworlds, and I have begun to look with curiosity at the recognizable everydayness and unquestioning of mothering. Years ago, a particular prompt revealed the landscape of a whole world of scholarship (a community, really) attending to motherhood; it was here that I felt like I found my place and identity as a scholar—ahem, a motherscholar (see, McDermott, "Becoming a Mother")! I began to realize how much I needed, and continued to desire, stories that push at the walls of normative motherhood as a patriarchal institution; these are the untold stories that create m/otherworld possibilities. As Haraway intones, "The burning question is how to join in telling the needed stories, building the needed worlds

and muting the deadly ones" (18). *Mothering Outside the Lines*, as a collection of these much-needed stories, not only names and marks the boundaries, the walls, as well as the seemingly rigid container of patriarchal motherhood, it also gestures to the ways in which mothering has many ways of taking shape outside the lines, in the in-between spaces.

After being gifted with the un(der)told stories gathered in this matricentric carrier bag I was brought back to some memories. (I imagine memory as another form of story that our bodies carry. As items carried in our bodies, memories, thus, are ready to be reached for or come to the surface, helping us to make sense of the present; a present which is always already drawing from the past as we imagine and move towards the future.) I share this (partial) story of how I have arrived here, now, and in what ways to express gratitude for the ways I have been mothered into scholarly dispositions that contribute to gestating m/otherworlds within academe and beyond.

Many years ago, I took an upper-level undergraduate sociology qualitative methods course with Dr. Prue Rains. At the time, I could never have imagined how Dr. Rains's teachings would shape the contours of my scholarly becomings—how I approach my teaching and research. Through the experiences nurtured by Dr. Rains, I came into and embraced the disposition of making the familiar strange as an orientation towards building more just worlds. We were invited to observe a space/community we deemed familiar and to consider what goes unnoticed in the cultural and embodied habits that signal status, rank, and belongingness within the group. We were encouraged to consider how habits come to illustrate the workings of power within and beyond the group dynamic—how individuals and groups are situated in society through the materiality of discourses and psychic absorption of institutional pressures.

Even with this background—with this offering of a way of being in the world that can hold the tension of critically noticing what is while reaching towards what can be(come)—I remained vastly unprepared to question, or to even know to question, the role and experience of mothers in society. I remember, for example, being stunned by my sheer unknowingness of the pregnant body, of my pregnant body—what it is capable of and how to be in it through pregnancy—that I now wish I had been more able to embrace rather than let the medicalization, fear, and concern overwrite the experience. Flash forwards several years, I

was at the beginning of a tenure-track assistant professor position, with one child in kindergarten and another in preschool, when I received an invitation—another gift—to contribute a chapter on women negotiating life in the academy (McDermott, "Becoming a Mother"). I was asked to reflect on my experiences as a mother of young children. And just like that, my world(s) changed and expanded in ways I had not yet imagined, as the invitation attuned me to the *boundaries* insisting that mothering and scholarship be kept separate as though I can split my being. I was unaware, at the time, that you could study motherhood or that motherhood is even a contentious site rife with tacit rules that overdetermine our relations, actions, and beliefs. Motherhood simply was, and I merely individualized any questioning I had as my own uncertainties and inabilities, taking individual responsibility for structural, material, discursive pressures. Soaked through to the bone in the socio-cultural, institutional, historical, and personal familiarity with motherhood, I consigned it to the nonpolitical realm.

Although I focussed my scholarly attention on questioning other areas of my lifeworld that contribute and uphold inequities, such as who can speak in what ways and how are they heard (see, McDermott, "Mapping the Terrains"), motherhood remained unquestioned in my life. I realized in the process of researching and writing "Becoming a Mother" that I needed stories about the complexities of mothering as well as about the possibilities of mothering beyond the intensive motherhood scripts. Scripts that create a cacophony ricocheting off the patriarchal walls bounding the experience, the work, the identity, the relations of possibility contained within expansive, creative, abundant mothering. I needed, *we* need, stories that allow us to imagine otherwise and other ways of doing m/otherwork. I needed, *we* need, a matricentric collective to hold us as we find our ways to becoming a mother. Several years into this realization that mothering can and ought to be studied, and that stories of mothering need to be wrested from the dominant scripts, I was invited to review *Mothering Outside the Lines: Tales of Boundary-Busting Mamas*, and I once again felt the embrace and possibility of carrying forth m/otherworlds.

I return to the memory and the gift of Dr. Rains's teachings with a sense of gratitude. Defamiliarization has carried me towards a matricentric collective and has affirmed the life I am navigating as a m/otherscholar. If mothering is "the practice of creating, nurturing, affirming,

and supporting life" (Gumbs, 9), I say that Dr. Rains mothered me into the scholar possibilities I have been growing into. Because of Dr. Rains's gifts of knowledge (McDermott, "Mapping Contours"), I have come to understand that no matter how insurmountable the embedded imperialist white supremacist capitalist patriarchy (hooks) seems, we can live and cultivate "fourth world" (la paperson) possibilities, even from within the institution—much like the stories of *Mothering Outside the Lines* gesture towards as well. We can do this by orienting ourselves differently, by acknowledging and expressing gratitude for the gifts and relations and possibilities offered through others' scholarship, and by naming how we have been shaped by and carried through the work and stories of others (McDermott "Mapping Contours").

In the arcs of my writing, scholarship, and teaching, I am bending towards m/otherworlds by practising gratitude for the gifts of knowledge I am offered and by "creating, nurturing, affirming, and supporting life" (Gumbs, 9) in and through gifts of knowledge. In expressing gratitude, and in naming how others' lives have influenced my own, I am committed to rescripting the individual and competitive underpinnings of sole-authored scholarship. Our ideas are relational; there are certain stories that resonate and offer another way of being, doing, and relating in the world. This is why I was so moved after encountering a tweet by Dr. Sarah Martin that described an assignment for students in her course, which involved writing letters of gratitude to scholars whose writing and thinking is shaping their own—others are out there doing scholarly work beyond the disciplinary norms of individual competition. I embody this gratitude here by thanking Dr. Rains for the gift of questioning the tacit rules, norms, and habits of being, doing, and relating in the world as many of the contributors in the volume express gratitude for the teachings of/from m/others.

As an interesting side note, while writing this I went back to look up Dr. Rains, who retired shortly after I convocated with my bachelor of arts. I found that she, too, had researched motherhood and had published on the topic (during the time I was in her course, no less) (see, for example, Rains, Davies, and McKinnon)! I wonder, now, if somehow, that knowledge of Dr. Rains's research did, indeed, enter my carrier bag with the other gifts she offered. At the very least, because of her teachings and research as well as other m/otherscholars—scholars who study motherhood—I have stories to tell my stories with! Because of the stories

gathered in Parr and Martin's matricentric collective, we have dynamic stories to ground and inspire our mothering stories as we reach towards m/otherworlds.

As I wind down this foreword, I hope you, too, may feel collected in this bag of stories. Bring what is in your carrier bag and join us as we collectively carry forth m/otherworlds.

Works Cited

Gumbs, Alexis Pauline. "Introduction." *Revolutionary Mothering: Love on the Front Lines*, edited by Alexis Pauline Gumbs, China Martens, and Mai'a Williams, PM Press, 2016, pp. 9-11.

Haraway, Donna. "Receiving Three Mochilas in Colombia: Carrier Bags for Staying with the Trouble Together." *The Carrier Bag Theory of Fiction*. Ignota, 2019, pp. 9-22.

hooks, bell. *Killing Rage: Ending Racism*. Henry Hold and Company, 1995.

Hurston, Zora Neal. *Dust Tracks on a Road: A Memoir*. J. B. Lippincott & Co, 1942.

King, Thomas. *The Truth About Stories: A Native Narrative*. House of Anansi Press, 2003.

la paperson. *A Third University is Possible*. University of Minnesota Press, 2017.

Le Guin, Ursula K. *The Carrier Bag Theory of Fiction*. Ignota, 2019.

Maracle, Lee. *Memory Serves: Oratories*. NeWest, 2015.

McDermott, Mairi. "Becoming a Mother in the Academy: A Letter to My Children." *Women Negotiating Life in the Academy: A Canadian Perspective*, edited by Sarah Elaine Eaton and Amy Burns, Springer, 2020, pp. 161-73.

McDermott, Mairi. "Changing the Stories We Live By: Reflexions on Epistemic Responsibility and Solidarity as Praxis." *Radically Dreaming: Illuminating Freirean Praxis in Turbulent Times* (pp. 255-264), edited by Tricia Kress, Robert Lake, and Elizabeth Stein. DIO Press, 2022.

McDermott, Mairi. "Mapping Contours of Gender and Knowledge Production: Towards Scholarly Writing as Gifts of Knowledge." *Women in Scholarly Publishing*, edited by Kristina Hultgren and Pejman

Habibie. Routledge, in press.

McDermott, Mairi. *Mapping the Terrain of Student Voice Pedagogies: An Autoethnography.* Peter Lang, 2020.

Okri, Ben. *A Way of Being Free.* Phoenix House, 1997.

Rains, Prue, Linda Davies, and Margaret McKinnon. "Social Services Construct the Teen Mother." *Families in Society: The Journal of Contemporary Human Services*, vol. 85, no. 1, 2004, pp. 17-26.

Table of Contents

CONTENTS

Boundaries:

Lines. Edges. Frontiers. Confines. Restraints. Borders. Rules. Limits. Partitions.

Real or imagined lines that mark the edge of something; frontiers that confine or restrain the extreme extent of a subject, object, territory, landscape, or sphere of activity; a border that shows where one entity ends and another begins; a point that shows where two beings become different; unofficial rules about what should or should not be done; limits or partitions that define acceptable behaviour and ways of being in the world.

Moral. Familial. Social. Economic. Political. Cultural. Religious. Spiritual. Psychological. Physical. Emotional. Time.

Mothering Outside the Lines:

to mother in creative or unconventional ways; to think or mother in a way that does not conform to set rules, real or imaginary; to engage in motherwork and maternal practice with or without the formal title of mother; to redefine (un)official rules about what should or should not be done; to bust boundaries that have been set for us, by us, and with us as mothers; to (re)set and enforce frontiers and boundaries that mark value for self and other; to accept a continual sense of becoming as mothers where change is not only inevitable but constant; to mark the ending of one being and the beginning of the next; to embody with grace the juncture where two beings become different; to embrace as part of the journey the (dis)continuities, (in)stabilities, (un)certainties, ambivalences, ambiguities, and paradoxes of motherhood.

Introduction

(Re)Setting Boundaries: An Invitation to Mother Outside the Lines

Michelann Parr

In a traditional sense, boundaries set parameters—both internal and external—within which to exist. They differentiate us from each other, help us to focus on what is most important, and foster relationships by creating clear expectations and responsibilities. On a simplistic level, "boundaries are simply our lists of what's okay and what's not okay" (Kelly Rae qtd. in Brown, *Strong* 126). But not all boundaries are good boundaries.

We who mother regularly encounter moral, familial, social, economic, political, cultural, religious, spiritual, psychological, physical, emotional, time, real, or imaginary structures that influence our thoughts, actions, and imaginations, forging "a path that keeps us busy, preoccupied, self-denying, and obedient" (Evans 3). With or without our awareness, we fall prey to externally imposed boundaries that tell us how to behave for good, for bad, in sickness and in health, and sometimes until death do us part. Although such boundaries are often perpetuated and sustained to keep us safe from harm, they often serve a different purpose—that of regulation, control, oppression, and marginalization. It is these boundaries we wish to bust in this collection. We accept our role in (re)setting, (re)defining, (re)drawing, and (re)colouring the boundaries, edges, and (un)official rules that are often ambiguous, pervasive, and perpetuated. We have become acutely aware, personally and professionally, that without our sustained attention and

intention to such limits and confines, we may put ourselves and others in harm's way; we may complicitly limit our own potential and that of others who mother, and we may undermine our being and becoming as mothers.

This collection shows that when faced with ambiguous and untenable boundaries, some mothers[1] choose to mother outside the lines. They resist the urge to accept the assumed, the unpredictable, or even the demanded boundaries—whether they be internal or external, visible or invisible, real or imaginary.

The mothers who have contributed to this collection exemplify how mothering outside the lines requires a continual process of gathering strength, meeting ourselves where we are, and healing the enemy within (hooks). Sustainable growth and change happen when we, as those who mother, transgress; when we push through discomfort, pain, and unfamiliarity; when we explore the edge of our boundaries; and, most importantly, when we (re)set and (up)hold boundaries of our own making: boundaries that respect and value the work we do as mothers (O'Reilly) as opposed to complicitly accepting those that limit and restrict us from the full extent of our being and becoming as mothers.

In *Rising Strong: How the Ability to Reset Transforms the Way We Live, Love, Parent, and Lead,* Brené Brown writes that well-defined and well-respected boundaries foster compassion for self and others in a way that keeps us out of resentment, shame, pressure, judgment, criticism, disappointment, and guilt—all of which have plagued mothers for years. Not setting boundaries for ourselves, we often find ourselves in the swamp and weeds of our own making, so to speak: We wonder if we have done enough, if we have truly loved unconditionally, or if we have set boundaries that are too restrictive (for ourselves and others). In fact, we typically do more than enough and love until it hurts, but when relationships change as they inevitably will, we find ourselves knee deep in outdated identities and boundaries that no longer serve. And it is not easy to reset, particularly when we have years' worth of mothering behind us. The reality is that no one can do this work for us; this is work that we must undertake for ourselves, as we work towards a matricentric feminist cause. Through it all, we hope while understanding that where there is hope, there is difficulty. Hope animates our struggle and gives us a sense that our efforts are worth it. Hope "carries us through when the terrain is difficult.... [Hope] is behind us when we have to work for

something to be possible" (Ahmed 2).

Blurring, resetting, and renegotiating maternal boundaries are ultimately acts of hope (Ahmed), courage and compassion (Brown), spiritual exercises in inner freedom (Evans), and maternal practice, which is critical not only to individual mothers but also to the identity, mental health, and well-being of the broader matricentric collective (O'Reilly). Significantly, when we (re)set and (up)hold boundaries, we show others that we value ourselves and the work we do, which allows us to mother from "a place of integrity and extend the most generous interpretations of the intentions, words, and actions of others" and of ourselves (Brown, *Rising Strong* 123). The side benefit, of course, is that we are also modelling healthy boundary setting for our children and for others we encounter.

In this collection, the authors transgress and uphold their maternal integrity as they write at the edge of comfort and take up the challenge of exploring the boundaries of maternal practices—their own, their mothers', and those found in literature, media, or popular culture. These mothers assume a hopeful stance, as they actively choose courage over comfort, push through what is fun, fast, or easy, and show how they come to mother outside the lines in all its simplicity and complexity. As they bust through outdated, tired, and ambiguous boundaries, they find and (re)set new boundaries that restore dignity and self-respect for themselves, their children, their families, and for the matricentric feminist collective, particularly those whose voices may continue to be silenced and marginalized by structures and limits beyond their control.

When we honour ourselves by (re)setting, and when we share our experiences of dancing at the edge of our boundaries, we find that we have much in common with the butterfly when it emerges from its cocoon: We push through resistance; we value the struggle that makes us strong; and when we come together, we form a kaleidoscope of maternal experience that offers us nourishment and comfort for our journeys.

As editors, we have been gifted the stories gathered in this collection, and we are honoured by the teachings and insights afforded by each one. As we read, leaned in, and re-read, we began to (re)consider our own frontiers within the context of the dominant narrative. We nudged ourselves in and out of comfort as we braved the "wilderness" we often encounter when asking the more difficult questions (Brown, *Wilderness*). As we explored our individual boundaries as mothers, we came to understand where and how we belong within the broader maternal

collective. As editors, these stories warranted our undivided attention, reflection, imagination, and compassion; we hope that you find similar levels of engagement, reflection, compassion, but mostly inspiration.

Collectively, these stories tell the tale of hopeful and courageous mothers who have taken up the challenge to mother outside the lines; each in their own way, they help to redefine what mothering is all about, answering Andrea O'Reilly's call for mothers to take up the unfinished work of feminism in a matricentric feminism, one that "positions mothers' needs and concerns as a starting point for a theory and politics on and for women's empowerment" (14).

A Storied Organization

Regardless of whether they are a narrative, poem, scholarly reflection, rant, or journal, we refer to our authors' tales as stories. The notion of story fulfills our need for connection by creating a space of relationality and reciprocity—a space of giving and receiving. It is also a site of intimacy and vulnerability that allows for both personal and social change (see Martin and Parr). Story, to us, is like mothering; we never quite know where we are going or what shape it will become until we are in the midst of it. As we get deeper into the process, we discover who we are as mothers, as human beings, and where we fit in the matricentric feminist collective (O'Reilly). As Carolyn Ellis says, "Writing difficult stories is a gift to self, a reflexive attempt to construct meaning in our lives and heal or grow from the pain" (26).

At the risk of establishing real, arbitrary, or even imaginary divisions, we have organized our authors' stories into three parts that make sense to us; it is entirely possible that you see a different organizational structure, and that is okay. Feel free to (re)set our partitions—in all honesty, setting this structure was pretty blurry for us, but we finally found one to settle with.

"Part One: Becoming at the Edge of Our Internal Boundaries" gathers stories that focus on authors' encounters with self-imposed and/or deeply internalized boundaries within the context of the broader dominant narrative. The authors document their quest to continually renegotiate, stretch, (re)set, enforce, and reject arbitrary and unofficial rules that do not serve them; to grow through resistance to the patriarchy and the discomfort imposed by normative expectations; and to come

to know themselves—the good, the bad, and the beautiful—within the context of their motherhood experiences.

"Part Two: Honouring our Boundary-Busting Foremothers" pays tribute to our experiences as daughters long before we were mothers or even planned to mother. The authors trace and express gratitude for their mothers; they often identify specific characteristics and traits gifted to them by their mothers. They recall, with pride, their lived maternal experiences as a mother and/or daughter, and they show us that when we pay attention and look carefully, there is much to be found, even in the struggle.

In "Part Three: Paying Homage to Popular Culture Boundary-Busting Mamas," the authors explore and frame maternal experiences within the context of publicly available literary and media works. Interestingly, almost every author in this collection references a snippet of music, a memorable poem, a childhood story, contemporary media, or literary influences. Though not a connection we expected, we find that it makes this part all the more compelling. As mothers, we read, listen, view, encounter, and experience texts of all sorts. No matter where we turn, there are influences—literary, media, and other—that permeate our lives and often model unofficial rules or tacit assumptions, setting arbitrary boundaries. Without critical interrogation, we accept complicitly with no real awareness of how/why texts of all sorts set, enforce, or bust boundaries. Critical interrogation helps us to explore, to restory, and to imagine a different way, and a more open and hopeful future.

In this three-part collective story, we bear witness, redeem, care, heal, and transform. We move in and through experiences in a way that culminates in new, creative ways of being in the world. We open and expand rigid boundaries, settling into those that are healthier and more mindful. We liberate imagination and intuition in our quest to become mothers who take up the matricentric feminist cause. We reset our internal boundaries, reject externally imposed boundaries that no longer serve, value change, accept the challenge of mothering outside the lines, honour our capacity to grow, and return to our stories with a reflective mindset.

Part One: Becoming at the Edge of Our Internal Boundaries

In Part One, we get honest about the stories we make up about our struggles; we revisit, challenge, and reality check our narratives as we write around "topics such as boundaries, shame, blame, resentment, heartbreak, generosity, and forgiveness" (Brown, *Rising Strong*, 77). As we lean into the multiple perspectives offered by our writers' stories, we confront the enemy within (hooks) and learn to extend the same generosity of spirit to self as we so often do to others. We come to recognize that internal conflict is part of the process of change, a source of knowing, and a site of deeper inquiry. Intentionally staying with ourselves and on the path, we find deep within ourselves spaces and places of hope, compassion, healing, empathy, and expanded consciousness.

In "Breaking the Silence of My Motherhood: Rabbit Holes, False Starts, (Un)Finished Fragments, and Hopeful Connections," Michelann Parr rumbles with her fragmented thinking (and writing) as she confronts silence, her enemy within (hooks); she ultimately comes to understand that her silence was just as much about her fear-based self-protection and intolerance of uncertainty (Brown, *Rising Strong*) as it was imposed by the patriarchy. Falling in, falling from grace, and falling to pieces, Parr gives herself permission to stay in the rabbit hole of silence, both literal and metaphorical. It is here that she comes to understand silence as a space of gratitude, healing, and hope as opposed to rejection, pain, or evidence that she had failed as a mother. When ready, she emerges hopeful and calls for others to confront the pains and silences of motherhood—what we have typically been conditioned to never expose for fear that we change what we have come to know as motherhood and our relationship with our children. Intentional white spaces, pauses, marginalia, and questions invite the reader to pause and engage in the hopes of finding peace, hope, and healing within the stillness of their own silence.

Tanya L'Heureux picks up the thread of peace, hope, and healing in "My (Paran)theses," as she reflects on her purpose, passions, and contradictions in mothering, (in)formal caring, studying, managing a chronic illness, and a desire for a more just world. At the invitation of the editors, L'Heureux's poem is presented in two forms: with and without "parantheses," which express different feelings and struggles,

as she plays with the sometimes seemingly paradoxical existence of her mothering and professional theses. For Tanya, the ongoing dialogues with her poem are a way of storying and unpacking the struggles, ambiguity, (non)sense, and (un)becomings of standing in the tragic gap of reality and imagined possibilities as she enacts her response-abilities within caring and social justice work. Readers are invited to play with their own (paran)theses as they experience this tale in both its simplicity and complexity.

"On Children: Forever Is Unconditional," by Jennifer Mehlenbacher, captures an incredibly complex internal and external journey, documenting Mehlenbacher's firstborn daughter's years of transitioning to life as a man and a son. After coming out as a lesbian at fourteen, then as pansexual, and then as bisexual over the course of her teen years, her daughter finally realized at the age of twenty that she truly was a trans man. Jennifer's story is framed by "On Children," a poem penned by Khalil Gibran, which offered comfort and a reminder that her children had their own thoughts and that although they were from her, they did not belong to her. Through this tale, Mehlenbacher processes her family's experience, alongside her own thoughts and emotions, which makes it all the more real and yields a space of greater understanding, reflection, and perspective. Readers will find comfort and hope in this piece, particularly if they face their own transitions with complicated feelings and reactions. There is nothing more simple or more complex than Mehlenbacher's concluding insight: Maternal love is both unconditional and forever.

In "Maternal Expectations," Kate Rossiter traces the complicated feelings and reactions that arise throughout her mother's struggle with early onset Alzheimer's disease—a journey that while shared with her mother is incredibly isolating. As Rossiter reflects, she finds that the relationship between mothers and daughters is often beset by fuzzy relational lines: Our bodies are one, then two, and then blur as they mirror each other's routines and cycles. Alzheimer's is incongruent with these lifelong blurred boundaries; its effect is to deepen isolation and to individuate by locking the sufferer into a prison of their own mind while demanding the most intimate and demanding forms of care. This piece marks the debut of what is likely to be a much longer struggle to demarcate where these blurred lines between mother and daughter have been forcefully cleaved by illness, with Rossiter mapping the increasingly

lonely place she inhabits in the face of her mother's dementia. Whereas Rossiter struggles to make sense of it all, her children's unconditional love and acceptance of their grandmother are not lost on her. This piece is raw, honest, and intensely personal. Readers who find themselves struggling to find order in the seeming chaos of changing relationships, or who are in process of redefining boundaries with aging parents, might find kinship in this piece and grant themselves permission to let it all out as an act of healing.

Part One concludes with "Beyond the Edges of Order: A Framework for the Motherhood of Becoming" by Drisana McDaniel, who describes parenting as a Black, single, never-married woman of three as a queerness of its own. She shows how she has grown beyond the edges of order, how she has been disrupted and delivered, and how her recovery has been tended to by an Allelujia Chorus (Pinkola-Estes 321). Making her way through the muck of shame, stigma, and collective trauma, McDaniel falls upwards and gains insight; her healing salve becomes her endorsement of the counternarrative Saidiya Hartman describes as the "terrible beauty of wayward lives" (30). This tale is rich in non-linearity and grounded in the understanding that the past is present, and the future is now—a theme that was more than evident throughout this opening part. To readers, McDaniel offers a mothering methodology that culminates in a four-part survival framework that shows how stories increase our capacity to be with what is, wrestle with paradox, honour change, and think about how to live and what that might mean.

Part Two: Honouring Our Boundary-Busting Foremothers

Part Two is filled with memory work and survival stories that pay tribute to our own mothers (and maybe even our mother's mother); in (re) storying, we give back some of what was offered to us in childhood. Whereas Part One documents internal struggles at the edge of our comfort, Part Two transitions into bearing witness and honouring our own mothers who seemed to naturally and instinctively mother outside the lines, no matter how difficult that might have been. Each in their own way, these stories exemplify our capacity to stay with what is, as contributors wrestle with how and why these anecdotes and memories of their lives, no matter how joyful or painful, translate into who they

are, where they have come from, and who they are becoming. As we think deeply about past, present, and future lives, and all that might mean, we honour our courageous and creative capacity to both be and become.

BettyAnn Martin opens the section with "My Mother's Legacy: Recovering the Gifts of Irreverence," a meandering exploration of memory inspired by photos and artefacts. One photo in particular—her inspiration for this chapter—graces the front cover of this text. Martin engages the past and reflects on her mother's legacy in relation to her personal history as well as the present and possible future. Time offers context, softens memories, and recalls feeling, thereby creating space for meaningful lessons and ways of knowing that connect family through the generations. Martin bears witness to her mother's strength and irreverence; this inheritance—once a source of tension and embarrassment—she reframes here as a site of possible freedom. By approaching memory with a gentle empathy, she recovers her mother's legacy as a gift with meaningful implications for her life and that of her children. This piece acknowledges that in allowing ourselves to resee memory, we are liberated to effectively (re)claim history, relationships, as well as the hope and healing necessary to (re)author our own stories. Readers are invited to engage their own memory work, open the metaphorical box of photos and artefacts, call forward the formative moments that make you who you are, and explore what is worth keeping and what is worth passing down to those you mother.

Darlene Tetzlaff picks up this memory work in "The House That Built Me." She opens with lyrics from a song performed by Miranda Lambert in 2009. This piece reflects where Tetzlaff came from, how this influenced her choices and life journey, and how those choices now affect her own children; it is a moving tribute to her mother, who offered grounding through her example in resilience, empathy, and humility. Tetzlaff's humble beginnings nurtured a passion for learning and sparked a drive to work hard, allowing her to consider diverse perspectives as well as to listen and suspend judgment. Making herself vulnerable, Tetzlaff shares her experience of living in that little house; she works through the shame she felt as a young person growing up and ultimately understands the role this place played in her emotional construction. Tetzlaff's story is ultimately one of finding acceptance and worthiness in a world that can sometimes be unjust and inequitable. Readers are invited to see

themselves in this tale and to reflect on the houses that built them and the emotional ties that bind them to their mothers: We cannot know strength without resilience, wisdom without experience, and survival without faith.

Taking up the themes of strength, wisdom, and survival, Susan Picard frames "The Whole Story" with a song that she wrote and performed over twenty years ago, mere weeks after her first child was born. What originally began as a love song to correct the misguided fairy tales of her young daughter's childhood inspired an anthem of tears. In this piece, Picard revisits this song and the stories that inspired it and finds strength in the fierce independence and determination of her mother and grandmother in the face of war, loss, and love. She comes to realize that the happily-ever-after path suggested of motherhood tends to ask more of us than we could ever have anticipated or thought we were able to give. In living and in writing, Picard comes to understand that "Suffering, if we experience it correctly, makes us sensitive to the suffering of others, awakens in us a new awareness, and creates a breach in our excessively egocentric attitude toward the surrounding world" (Dabrowski 30-31). With the help of her foremothers, a song in her heart, and the not-so-gentle guidance of her daughters, she learns to suffer with others, offering a deeper understanding of love, acceptance, and hope. As readers move back and forth between anecdotes about Picard's mother, grandmother, and self, they discover both the power and privilege of intergenerational bonds.

In "Resilient Independence: A Single-Lone Mom Reflects on Her Mother's Legacy," Natasha Steer picks up the thread of intergenerational bonds as she reflects on the influence that her mother's single motherhood had on her; she explores how her childhood experience connects to and affects her own parenting journey. Her story spans three generations beginning with her mother's experience of singlehandedly raising a biracial daughter in the latter part of the twentieth century to her own present experience at the beginning of the twenty-first century as a biracial single teen mother of a son. Her piece explores the roles of race, class, age, and various degrees of privilege on the single-lone mother. Ultimately, she comes to understand that her and her mother's experiences are similar yet different, largely as a result of shifting cultural acceptances, prejudices, and stigma. In the writing, she appreciates all that her mother has gifted her by making the choices she did even if, at

the time, she did not fully understand them. Readers are invited to reflect on the many privileges they bring to their experience of motherhood and how maternal life ebbs and flows in response to different times, cultures, and contexts.

"I Hope You Dance" by Zoe Oliveira is a youthful reflection of her childhood experiences; in the writing, Oliveira recognizes that the warmth and fondness of such memories is not something to be taken for granted and is a great privilege not afforded to all. Oliveira pieces together a collection of anecdotes that show the decisions her mother made to mother differently and the lived consequences of those choices. As Oliveira traces individual lessons learned along the way, within the context of daily life, she identifies ways in which her mother seamlessly and knowingly fostered these open ways of being in her children and others who entered their home. She expresses unconditional pride as she bears witness to her mother's unconventional generosity and grace, coming to understand that who she has become is credit to her mother. This piece is honest, refreshing, and restorative: a true tribute offered from daughter to mother. Her mother's decision to mother outside the lines fostered Oliveira's confidence, imagination, and willingness to put down on paper stories, which by her own admission, matter only to those who they are about. Readers are invited to reflect on the stories that matter only to their families—the good, the bad, and the beautiful.

Part Three: Paying Homage to Popular Culture Boundary-Busting Mamas

Creators—mothers, writers, filmmakers, poets, and photographers, to name a few—were once children who were gifted with the capacity to critique, (re)imagine, (re)create, (re)imagine, and (re)set boundaries. No matter who or where we are in the world, we encounter the influences of such creativity—all of which reflect a creator's way of being in the world, a particular time and place. Creation is often a reflection of the dominant and cultural narratives of the day that not only invites but often demands critical engagement, interrogation, and reflection.

Through stories, we experience different ways of being; we gather roles to try on, and we are offered the opportunity to vicariously experience life in a way that differs from our own. As Jane Yolen once said: "Stories are powerful. They are a journey and a joining. In a tale, we

meet new places, new people, new ideas. And they become *our* places, *our* people, *our* ideas" (8). Interrogating and understanding these influences are critical for the matricentric feminist collective. It is in this journey of joining, interrogating, and (re)creating that we take up the real work of stretching and (re)setting our assumptions, judgments, and boundaries to honour the work of those who mother.

Andrea O'Reilly opens Part Three with "'They Both Begin with Blood, Pain, and Terror': Transgressing Normative Motherhood in and through the Contemporary Psychological Thriller, *The Perfect Mother* by Aimee Molloy, *Little Voices* by Vanessa Lillie, and *Little Disasters* by Sarah Vaughan." This piece captures how three contemporary mother writers employ the genre of the psychological thriller to position their mother protagonists as "boundary-busting mamas" and portray mothering outside the lines of conventional motherhood. O'Reilly describes how Molloy, Lillie, and Vaughan probe the maternal psyche to reveal what patriarchal culture denies: maternal ambivalence, anxiety, apprehension, aversion, regret, reluctance, indecision, and uncertainty. These three authors convey and confirm these tabooed maternal sentiments to validate and vindicate the mothers' experiences of them; to critique and challenge the normative institution of motherhood, which denies and disparages mothers in its idealization and naturalization of maternity; and to transgress and transform the scripts of normative motherhood by making possible a mothering outside the lines. Encountering this chapter, readers may find that the use of the psychological thriller genre to portray mothering is a paradox in itself, particularly as it showcases the pain that mothers have been conditioned to not reveal (Rose).

In "Creating a Champion for Women: The Transgressive Maternal Practices of Andrea Dworkin's *Mother, Sylvia*," Valerie Palmer-Mehta immerses herself in the papers of radical feminist Andrea Dworkin to see how she marshalled the resources to read so vigorously against the grain of Western culture's perspectives on gender and sexuality at a time when such perspectives were rare. She was curious about how Dworkin maintained her voice and stance when she was attacked not only by those interested in maintaining the status quo but also by those within the feminist movement itself. Ultimately, what Palmer-Mehta finds most curious is that the contentious relationship Dworkin had with her mother, Sylvia, likely helped her hone the unique oppositional approach that was fundamental to her discourse and practice. A feminist and

antiracist advocate in her own right, Sylvia took nothing for granted—and she did not allow her daughter Andrea to take anything for granted either. As suggested by the writings presented, it is possible that Dworkin did not realize the impact of her mother's behind-the-scenes work in producing such a strong and active feminist. Through this, readers may reconsider some of the conversations and encounters they have had with their own mothers, perhaps finding a piece of wisdom or a perspective that they had not yet considered.

This part concludes with "Mothering with Cancer," experienced and written by Suzanne Edwards, who interweaves personal narrative, literary analysis, and feminist disability theory as she explores motherhood in the liminal space between life and death. In a heart-wrenching account, she analyzes how cultural ideals of motherhood in English-language literary history and contemporary popular culture frame the "good mother" as one who embraces death in a self-sacrificing act of maternal love or as one whose mortality is never in question. Diagnosed with incurable ovarian cancer during the birth of her second child in 2011, and in and out of treatment over the last ten years, Edwards's own maternal experience transgresses boundaries between maternal death and health. Edwards suggests that despite their cultural elision, dying mothers' visceral understanding of selfhood as shifting and unstable—their daily negotiation of accepting others' care, requiring self-care, and caring for their children—can be a form of feminist motherhood that embraces nonhierarchical interdependencies. In this piece, readers come face-to-face with the resilience of the maternal spirit in the face of daily impermanence, and we are reminded today, more than ever, of the gift that is now.

Parting Thoughts

As editors, we have honoured each of these stories with our openness, compassion, and sustained attention. We invite you to do the same. Spend time with these stories. Read between the lines. Notate, question, and wonder. Recognize that sharing difficult stories is a gift not only to yourself but also to others. It is a hopeful stance—an attempt to heal and grow collectively, sometimes through struggle, sometimes through resistance, but always through hope. When we share our stories, we become yet another thread to be woven continuously through time,

place, and people; here, we find that we are not so alone.

Collectively, we who mother outside the lines find resilience, empowerment, and strength to face whatever comes.

Endnotes

1. As both Andrea O'Reilly and Sara Ruddick have done, when we use the term "mother," we are referring to those who mother and those who engage in motherwork or maternal practice, regardless of whether they are offered the formal title of mother.

Works Cited

Ahmed, Sara. *Living a Feminist Life.* Duke University Press, 2017.

Brown, Brené. *Rising Strong: How the Ability to Reset Transforms the Way We Live, Love, Parent, and Lead.* Random House, 2017.

Brown, Brené. *Braving the Wilderness: The Quest for True Belonging and the Courage to Stand Alone.* Random House, 2017.

Dąbrowski, Kazimierz. Personality-Shaping Through Positive Disintegration. J. & A. Churchill Ltd., 1967.

Ellis, Carolyn. "Telling Secrets, Revealing Lives." *Qualitative Inquiry,* vol. 13, no. 1, January 2007, pp. 3-29.

Estes, Clarissa Pinkola. *Women Who Run with the Wolves.* Ballantine Books, 1992.

Hartman, Saidiya. *Wayward Lives, Beautiful Experiments: Intimate Histories of Riotous Black Girls, Troublesome Women, and Queer Radicals.* W. W. Norton & Company, 2019.

Evans, Shannon K. *Rewilding Motherhood: Your Path to an Empowered Feminine Spirituality.* Brazos Press, 2021.

hooks, bell. *Feminism is for Everybody.* Routledge, 2012.

Martin, BettyAnn, and Michelann Parr, editors. *Writing Mothers: Narrative Acts of Care, Redemption, and Solidarity.* Demeter Press, 2020.

O'Reilly, Andrea. "Matricentric Feminism: A Feminism for Mothers." *Journal of the Motherhood Initiative,* vol. 10, no. 1-2, 2019, pp. 13-26.

Rose, Jacqueline. *Mothers: An Essay on Love and Cruelty.* Farrar, Straus, and Giroux, 2018.

Ruddick, Sara. *Maternal Thinking: Toward a Politics of Peace*. Beacon Press, 1989.

Yolen, Jane, editor. *Favourite Folktales from Around the World*. Pantheon Books, 1986.

Part One

Becoming at the Edge of Our Internal Boundaries

Out of silence—
hope.

Story One

Breaking the Silence of My Motherhood: Rabbit Holes, False Starts, (Un)Finished Fragments, Hopeful Connections

Michelann Parr

Abstracting in the Margins

The reference to rabbit holes, the opening found poem, and other italicized lyrical quotes sprinkled throughout this chapter are borrowed from a childhood favourite, *Alice's Adventures in Wonderland* by Lewis Carroll (1865), which I have encountered in many forms: book, movie, animation, even performance. In this chapter, I slip back into a wonderland of sorts, fall deep into a rabbit hole, and touch the edges and boundaries of my maternal silences. It is here that I come to understand Alice as a tale of growing up: a girl's struggle to survive in the confusing world of adults with arbitrary and uninterrogated rules as well as bad habits that are incomprehensible to most children (de Rooy). As we grow up, we learn to cope with the nonsensical rules, and we get better at managing the situation, albeit less creatively. As I reflect on a years' worth of living and writing through silence in its many forms, and sometimes the absence of silence, I do my best to adopt a beginner's mindset. In the writing of this chapter, many a book on feminism,

women's ways of knowing, the patriarchy, maternal thinking, and silence are revisited or encountered for the very first time (but definitely not the last). This chapter is a project of self that I had long postponed (da Silva; Gleeson). It is one that took far longer than it should have (Olsen), as everything stirred up something else and touched everything I had ever touched (Bonnaffons), often pointing me in a crooked, less than linear line (Indigo Girls). Relegated to the margins and the white spaces, the details are far less important than my fragmented experience with silence over the course of my maternal lifetime—with young children, with teenagers, with adult children, and now coming full circle with grandchildren. Reading between the lines, those who engage with this chapter might observe my efforts to grow up as I recursively, sometimes ambivalently, move through the phases of received knowledge (listening to the voices of others); subjective knowledge (hearing the inner voice and the quest for self); procedural knowledge (acknowledging the voice of reason and separate and connected knowing); and constructed knowledge (integrating the voices) (Belenky et al.). Important to note is that it is only in the second half of my life that I have dared to look back—to (de)construct my past and find my own voice to truly understand who I am and have been as mother. I am doing my best to fall up, to fall in, and to fall forward while recognizing that falling from, falling out, and falling apart are all part of the process. That I still struggle to finalize, declare closure, and continue to hear my inner critic suggests that I'm not quite there. Yet through it all—the living, writing, and revising—I now realize that had I only heard the noise, I would have missed the protective and healing embrace of silence.

~

Down the rabbit hole she went,

 Considering in her own mind.

Never once considering how she was to get out again.

What a curious feeling.

 It's no use now to pretend to be two people—

 There's hardly enough of me left to make one respectable person.

What nonsense I'm talking.

 Stop this moment, I tell you.

What will become of me?

Who are you?
 Who in the world am I?

I hardly know at present.

I know who I was when I got up this morning.
 But I must have been changed several times since then.

I can't explain myself because I'm not myself.
 It is wrong from beginning to end.
 I'm never sure what I'm going to be, from one minute to another.

How puzzling all these changes.

I could tell you my adventures—beginning from this morning,
but it's no use going back to yesterday because I was a different person then.

<div align="center">~</div>

> To become a mother by any means is to cross a threshold;
> it is to shatter one's universe
> and then have it put back together as a wholly other place.
>
> —Kerry Clare 11

Deeper and deeper, I fall once again into the rabbit hole that is the silence of my motherhood; today, my fall is buffered by principles and practices of yoga that ground me, helping me to honour the big questions and explore the rhythms of my ordinary daily life as a mother (Cushman). I move in and out of memories, moments, texts, things said, things left unsaid, and the bits and pieces of my embodied experience of motherhood, both embracing and resisting the silences of past and present. I shatter and rearrange seemingly disparate pieces and settle into the pauses, breaks, and grooves: ignoring and acknowledging, bounding and unbounding, being and becoming, pushing and pulling, stretching and contracting, holding and letting go, as well as giving life and mourning loss. I weigh the abstractions of life, distinguish between relevant, verifiable, contestable, and even sanctioned facts, and consider the absence of presence alongside the presence of absences (Bonnaffons).

Motherhood is "a slippery subject that refuses definition," in which form meets function, design flirts with default, and shape is elusive; "It is a falling from and finding of grace, a falling in and out of love, and heartache by the hour. Motherhood is the ultimate confrontation with

yourself;" it is a journey to find "whatever there is to discover at the bottom of your soul" (Marchiano xii).

Down, down, down.
There was nothing else to do.
> *Would the fall never come to an end?*

I balk at the question of form that "long block of prose [that] seems to suggest a linear accretion of meaning" (Bonnaffons). I settle into a shape that is uniquely mine. Much like my experience of motherhood (Rich, *Born*), "the more [I] poke at my subject, the more it seems to spread in all directions, touching everything [I've] ever touched" (Bonnaffons).

~

What does it call itself, I wonder?

Multiple files, fragments, forms, and experiences are handwritten on scraps of paper, Post-it notes, in the margins of texts, in stacks of notebooks, or buried deep in my password-protected spaces, none of which quite capture the impossible subject of motherhood (Baraitser), which is after all not a subject at all but a way of being, an experience, a framework, as well as an institution (Rich, *Born*). I do wonder though:

> How to represent the robustness of [my] lived experience while also representing the experience of obscurity, of erasure? How to explore the messy, fluid realities of the body without sacrificing so much linearity that [my] work is labelled incoherent or unreadable? How to transcend the "diminutive," the traditionally "feminine," without devaluing it? (Bonnaffons)

> Sometimes the world steers you towards the broken apart, the work that refuses to be glued together, that basks in its un-ness. (Gleeson)

Curiouser and curiouser.

I grow curious about the fragment as conceived by Camelia Elias: "A universal with no stable position in time or space ... defined in relation to its truthfulness ... [and] its undeniable existence ... a collection of words put together which are resonant of the voice of creative imagination" (432). In its being and becoming, the fragment disrupts "the notion

that there is one, single, correct 'master narrative,' traditionally a tool for propagating a patriarchal view of the world" (Callahan 10). I am drawn towards "an essay made up of fragments—one that may be called lyric, mosaic, segmented, braided, collaged, or sectioned" (Callahan 10), even a "dialectics of perspective ... in the time and space of the poetics of intersection" (Elias 433).

I love that the fragment dictates how to be read; it invites the reader into sustained attention, allowing them to participate in sense making, to think deeply through the white spaces, and to respond in a feeling way, all of which turns the reading into a deeply aesthetic and relational practice (Rosenblatt). I consider leaving the following page of this chapter blank, inviting my readers to fill its white space with their own silences.

<<This page left intentionally blank by author.>>

I settle for an intentional arrangement of text and white space for readers to jot down their questions, comments, critiques, connections, interrogations, curiosities, wonderings.

I am enamoured with the fragment's possibility: that which may be "emancipatory and politically productive" (Levine 112). I applaud its "associative logic," "openness to visuality as a tool of meaning-making," and suitability for "expressing embodied truths—especially those previously neglected or experienced in the gaps between sanctioned 'facts'" (Bonnaffons).

<div style="text-align: right;">

Inhale space.
Exhale restraint.

</div>

I am liberated by this fragmented way of being: its acceptance of my experience of contradiction; its warm reception of repetition as necessary in understanding my emotional truth (Callahan; Cohen; Elias); its focus on performativity, complexity, and authenticity (Elias); and its uncanny resemblance to the experience of motherhood (Rich, *Born*). Trusting that this is exactly where I need to be, I rightfully/writefully locate myself in the "'great soup of being'—the confusions of lived time, the jagged shape of thought, the betrayals and silences of the body" (Bonnaffons).

I imagine this process as transgressive, as breaking form, as pushing back against yet another set of rules or lies or boundaries into which I was born, to which I have tacitly agreed, those which often keep me silent. I resist the persistence of the patriarchy and its impact on how I

mother, how I write, and how I am in the world (Gilligan and Snider).

Like the fragment, motherhood exhibits a "state of *being*" ("it exists as it *is*") and a "state of *becoming*" (it "becomes something else by being theorized in critical discourse") (Elias 33). Much like Sara Ruddick's notion of "the child," I most enjoy the status of being—"an 'open structure' whose acts are irregular, unpredictable, and often mysterious" (*Maternal* 352).

I transgress.

I resist.

I accept my ambiguity, my ambivalence, my (un)finishedness, and my (dis)continuity.

I commit to (un)becoming, (un)doing, and (un)writing.

What is writing and silence and being and motherhood and children if not a series of fragments, a string of lyrics, a dialectics of perspective, a poetics of intersection, and a whole lot of white space?

~

More than any other human relationships, overwhelmingly more, motherhood means being instantly interruptable, responsive, responsible.... It is distraction, not meditation, that becomes habitual; interruption, not continuity; spasmodic, not constant toil.... Work interrupted, deferred, relinquished, makes blockage. (Olsen 18-19)

I [write] on trains, on my phone in hospital waiting rooms, in the time before my children [and now grandchildren] w[a]ke, before the world burrow[s] into my brain for the day and creativity [is] postponed for another 24 hours. This [story] was born out of fragments of time, so its methodology mimics the way it was written: fitfully, out-of-synch, in snatched scraps. The shape (there's that word again) made sense to me only when I'd finished it. (Gleeson)

The cost of "discontinuity" (that pattern still imposed on women) is such a weight of things unsaid, an accumulation of material so great, that everything starts up something else in me; what should take weeks, takes me sometimes months to write; what should take months takes years. (Olsen 39)

~

46

And things are worse than ever—
 for I never was so small as this before.

In order to survive and be accepted, I adapted. I silenced myself. I studied what they wanted me to study. I didn't have any passion for what I was doing anymore, I was just adjusting. Giving up on what you love is very painful. Now I understand that I simply postponed my project, but at the time I couldn't understand this. I suffered in silence. (da Silva 201)

I listened. I mothered how they wanted me to mother. I heard others speak words that I wished were mine. I was torn between false dichotomies. Right or wrong? True or false? Good or bad? Black or white? Love or indifference? Connected or detached? Married or divorced? Divorced or annulled? Dissonance or paradox (Brown, *Atlas*)? I was stuck, emotionally starving (Jack), and hungry for more of my being, but "immersed in a society that has always told us the hunger of women is bad. Dangerous. Undesirable.... Indoctrinated in every possible way to believe that our hunger will make us too big, too indelicate, too uncomfortable to be around" (Evans 8). Still in silence I stayed, not realizing that in doing so, I was also postponing my project of self.

~

In my moments of solitude, one would guess that I would have chosen silence over the noise of everyday family life. Not so much. My multidisc player was locked and loaded. I had long ago set aside my beloved *Girls, Girls, Girls!* (1976)—the first vinyl I ever owned—a collection of songs written and sung by men about women. I turned to new voices that were "at once familiar and original"—voices that were "arising out of maternal [and feminist] practice, affirming its own criteria of acceptability, insisting that the dominant values [were] unacceptable and need not be accepted" (Ruddick, *Maternal* 357). These boundary busters and rule breakers became my more knowledgeable others (Vygotsky); they offered me a way in and a way through, a place to let it go and let it out, a space to fall forward (if even in solitude). When I was not up to speaking my truth, sharing my inner world, or communicating my feelings, I strategically cued the most relevant songs, cranked the volume, and sang along. I still do.

I was silent all those years (Tori Amos), often torn because nothing seemed right (Natalie Imbruglia). Nothing I had was truly mine (Dido), and on the days when nothing seemed to go my way (Shania Twain), I longed to pack up what was mine and go someplace where no one knew me (Jann Arden). I disguised my feelings and willed for others to just not ask me how I was (Suzanne Vega) because I really was not sure. And I commiserated: Who would save my soul if I could not save my own? (Jewel). I discovered that there was more than one answer to that question, which often pointed me in a crooked line (Indigo Girls). And I carried on: "Every Christmas card showed a perfect family," and everything ran right on time through years of practice and design (Mary Chapin Carpenter).

Immersed in the fragmented time and space of maternal thinking (Ruddick, *Politics*) and the nonlinearity and continual interruption to life (Olsen), I love(d) being a mother, despite its difficult times. I truly believe(d) that I was an empowered mother (O'Reilly) if not a more than "an equal partner in marriage and thus charged with making the right choices and decisions for [my] family needs" (McRobbie, "Feminism" 119). In the early years of my motherhood, my brand of feminism closely resembled lifestyle feminism, in which "There could be as many versions of feminism as there were women" (hooks, *Feminism* 5). To "ensure a stable upbringing for [my] children," I focussed on "'juggling' and combining responsibility," and I dismissed the narrative that "female mental health and well-being were dependent on being able to exit a marriage" (McRobbie, "Feminism" 124). Invoking choice feminism, I believed that as long as I did what I wanted, it should be considered "a feminist act" (Sørensen 299).

A (k)not? Oh, do let me help to (un)do it.

With my current consciousness, I have come to appreciate the contempt my husband had for my music, acknowledging that it may have deviated from the "standard of absolute silence" in a way that might have been "thought to be loquacious and out of line" (Belenky et al. 45). Perhaps he heard what I was not communicating for myself, and it was my medium of choice that caused his disdain. Perhaps my music signalled an absence from my marriage, the presence of silence, resistance to life as it was, visible impatience to discover the best version of myself, and growing awareness of the choices I had yet to make.

Perhaps in my (k)not knowing what I did not know, with little tangible to call my own, I subverted and silenced my voice, which in turn sabotaged my marriage. Or perhaps my marriage was destined to fall apart from the beginning by the ordinary and taken-for-granted injustices and microaggressions inherent to the institution of marriage, which not only informed my marital relationship but also seeped into the relationships with my children. For years, I stayed silent, unaware of these discourses into which I was born (Shields). I conformed and lived a life in performative harmony with the shared cultural script (Fivush)—not making the rules but enforcing them (Rich, *Born*) and, unknowingly, perpetuating them.

Many years passed but eventually my "resentments and experiences, guilts and sufferings" were no longer hidden (Heilbrun 69), and the shattered pieces of my being were no longer recognizable, even to me. As my children became more knowledgeable feminists-in-training, they took note, and I found that "my silences had not protected me" after all (Lorde, *Transformation* 41).

This was no longer the safest place I'd ever find (Mary Chapin Carpenter). Not for me. Not for my children.

Isn't that ironic? (Alanis Morrisette).

When the divorce papers were finally signed, I personalized my ringtones. Much to my teenagers' chagrin, every time their other parent called, The Chicks would belt out, "I'm not ready to make nice. I'm not ready to back down." It took years for me to change the ringtone, and "I'm still mad as hell."

What an ignorant little girl they'll think me.

Today, I realize that postponing my matricentric feminist (O'Reilly) project of self was an imperfect decision with its own set of consequences and painful casualties: I begin to let it go and test my limits (Idina Menzel), melting away "outdated parts of [my] personality" Marchiano xii) and forging new structures. I now understand the patriarchy for what it is: "A voice or framework, a way of seeing and speaking about things rather than how things are" (Gilligan and Snider 128). I now see how the persistent and ongoing impacts of the patriarchy damage both men and women (hooks, *Feminism*; *Change*). I view motherhood no differently, with its "prescriptions and conditions in which choices are made or blocked; they [too] are not 'reality' but they have shaped the

circumstances of our lives" (Rich, *Born* 42). I now appreciate that "The enemy within must be transformed before we can confront the enemy outside" (hooks, *Feminism* 12).

~

Who am I then?
> *Tell me that first, and then if I like being that person, I'll come up:*
> *If not, I'll stay down here.*

I wonder if a feminist reading of my life would suggest that I was oppressed as a mother under the patriarchy as woman and mother (O'Reilly). As a woman, I felt that I had taken the necessary steps towards being a feminist—integrating feminist ways of being and moving in the world. But fully occupied in the experience of mothering, I did not realize that the institution of motherhood was built on the very ground of the patriarchy (Rich, *Born*). At the time, I could not fathom that there might have been some sort of voice telling me what to do (Ruddick, *Politics*), and I did not feel entrapped "in conventional feminine roles and ideals" (Solnit 8). Like many other women and mothers, I had not yet found my consciousness. When challenged, I verbally rejected perceptions of myself as a passive, silent, and self-sacrificial carer (Evans; Rich, *Born*). But without awareness and intent, I unknowingly settled in: adapting in the moment by detaching myself from relationships (even those that had stood the test of time) and "becoming seemingly self-sufficient, independent, and not needing others ... seemingly selfless, without a voice or needs and desires and perceptions of [my] own" (Gilligan and Snider 118).

My experience of motherhood might have been different had O'Reilly's words been even but a whisper: "Mothers—arguably more so than women in general—remain disempowered despite forty years of feminism.... Motherhood, it could be said, is the unfinished work of feminism" (13-14). I wish today that matricentric feminism, which "begins with the mother and takes seriously the work of mothering" (18), had been part of my earlier experience of motherhood.

You ought to be ashamed of yourself—a great girl like you—to go on crying in this way.

I wonder if my enemy within made the personal political in a way that was deeply felt and internalized by my children. I wonder if my children saw the incongruency of what they were being taught in terms of feminist consciousness and how I embodied the very acts of mothering. I wonder if my children's reading of the intersectionality between feminism and motherhood was light years ahead of its time. I wonder what legacy they now carry with them. Do my children realize that at the time, I did my best but did not fully understand the ubiquity of the patriarchy, the purposes it serves, and how to change it (Gilligan and Snider)?

Accepting the flaws and imperfections of my past selfless self (Brown, *Myths*), the one who lacked in awareness, agency, and voice, I realize that I struggled to see myself mirrored in the eyes of my children: "In the absence of resonance, or when what comes back is so distorting that we can't recognize ourselves in people's responses to us, we not only experience an absence of connection with others but also perhaps a loss of trust in our ability to communicate what we want to say" (Gilligan and Snider 119).

You've no right to grow here.

Keeping the peace, I pushed to the margins the very questions—reflexive and critical—that I needed to grow, to be, and to (un)become. Not rushing my stay, down I stayed, "in the depths of the ground of [my own] being (Murdock 93).

Questions Pushed to the Margin

What are the words you do not yet have? What do you need to say? What are the tyrannies you swallow day by day and attempt to make your own until you will sicken and die of them, still in silence? (Lorde, "Transformation" 41)

<div style="text-align: right">

Inhale peace.
Exhale fear.

</div>

~

If you would only tell me the right way to begin, I will do it as well I can.

As I continue to process my silences, find ways to communicate what I feel and want to say, and begin to heal the enemy within, I come to understand that the political was intensely personal not just for me but also for my children. As I free myself from the shackles of the institution of motherhood and settle into my ongoing and ever-evolving experience of motherhood, I find that I have more questions than answers:

- What are the silences of motherhood, my motherhood, that need breaking?

- How do I break the silences that have become unnatural, hidden, censored, unnamed, tacit, culturally scripted, and seemingly accepted in the very space of my home?

- What is real? What is imaginary? What is faith? What is reason? What is truth? What is treason? (Amy Sky)

- Who am I to write through these silences?

- Why am I writing? Why do I choose this medium? What purpose does it serve?

- Who am I writing for? What am I writing towards? What do I hope to achieve? What are the rewards? What are the risks? For me, for my children, and for others who mother?

- How will I break my silence with my children so they can break theirs?

- What exists in the margins? What exists in the body text? What is footnote/endnote?

- What is worth saying? What is worth keeping silent? What's the difference?

- What is my responsibility to myself, to others, and to a real or imaginary collective?

- How do I free myself, and other mothers, from the internalized ideas we carry of our children's thoughts, opinions, and experiences that inevitably mediate our relationships and communication with our children?

- How do I show my children who I am? That I am not the mistakes that I have made, the things that cause me pain, even pieces of the dream I left behind (India Arie Simpson)?

Amidst a willingness to (un)do and begin anew, I am apprehensive: Will my words be perceived as weapons and used to separate and diminish instead of connecting and empowering (Belenky et al.)? Will I find active compassion and empathy, or will I just hear words: "The narrative we tell ourselves to make other people real to us, to feel for and with them, and therefore extend and open ourselves" (Solnit 36). I fear a refusal to listen, hear, and be understood that "breaks [the] social contract of recognizing another's humanity and our connectedness" (Solnit 36).

So, I continue to exercise my right to remain silent and protect myself from having my words used against me. Yet again, I become what I need to become. I shut down. I deny some part of myself and my humanity. And I protect myself from some kind of vulnerability (Brown, *Daring*), which then renders my much-needed self-compassion and self-empathy inaccessible.

> when we speak we are afraid
> our words will not be heard
> nor welcomed
> but when we are silent
> we are still afraid. (Lorde, "Litany")

There was a long silence after this—
 only whispers now and then.

~

Still in silence, I search. If I knew then what I know now, what might I have done differently? Would I have held my mother tongue still? Would I have let the transgressions go unnoticed and unspoken? Or would I have broken my silence? I wonder what meaning my children made of the times when there was nothing left for me to do but to break the silence, the times the volcano finally erupted (Le Guin) and my unbidden and unrestrained emotions spurted out. What trauma do they carry with them as a result?

> ...male culture assumes that feelings are something that people should stay on top of and puts women down for being led by their feelings (being underneath them).

> ...women have all along been generally in touch with their feelings.... [this] has been their greatest strength, historically and for the future... we have used our feelings as our best available

weapon—hysterics, whining, bitching, etc.—given that our best form of defence against those with power to control our lives was their feelings toward us....

...when we had hysterical fits, when we took things "too" personally, [we were] responding with our feelings correctly [but maybe not always in the most productive way] to a given situation of injustice. (Sarachild 273)

I hear the still-small voice of Audrey Lorde's daughter: "Tell them about how you're never really a whole person if you remain silent, because there's always that one little piece inside you that wants to be spoken out, and if you keep ignoring it, it gets madder and madder and hotter and hotter" (Lorde, "Transformation" 42).

Some thirty-eight years into my motherhood, I question whether my notion of choice, feminism, and empowered mothering was just an illusion and a powerless responsibility (Rich, *Born*) that restrained my power to contest, challenge, and counter "the patriarchal oppressive institution of motherhood" (O'Reilly 18) and, therefore, my and my children's experience of motherhood.

~

Silence—
and then confusion of voices.

By "being silent, one can impose silence on others" (Fivush 91).

Dear Child of Mine,

Perhaps your silence would be bearable if I had some gist, some inkling, of what it was that you were processing—perhaps not the details but the generalities. Without any word from you, I am left to ruminate, to meander through memory, and to sift through a past where I did the best that I could with the resources I had at the time. Sure, perhaps today, with today's consciousness, I might have done differently. But I would not have loved you differently, and I could not have given more. I gave my all to the experience of motherhood. Is that the source of the empathy you declare? Is that what you are still processing? Do you see motherhood more as sacrifice than choice? Do you wonder whether if I knew then what I know now, I might not have made the same choices? I am not (and never claimed to be) perfect (McRobbie, "Notes"), and I made my share of mistakes. Perhaps I was not the mother you needed me to be?

Dear Child of Mine,

As I attempt to process your silence, I wonder if it is the institution of motherhood (Rich, *Born*) that you are processing, perhaps questioning, perhaps interrogating, perhaps doubting? Does your ambivalence come from not yet knowing what you want or how you feel about motherhood? Do you wonder whether you will experience the absence of something? Perhaps "the backdrop of your evolving womanhood" is "the impossibly paradoxical experience of motherhood and mothering, both liberation and trap, exquisite pleasure and appalling drudgery" (Baraitser 2)? Perhaps there are days when you question the primary purpose of a woman's life if not motherhood? (Heti)? Other days, you push back against this way of being and feel that the choice to mother is one that puts a woman's very personhood at risk—potentially subsumed by the very acts of mothering.

Dear Child of Mine,

How can I build a bridge when I have no understanding of the terrain, of the great chasm that lies between our two standpoints (Plank)? Where do I even begin when the only structure you are willing to build is grounded in absence? I wonder how I might have silenced you, how my ongoing silence might now be contributing to your silence (hooks, *Change*). I wonder how to break this silence, how to build a relationship that honours who we are today, releasing the weight of who we were in days passed. I wonder how to communicate these new ways of being that allow us to be seen and heard while resisting the urge to anger, defend, and protect. I wonder how to heal the generational impacts of my maternal silence to become "a [more] responsible mother: one who shows her children how to be fully alive" (Doyle 75).

> I take a deep breath,
> I honour my feelings,
> I hold the silences you so desire for just a little longer,
> I honour your need to process,
> I stay here for longer than I want to,
> I wait for what seems like a lifetime,
> I know this too shall pass.

~

Silence all round, if you please.

As a mother, I have come to know all too well the sounds of silence: its ebbs and flows; its mountains and valleys; its lightness and darkness; its warmth and frigidity; its whispers and echoes; its company and isolation. I have encountered silence as pathological, a defensive reaction born of confusion or the desire to appear in a way that one is not really feeling. I have encountered silence as defeat (Gilligan), silence as defiance (Mahoney), and silence as resistance (Mahoney). I have experienced how

> moments of withdrawal create a space of silence, where one does not have to be accountable. The capacity to speak out is nurtured in these episodes of nonspeaking that are often experienced subjectively as times of shame, confusion, and anxiety. Far from being (only) moments of defeat, they also contain the possibility of strength and action through the subjective state of noncompliance. (Mahoney 622)

I appreciate the natural silences—"that necessary time for renewal, lying fallow, gestation, in the natural cycle of creation" (Olsen 6).

I embrace that

> Silence can be a plan
> rigorously executed
> the blueprint of a life
> It is a presence
> it has a history a form
> Do not confuse it
> with any kind of absence. (Rich, *Cartographies* 17)

In the vast and seemingly never-ending landscape of silence, I have explored its realms: "Silence imposed from within; silence imposed from without; and silence that exists around what has not yet been named, recognized, described, or admitted. But they are not distinct; they feed each other; and what is unsayable becomes unknowable and vice versa, until something breaks" (Solnit 28).

I fight against the unnatural silences (Olsen)—

> the unnatural thwarting of what struggles to come into being, but

cannot (6).... the *hidden* silences; work aborted, deferred, denied — hidden by the work that does not come to fruition (8).... [the] Censorship silences. Deletions, omissions, abandonment of the medium... paralyzing of capacity (9)....Other silences... the knife of the perfectionist attitude in art and life.... the absence of creativity (9).... the silences where the lives never came to writing (10).... [the] restlessness, indefinable yearning, a sense of restriction (11).

"Silence pervades when the wailing ceases" (Murdock 92).

I now accept

Silence as a space of possibility.... Entering the stillness of silence we might communicate deeply at the edges of sound. Silence allows us the space to breathe. It allows the freedom of not having to exist constantly in reaction to what is said. Standing in silence allows for that breath, for that reflection that can create a space of great healing ... silence [is] a space of fluidity, non-linearity, and a sacred, internal space that provides a refuge—especially for nondominant peoples. Silence is a process that allows one to go within before one has to speak or act. (Rowe and Malhotra 2)

Inhale.
Exhale.

~

Maternal voices have been drowned by professional theory, ideologies of motherhood, sexist arrogance, and childhood fantasy.... Alternately silenced and edging toward speech, mothers' voices are not voices of mothers as they are, but as they are becoming. (Ruddick, *Politics* 40)

Existential Crises in the Margins

Borrowed from the St. John of the Cross's *Dark Night of the Soul* (1584-85), I conceptualize the "dark night of mothering" as the rejection of conceptual, cultural, and patriarchal frameworks that no longer serve the experience of mothering. A rupture in identity. An existential crisis. A period of utter desolation, disconnection, and emptiness. A feeling of separation. The space between who you were/are and who you will

become. No solid or stable ground. A difficult and significant transition to a deeper perception of embodied maternal experience, thinking, and place in the world. An intervention. A search for connection.

~

Today, I imagine writing a book in response to Michele Filgate's *What My Mother and I Don't Talk About: Fifteen Writers Break the Silence*, which is evidence that it is generally acceptable for children to share their stories, interpretations, and critiques of their experience of being mothered. Mothers are deemed the prime cause of their children's positive or negative development, and we are typically slow to give credit, but quick to blame (Murdock). "Texts that are 'sited' in the writer's identity as a mother" (Malin) are rare, particularly when relationships are under pressure, perhaps because, as noted by Carol Gilligan, "Women consider the failure of relationships to be a moral failure" (qtd. in Jack 523). The resultant shame, confusion, and anxiety position women to adopt a space of silence (Mahoney)—perhaps to keep the peace, perhaps to resist, perhaps as fear of failure, or perhaps because the universal patriarchal views that feminists have long attempted to dismantle are still alive and well, particularly in pandemic times (Wallace).

Filling this gap in the literature, I propose a complementary edited collection that captures what those who mother wish they could share with their children: "the hilarious, the painful, the awkward, and the downright messy" (*What My Mother*'s book jacket). This book is a challenge to take back the dark night of mothering by putting the embodied experiences of mothers out there in the world, for the world.

I am interested in hearing from the disillusioned, disenfranchised, and maybe even disengaged, who mother. I want to know: What are your fears, hopes, dreams, struggles, pains? What is it that you and your children do not talk about?

My goal is that this collection be a homeplace (hooks, *Homeplace*)—a hopeful reckoning with self through evocative autoethnography (Bochner and Ellis) and/or critical narrative inquiry (Jørgensen and Largacha-Martinez). It is "a place where a writer [those who mother] can lay claim for control over their own story (Filgate xiv) and a response to Tillie Olsen's invitation to confront the silences of everyday life. On the broader landscape of maternal studies, this collection aims to "produce work that opposes structures of domination, that presents possibilities for a transformed future by willingly interrogating [our] own work [as

those who mother] on aesthetic and political grounds ... becom[ing] an act of critical intervention, fostering a fundamental attitude of vigilance rather than denial" (hooks, *Homeplace* 53).

When revealing what it means to mother, there is a tendency to sugar coat the truth, downplay the awkward, gloss over the messy, ignore the obvious (Zerubavel), and rationalize, even deny, a truth that rumbles deep within (Hasseldine). Maybe, as Brené Brown suggests, all of this is an effort to "fit in" to the organizational structure of our families at times when we do not quite feel that we "belong" (*Heart*, 162-63). Many have accepted this as an all-encompassing maternal plight and unspoken contract with our children, our children's other parents, and the many others in our lives: "What the pain of mothers must never expose is a viciously unjust world in a complete mess" (Rose 12).

Getting caught unknowingly in the spiral of silence (Noelle-Neuman), those who mother often ignore the lived tragedies of the present. We tuck away the hurt, pain, and evil of our daily existence, and we store it all in a box hidden deep within ourselves. Like Pandora, we keep this box stuffed to the brim with things unspoken, locked, and hidden out of plain sight. We embody the myth that suggests that to do differently would put mothers' very identity in jeopardy or, at the very least, the relationships with their children. Nevertheless, those who mother persist—some accepting things as they are and some hoping that one day this too shall pass.

In the patriarchal present, being responsible to others often requires that we shut down our curiosity, happily accept and shoulder the burden of not knowing, and choose silence. Dana Crowley Jack's theory of silencing the self is deeply rooted in women's subordination to men—something that may, without pushback, result in mothers' subordination to children as they grow into their own consciousness. In this collection, I urge you to break free of the self-silence boundaries and step out of the spiral of silence that exists as part of the dominant patriarchal narrative. Resist the tendency to play it safe by putting the needs of others before the self. Disrupt the normative and unsettle what is generally accepted and judged by external standards. Avoid falling prey to the stories your children (particularly those who have grown past the open-mindedness of childhood) tell or restory within their own experiences to avoid conflict and possible loss of relationship. And most importantly, send to the margins the lived and imaginary responses you might hear when

sharing your truth.

Adopt Adrienne Rich's (*Lies*) agentic and resistive view wherein silence is a plan, presence, and blueprint for life. Resist the enemy within (hooks, *Feminism*) by bringing your inner and outer selves into alignment (Jack). Rigorously write through the silence while knowing that ultimately you become "the stories you write" (Ellis 22). Together, we can change the scripts and the maps and allow our truths to erupt (Le Guin).

While breaking the silences of motherhood requires the collective *we* (Belenkey et al.; Martin and Parr; O'Reilly; Rich; Ruddick; and many others), this is intensely personal work that comes with monumental relational responsibilities, both positive and negative, life enhancing and life destroying (Ellis). It is possible that throughout this process, you will feel dialectical oppositions at play as you teeter between expression and protection as well as disclosure and restraint (Bochner):

> Seldom are we completely open with people in our lives about how we see them or how we see ourselves relative to them. We often fear that those in our stories will be hurt by what we've revealed, how we've interpreted events or people, or how we ourselves feel. Often we operate under the fear of the unknown; we don't know how intimate others will react to what we write, and it feels safer to stay in the accustomed disclosure (or non-disclosure) system that is predictable and comfortable. (Ellis 17)

"Using the agony of mother to deflect from our awareness of human responsibility for the world has a long history" (Rose 12) has become a burden that often finds itself in the shadows, borderlands, and liminal spaces of mothering. As those who continue to mother children of all ages, we must take up the challenge and find a way to break and articulate our silences in honest and authentic ways that preserve our maternal integrity, are morally and ethically responsible, and do not present as a lifelong list of complaints and resentments (although this may certainly be part of our processing, and that of our children). We must find a way to bridge our differences and transform our silence into action (Lorde, "Transformation"). As noted by Carolyn Ellis, "Writing difficult stories is a gift to self, a reflexive attempt to construct meaning in our lives and heal or grow from the pain" (26). Writing about, through, and with silence is an opportunity to take back the dark night of mothering and awaken our mothering selves "into something deeper, which is no

longer based on concepts in [our] mind[s]. A deeper sense of purpose or connectedness with a greater life that is not dependent on explanations or anything conceptual any longer. It's a kind of re-birth" (Tolle).

This collection is open to all forms of media, including visual arts, poetry, song, script, story, literary reflection, fiction, and nonfiction. Story is welcome in all its shapes and sizes—in its bits, pieces, fragments, images, letters, text messages, actions, and dialogues. I encourage you to resist the traditional narratives that bind and structure lived experience into a coherent, linear whole. These structures may interfere with how you choose to live, retell, revise, and transform your experience as someone who mothers (Jørgensen and Largacha-Martinez). Embrace this as an empowering and creative practice with no limitations, judgments, or inner critics.

For this imaginary collection, I invite submissions from those who find resonance in the call and who seek comfort in a matricentric feminist collective (O'Reilly), although I do reserve the right to refuse defensive positions that serve to further silence, minimize, blame, or reject the experiences of those who mother. Potential authors include those who have ever had children; those who want or hope to have children but are doing their own reckoning with the institution of motherhood, silence, and ongoing patriarchal norms; those who strive to know themselves and find their way home; those who seek a life of peace and inner silence; those who wake up some days to realize that they do not know their children, cannot help them, or even worse, do not much like them; those who seek to be reborn into life once their children claim their independence; those who have ever felt the sting of being "seen as the cause of everything that doesn't work in who [their children] are" (Rose 6) or who they are becoming; and those who are trying to disrupt and queer motherhood, searching or creating an experience uniquely their own. Acknowledging that motherhood intersects with gender, race, ethnicity, Indigeneity, sexual orientation, class, age, disability, creating interdependent and overlapping experiences of oppression (Crenshaw), this collection invites voices that have been historically and systemically ignored, marginalized, diminished, distorted, undermined, or silenced.

"Come out and tell us what time of night it is! Don't let us sink back into silence. If we don't tell our truth, who will? Who'll speak for my children, and yours?" (Le Guin 160). Be curious and unlock Pandora's box to release, through the very act of writing, its one last gift into the world—that of hope:

Where there is hope, there is difficulty. Feminist histories are histories of the difficulty of that *we*, a history of those who have had to fight to be part of a feminist collective, or even had to fight against a feminist collective in order to take up a feminist cause. Hope is not at the expense of struggle but animates a struggle; hope gives us a sense that there is a point to working things out, working things through. Hope does not only or always point toward the future, but carries us through when the terrain is difficult, when the path we follow makes it harder to proceed. Hope is behind us when we have to work for something to be possible. (Ahmed 2)

~

My "need to speak, to give voice to experience, comes from a need to explain, justify, rationalise, convince, both others and [my]self. From this perspective, when power gives voice, silence is oppressive, but when power gives silence, voice is justification" (Fivush 94). "I have come to believe over and over again that what is most important to me must be spoken, made verbal and shared, even at the risk of having it bruised or misunderstood" (Lorde, "Transformation" 40).

Here, I would like to rest still in silence. Instead, I lean in to the often-offered encouragement to conclude with my own voice. And so, today...

I choose silence as protector, as resistance, as care:
> I leave the detail in the white space, the pain in the margins,
>> redacting the contestable fragments and words.

I choose silence as healing, as forgiveness, as reconciliation:
> I tuck away the unshared anecdotes,
>> leaving the situations and the stories (un)done, (un)written, (un)finished.

I choose silence as adaptive, as liberating, as sustaining:
> I cannot change the situation, so I find a new framework,
>> changing the stories I tell myself.

I choose silence as empowerment, as starting point, as life giving:
> I choose me,
>> knowing that now and not ever, was I wrong or bad or crazy.

I seem to see some meaning after all.

And now the shape makes sense.

You may call it "nonsense" if you like,
 I call it presence,
 resistance to absence:
 this stillness in silence.

Works Cited

Ahmed, Sara. *Living a Feminist Life.* Duke University Press, 2017.

Amos, Tori. "Silent All These Years." *Little Earthquakes,* Atlantic, 1992.

Arden, Jann. "Where No One Knows Me." *Jann Arden.* Universal, 2005.

Baraitser, Lisa. *Maternal Encounter: The Ethics of Interruption.* Routledge, 2008.

Belenky, Mary Field, et al. *Women's Ways of Knowing: The Development of Self, Voice, and Mind.* Basic Books, 1986.

Bochner, Arthur. "The Functions of Communication in Interpersonal Bonding." *The Handbook of Rhetoric and Communication,* edited by Carroll C. Arnold and John Waite Bowers. Sage, 1984, pp. 544-621.

Bochner, Arthur, and Carolyn Ellis. *Evocative Autoethnography: Writing Lives and Telling Stories.* Routledge, 2016.

Bonnaffons, Ann. "Bodies of Text: On the Lyric Essay." *The Essay Review,* 2016, http://theessayreview.org/bodies-of-text-on-the-lyric-essay/. Accessed 7 July 2023.

Brown, Brené. *Atlas of the Heart: Mapping Meaningful Connection and the Language of Human Experience.* Random House, 2021.

Brown, Brené. *Daring Greatly: How the Courage to Be Vulnerable Transforms the Way We Live, Love, Parent, and Lead.* Avery, 2015.

Brown, Brené. *The Myths of Perfection: Let Go of Who You Think You're Supposed to Be and Embrace Who You Are.* Hazelden, 2010.

Callahan, Shannon. "The Female and the Fragment(ed)." *Body Studies,* vol. 2, no. 2, 2020, pp. 9-13.

Carroll, Lewis. *Alice's Adventures in Wonderland.* Project Gutenberg, 1865, https://www.gutenberg.org/files/11/11-h/11-h.htm. Accessed 7 July 2023.

Chapin Carpenter, Mary. "He Thinks He'll Keep Her." *Come On, Come*

On. Columbia, 1992.

Clare, K., editor. *The M Word: Conversations About Motherhood.* Gooselane, 2014.

Cohen, Doris Eliana. *Repetition: Pat Lives, Life, and Rebirth.* HayHouse, 2008.

Crenshaw, Kimberlé. "She Coined the Term 'Intersectionality' Over 30 Years Ago. Here's What It Means to Her Today." Interview by Katy Steinetz, *Time,* 20 Feb. 2020, https://time.com/5786710/kimberle-crenshaw-intersectionality/. Accessed 7 July 2023.

Cushman, Anne. *The Mama Sutra: A Story of Love, Loss, and the Path of Motherhood.* Shambhala, 2019.

da Silva, Alexandra Lima. "Fragments of Myself: Autobiographical Writing as Freedom Practice in the Experience of an Afro-Latina Professor." *WSQ: Women's Studies Quarterly,* Fall/Winter 2021, vol. 49, pp. 195-206.

de Rooy, Lenny. "Themes and Motifs in the 'Alice' Stories." *Alice,* 2021, https://www.alice-in-wonderland.net/resources/analysis/themes-and-motifs/. Accessed 7 July 2023.

Dido. "Life for Rent." *Life for Rent.* Cheeky, 2003.

Doyle, Glennon. *Untamed.* Penguin Random House, 2020.

Elias, Camellia. *The Fragment: Towards a History and Poetics of a Performative Genre.* Eyecorner Press, 2021/2004.

Ellis, Carolyn. "Telling Secrets, Revealing Lives." *Qualitative Inquiry,* vol. 13, no. 1, January 2007, pp. 3-29.

Evans, Shannon K. *Rewilding Motherhood: Your Path to an Empowered Feminine Spirituality.* Brazos Press, 2021.

Fivush, Robyn. "Speaking Silence: The Social Construction of Silence in Autobiographical and Cultural Narratives." *Memory,* vol. 18, no. 2, 2010, pp. 88-98.

Gilligan, Carole. *In a Different Voice: Psychological Theory and Women's Development.* Harvard University Press, 1982.

Gilligan, Carole, and Naomi Snider. *Why Does Patriarchy Persist?* Polity, 2018.

Gleeson, Sinéad. "Fragmented Narratives Are Broken, Independent, and Honest." 2020, *Literary Hub,* https://lithub.com/fragmented

-narratives-are-broken-independent-and-honest/. Accessed 7 July 2023.

Hasseldine, Rosjke. *The Silent Female Scream.* Women's Bookshelf Publishing, 2007.

Heilbrun, Carolyn G. *Writing a Woman's Life.* Norton, 1988.

Heti, Sheila. *Motherhood.* Vintage Canada, 2019.

hooks, bell. *Feminism Is for Everybody* (2nd ed.). Routledge, 2012.

hooks, bell. *The Will to Change: Men, Masculinity, and Love.* Washington Square Press, 2004.

hooks, bell. *Yearning: Race, Gender, and Cultural Politics* (2nd ed.). Routledge, 2014.

Indigo Girls. "Closer to Fine." *Indigo Girls.* Epic, 1989.

Jack, Dana Crowley. "Reflections on the Silencing the Self Scale and Its Origins." *Psychology of Women Quarterly,* vol. 35, no. 3, 2011, pp. 523-29.

Jewel. "Who Will Save Your Soul?" *Pieces of You.* Atlantic, 1995.

Jørgensen, Kenneth Mølbjerg, and Carlos Largacha-Martinez. "Critical Narrative Inquiry—Storytelling, Sustainability, and Power." edited by Kenneth Mølbjerg Jørgensen and Carlos Largacha-Martinez. Nova Science Pub Inc., 2014, pp. 1-13.

Le Guin, Ursula K. *Dancing at the Edge of the World: Thoughts on Words, Women, and Places.* Grove Press, 1989.

Levine, Caroline. *Forms: Whole, Rhythm, Hierarchy, Network.* Princeton University Press, 2015.

Lorde, Audre. "A Litany for Survival." 1978, *Poetry Foundation,* https://www.poetryfoundation.org/poems/147275/a-litany-for-survival. Accessed 7 July 2023.

Lorde, Audre. "The Transformation of Silence into Language and Action." *Sister Outsider.* Crossing Press, 1984/2007, pp. 40-44.

Malhotra, Sheena, and Aimee Carillo Rowe. "Still the Silence: Feminist Reflections at the Edge of Sound." *Silence, Feminism, Power: Reflections at the Edges of Sound,* edited by Sheena Malhotra and Aimee Carillo Rowe. Palgrave Macmillan, 2013, pp. 1-22.

Mahoney, Maureen A. "The Problem of Silence in Feminist Psychology." *Feminist Studies,* vol. 22, no. 3, 1996, pp. 603-625.

Malin, Jo. "Babies and Books: Motherhood and Writing," 2004, *Literary Mama*, https://literarymama.com/articles/departments/2004/12/babies-and-books. Accessed 7 July 2023.

Marchiano, Lisa. *Motherhood: Facing and Finding Yourself.* Sounds True, 2021.

Martin, BettyAnn, and Michelann Parr, editors. *Writing Mothers: Narrative Acts of Care, Redemption, and Solidarity.* Demeter Press, 2020.

McRobbie, Angela. "Feminism, the Family and the New 'Mediated' Maternalism." *New Formations*, vol. 80, no. 80, 2013, pp. 119-37.

McRobbie, Angela. "Notes on the Perfect: Competitive Femininity in Neoliberal Times." *Australian Feminist Studies,* vol. 30, no. 83, Routledge, 2015, pp. 3-20.

Menzel, Idina. "Let it Go." *Frozen.* Walt Disney Records, 2014.

Morrisette, Alanis. "Ironic." *Jagged Little Pill.* Maverick, 1995.

Murdock, Maureen. *The Heroine's Journey: Woman's Quest for Wholeness.* Shambhala, 1990/2020.

Noelle-Neumann, Elisabeth. *The Spiral of Silence: Public Opinion—Our Social Skin.* University of Chicago Press, 1993.

O'Reilly, Andrea. "Matricentric Feminism: A Feminism for Mothers." *Journal of the Motherhood Initiative,* vol. 10, no. 1-2, 2019, pp. 13-26.

Olsen, Tillie. *Silences.* Delacorte, 1965.

Plank, Liz. *For the Love of Men: From Toxic to a More Mindful Masculinity.* St. Martin's Griffin, 2019.

Rich, Adrienne. "Cartographies of Silence," *The Dream of a Common Language: Poems 1974-1977.* Norton, 1976.

Rich, Adrienne. *On Lies, Secrets, and Silence: Selected Prose 1966-1978.* Norton, 1978.

Rich, Adrienne. *Of Woman Born: Motherhood as Experience and Institution.* Norton, 1976.

Rose, Jacqueline. *Mothers: An Essay on Love and Cruelty.* Farrar, Straus and Giroux, 2018.

Rosenblatt, Louise. *The Reader, the Text, and the Poem: The Transactional Theory of the Literary Work.* Southern Illinois University Press, 1994.

Ruddick, Sara. "Maternal Thinking." *Feminist Studies,* vol. 6, no. 2, 1980, pp. 342-267.

Ruddick, Sara. *Maternal Thinking: Toward a Politics of Peace*. Beacon Press, 1989.

Sarachild, Kathie. "A Program for Feminist Consciousness-Raising." *Radical Feminism: A Documentary Reader*, edited by Barbara Crow. New York University Press, 2000, pp. 273-90.

Shields, Carmen. "Using Narrative Inquiry to Inform and Guide our (Re)Interpretations of Lived Experience." *McGill Journal of Education (MJE)*, vol. 40, no. 1, 2005, pp. 179-188.

Simpson, India Arie. "I am Light." *SongVersation: Medicine*, Soulbird Music; Motown Records, 2013.

Sky, Amy. "Faith and Reason." *Alive and Wake*. Café Productions, 2012.

Solnit, Rebecca. *The Mother of All Questions*. HaymarketBooks, 2017.

Sørensen, Siri Øyslebø. "The Performativity of Choice: Postfeminist Perspectives of Work-Life Balance." *Gender, Work and Organization*, vol. 24, no. 3, 2017, pp. 297-313.

St. John of the Cross, *The Dark Night of the Soul*, https://makeheaven.com/st-john-of-the-cross.html. Accessed 7 July 2023.

The Chicks. "Not Ready to Make Nice." *Taking the Long Way*. Columbia Nashville, 2006.

Tolle, Eckhart. "On the Dark Night of the Soul." *Eckhart Tolle*, 2018, https://eckharttolle.com/eckhart-on-the-dark-night-of-the-soul/. Accessed 7 July 2023.

Twain, Shania. "Up!" *Up!* Mercury, 2002.

Imbruglia, Natalie. "Torn." *Left of the Middle*. RCA, 1997.

Vygotsky, Lev. *The Mind in Society: The Development of Higher Psychological Processes*. Harvard University Press, 1978.

Wallace, Cynthia R. "Rereading *Of Woman Born*: Motherhood as Experience and Institution." *Ploughshares at Emerson College: Critical Essays*, 21 Oct. 2021, https://blog.pshares.org/rereading-of-woman-born-motherhood-as-experience-and-institution/. Accessed 7 July 2023.

Zerubavel, Eviatar. *The Elephant in the Room: Silence and Denial in Everyday Life*. Oxford, 2006.

(Paran)theses—
A bridge between
the tragic gap of reality
and imagined possibility.

My (Paren)theses

Tanya L'Heureux

I'm living with(in) my (paren)theses.

My (k)nots,
My (p)resent,
My (w)here,
My (be)longing.

My subject(ivity),
My (dis)abilities,
My (non)productivity,
My (ir)responsibilities.

My (un)told (un)conclusions
That (non)sense (re)fuses.
My (un)favourable (in)actions
That (im)possibilities make (in)conclusive.

My (un)knowns,
My (non)fictions,
My (not) yets,
My (com)positions.

My (un)learnings,
My (dis)connections,
My (un)safety,
My (trans)formations.

My (un)changing (dis)trust, (dis)continuities, and (un)stuckness,
Live in my (counter)intuitive (un)fettering (dis)orientating (not)
enoughness.
My (un)certainty, (im)permanency, (in)consistency, (m)use, and (de)feat
Ring through my (con)texts, (ac)complicity, (e)vocations, (m)othering,
(r)age, and (dis-)ease.

I'm (un)living in my Yes (No)? (May)being.
(En)gaging (un)making of my many (mis)meanings.
(Dis)ordering (my)stories, (dis)embodiment, and (un)conditionality
In (un)structured, (il)logical (ir)rationalizing.

I'm (com)promising my (in)finite (he)art and poet(h)ics,
Feeling hope (less or ful?) and (dis)comforted.
Through this textu(r)al process of writing (righting?), quest(ion)ing,
and in(ter)vention,
I'm (un)broken, (un)spoken, (un)interrupted.

I'm (per)forming, (be)coming—so (im/op/de)pressing—
(Un)finished, (un)timely, and brought to (at)tension

While (un)breathing with(in) my (paren)theses.

My Theses

I'm living with my theses.

My nots,
My resent,
My here,
My longing.

My subjectivity,
My disabilities,
My "non"-productivity,
My responsibilities.

My untold conclusions
That nonsense fuses.
My unfavourable actions
That possibilities make inconclusive.

My unknowns,
My nonfictions,
My not yets,
My compositions.

My learnings,
My disconnections,
My unsafety,
My transformations.

My changing trust, discontinuities, and stuckness,
Live in my intuitive fettering disorientating not enoughness.
My certainty, impermanency, inconsistency, muse, and feat
Ring through my texts, complicity, evocations, mothering, rage,
and dis-ease.

I'm living in my maybeing.
Engaging unmaking of my many meanings.

Disordering my stories, embodiment, and conditionality
In unstructured, illogical irrationalizing.
I'm promising my finite heart and poetics,
Feeling hopeful and discomforted.

Through this textual process of writing, questioning, and invention,
I'm broken, spoken, uninterrupted.

I'm performing, becoming—so pressing—
Unfinished, timely, and brought to tension

While breathing with my theses.

No beginning and no ending.
Love is forever,
love is unconditional.

On Children: Forever Is Unconditional

Jennifer Mehlenbacher

On Children

By: Kahlil Gibran

Your children are not your children.
They are the sons and daughters of Life's longing for itself.
They come through you but not from you,
And though they are with you, yet they belong not to you.
You may give them your love but not your thoughts,
For they have their own thoughts.
You may house their bodies but not their souls,
For their souls dwell in the house of tomorrow,
Which you cannot visit, not even in your dreams.
You may strive to be like them,
But seek not to make them like you.
For life goes not backward nor tarries with yesterday.
You are the bows from which your children
As living arrows are sent forth.
The archer sees the mark upon the path of the infinite,
And He bends you with His might
That His arrows may go swift and far.
Let your bending in the archer's hand be for gladness;
For even as He loves the arrow that flies,
So, He loves also the bow that is stable. (33)

I was first introduced to the poetry of Khalil Gibran on my wedding day in 1995. My husband, Troy, and I had just exchanged vows on a beautiful, sunny, and warm day in Wyoming, NY. At our reception, my father gave a toast. He chose a poem by Gibran that reflected on relationships; he hoped to inspire us with its beauty and its message. Many years later, I happened upon the book of poetry at my parents' home and found another of Gibran's poems, "On Children," that struck an even more powerful chord within me.

Throughout my journey as a mother, one that spans the last three decades, I have returned to Gibran's words again and again—they have become a mantra for me during times when I need to refocus. I was gifted two beautiful children and could never have guessed what would lie ahead for my family and for me in raising them, which is why these words have always spoken to me. My children came through me but are not from me. They are not mine. They owe me nothing. They were born whole and perfect, destined to be exactly who they have become, are becoming. Their bodies were given to me to harbour for a time and to love unconditionally, always. That is the simple truth: These words were instilled in me long ago. They are the ones I recalled in moments where I was struggling to parent my "little people" and now as I continue to do so with adult children, especially through the difficult teen years.

"Mom, I need to tell you something."

That is where this story begins.

At the age of fourteen, my amazing, empathetic, old-soul, and exceptionally introspective daughter, Cami, announced that she was a lesbian. We were sitting in the car in our garage after I picked her up from some afterschool activity, and I could tell that she was nervous and edgy about something. I asked her what was on her mind. She sat quietly in the passenger seat for a few moments before turning to me pensively, looking a bit scared, and blurted out these words. She continued with, "I don't want you to be mad or upset." I remember my heart breaking ever so slightly at that, not at her admission, but at the realization that she thought I would be mad at her. I turned to her, calmly, took her hands in mine, and said, "Oh, sweetie, I'm not mad or upset; in fact, I'm not really all that surprised." At that, she looked straight at me, a bit befuddled, and said, "You're not?"

In fact, I really wasn't. I mean, I was a bit taken aback, thrown off guard I suppose, since she was just fourteen, and I hadn't expected this

to come up quite yet. Plus, she had, for a split second or so, had a boy-friend in the sixth grade. But, no, I wasn't all that surprised by her ad-mission. I was certain that no one in our family would be particularly surprised by this announcement, as there were signs that this might, one day, be her truth. I continued by saying, "Your father told me when you were nine years old that he felt you might be gay." At that, her eyes went wide, and I do believe her bottom lip dropped open. "He did?" she said, "When? So, he won't be mad either?" Again, I could feel my heart tear a little. "No, of course, he won't. We love you. We both love you. We don't care if you're gay. We just want you and your sister to be happy." I went on: "As for when he said he knew, it was at one of your little league games one summer. We were standing at the fence; he was your coach then, I think, and he said, 'You know, I think Cami might be gay.'" This made her smirk a little. "He said that he just sensed that you were a little different than the other girls by how you interacted with them versus the boys, by what your interests were—that you didn't like dolls, tea parties, dressing up, and things most girls your age liked. You were much more of a tomboy. Of course, I told him he was being ridic-ulous; at the time, you were only about nine, and I felt it was much too early to be thinking anything of the sort. I remember asking him to not bring it up with you in any way at the time because I didn't want to upset you. I thought that it was short sighted of him to read anything into your preferences. Just because you were more athletic, hated dresses, and never played with dolls didn't mean you were gay. He was being silly. I guess he'll get to tell me, 'I told you so,' huh?" She laughed at that and wiped away the few stray tears of fear that were brimming on her eyelids. I leaned over and hugged her and asked her if she wanted to tell him, or if she wanted me to. We decided she would, but I would stay with her. Of course, when she told him, he reacted as I had expected. He told her he wasn't surprised, or mad, and that he loved her no matter what and no matter who she was attracted to. He then turned to me and said, "I told you so," and we all laughed, with a few tears of relief mixed in for good measure.

Cami was fortunate. Over the next few days and weeks, she shared this information with many of her friends, who were all very accepting and supportive. They weren't too surprised, and I think that for her generation, this revelation was much more normal. Being gay or coming out was accepted much more easily and readily than in the 1980s when

I was in middle school and high school, and far more than during the decades my parents came of age. Cami was even more fortunate to come from a very loving and accepting family. When she shared this news with her sister, Kylie, my parents (Oma and Papa) and her other grandmother, she was again met with acceptance and love.

I was born in the early 1970s to parents who came of age and rebelled against their respective upbringings in the 1950s and 1960s. My mom was a "PK," or preacher's kid, whereas my father was raised in the Midwest on a small, rural farm. They met and married, and they collectively decided that I would be an only child raised without any religious dogma. I was encouraged and allowed to find my own way in my spiritual journey. I visited numerous denominations as a child and teen, but it wasn't until I was married with young children that my husband and I settled on becoming members of our local Episcopal church, which, at that time, my mother attended. I was raised in a picturesque and quaint college town and lived in a lovely middle-class home. My mother had a PhD and was a college professor. My father worked as the vice-president of sales in a local company. I had all the creature comforts and opportunities a child could wish for. I was loved, well educated, and well travelled. My parents had taken me all over the United States by the time I was a teen, and because my uncle had gone to university, married, and then remained in the United Kingdom (UK), I was also afforded the opportunity to visit several European cities. My parents instilled in me that all people are created equal and deserve love and respect, no matter their station in life. They made sure I understood my privilege, and my husband and I have worked to instill the same in our children.

One night, just after we were married, Troy and I got into a fight about our hypothetical children. It started as an argument about whether to baptize them or not, as I had not been, and he had. At that point, we didn't attend church and hadn't most of our lives. During the argument, I said something serendipitous—I asked him what he would do if one of our children ever turned out to be gay. How would he handle it? What would a church upbringing preach to them about it if we choose that path for them? He stated then that he would have absolutely no problem with a gay child, and if the church we attended did, then we wouldn't attend. I was being rather, pardon the pun, "holier than thou" about the whole thing at the time. I remember stating something to the effect that because of how I was raised, I wasn't sure that I felt comfortable raising

my kids in a church that could one day shun them if they turned out to be different. I would never have any issue with my children being gay, or anything else, because I was raised not to be prejudiced against anyone or any lifestyle. My upbringing and experiences proved that, didn't they? I was so certain of this—so sure that nothing could challenge this deeply held belief.

But over the course of the next several years after Cami's revelation, this notion was challenged. Many things I thought I knew about myself as a mother—my long-held, unshakeable beliefs—were tested in ways I never expected. At first, "Cami-girl," as we called her, revelled in her newfound sense of self. She seemed happier now that she could talk openly and honestly about her feelings and the crushes she was finding she had on other girls. Her teen years, in many ways, were typical of any child who finds themselves falling for someone and wanting to date and attend prom with someone they are interested in. The only difference for us was that Cami's affections were unrequited by those she was interested in because they were not gay. Although Cami was not shunned or bullied for being gay, she also was not a part of the "in" or popular crowd either. I was often told by her teachers and other parents how "sweet" and "nice" she was. They praised her for always being a friend to everyone. Cami was well known for befriending all the kids who found themselves friendless. I would often tease her that she seemed to be a lot like the caretaker of the misfit toys that are discarded in that old Christmas movie we would watch every year. She never liked that part of the movie, and I think her empathetic and caring personality wouldn't allow her to ignore or disregard anyone she thought was lonely or in pain, as she, herself, knew what that felt like. Looking back on it, I realize there was so much more going on under the surface, so much more turmoil and angst she was feeling and not processing; she didn't know how and didn't yet have the words to ask for help. But, in the moment, I just saw my sweet, kind kid helping others and didn't worry too much that although this made her everyone's friend, it kept her from having a best friend when she really needed one.

Cami was always close to my mother; she still is. As a child, Cami often preferred to go to her Oma for help and advice. That is why when my mother came to me concerned about Cami's lack of close friendships, she suggested Cami join the youth group at our church. At that point in time, we were attending church less and less. Troy and I started to

realize that we just weren't believers and that we needed to step away to reassess. Our daughters had stopped going when we did, but when I suggested that they join the youth group, they reluctantly agreed to give it a chance. Cami loved going to youth group meetings. For a time, she flourished there and found her people. In particular, she found a couple of girls her age to whom she became close. During this time, things seemed good, better than good. The niggling feeling I had that Cami wasn't completely okay and seemed depressed due to her lack of any close friends dissipated. She really thrived. She went to the meetings, hung out with the girls at each other's homes, and did typical teenage things like having sleepovers.

It wasn't long before things began to change again for Cami. It became known that there was unrequited love for one of her youth group friends, and this caused her friendships to unravel with most of the girls in the group. Over the next couple of years, she remained close with only one of them and had only two other friends she could really count on and talk to in school. Although I was a little worried about her and her lack of friends—her strained social situation—she assured me that she was alright. In hindsight, I wish I had asked more questions and talked more with her about her feelings about everything going on with her. But at the time, I was happy that she seemed happy enough, and I trusted that she was okay if she said she was. We were so busy with work and afterschool functions, sports, and homework that I just needed and wanted to believe that all was well. I thought that I had handled everything about Cami's coming out perfectly. She had found nothing but acceptance and love from everyone she knew. Her grandparents, extended family, and friends all supported her and barely blinked when hearing the news.

Besides that, we had Lauren. The ace in the hole. Lauren is a beloved family friend. She is now in her thirties and a clinical psychologist. I began babysitting Lauren when she was twelve-weeks old, and I was fifteen. Over the years, she became a mix of a little sister and a first child to me. I spent years nannying her and her sister and taking them everywhere with me. They were the children that I wanted some day—two sweet, perfect little girls. That was what I hoped my future would hold. They were so intertwined in my life. When Troy entered the picture, he quickly realized that they were a part of the package if he was dating me. They were the flower girls in our wedding. When we had Cami, Lauren

spent as much time as she could visiting with Cami as a young child, even when she herself went off to college and began her adult life. When Cami was six, she was diagnosed with a benign arm tumour. She spent many years having surgeries to try to fix the problem. When Cami was twelve, she suffered some PTSD symptoms from this trauma, and Lauren was the first person I called to give me advice and to ask if she could help informally counsel Cami. Lauren was who Cami would call in a moment of crisis as one might call on a big sister. More importantly, Lauren had also realized in college that she was gay. When Lauren met and decided to marry the woman of her dreams, she asked my children to be in their wedding: Kylie as the flower girl and Cami as the ring bearer. Cami relished her role. Lauren's wedding day was perfect. Hundreds of guests packed into the Episcopal church and watched as these two women took their vows. My children walked down the aisle proudly. I was thrilled to watch my children's faces as they watched the ceremony and the two newlyweds drive off together, down our main street, in an open top convertible for all to see. A gay marriage, to them, was normal and to be celebrated.

So, when Cami came out, she had Lauren. We had Lauren. We had this talisman of how wonderful and perfect being gay, being married, and building a life together could be. No matter the angst now, Cami knew that things would be okay and that her life as a gay woman was full of promise and possibilities. I had nothing to worry about. Lauren was there as a light in the darkness to guide us and to give advice and strength when we both needed it. Our family threw ourselves into Cami's gayness. I was so proud to tell anyone and everyone that I had a gay daughter. I was proud of her for declaring at such a young age what her truth was and for living authentically. As a family we embraced her, and we encouraged her to seek out more information about the LGBTQ community in our area. Her sister, though a young teen, adored her and supported her fully. We all went to LGBTQ events in our area, bought t-shirts, and flew rainbow flags from our home. I wore pins on my jackets and posted pro-LGBTQ memes and articles on my Facebook page. I even volunteered to become a "Safe Zone" trainer for my company. This would certify me to be a person within my company and community that was trained in issues and sensitivity regarding LGBTQ issues. We were the poster family for how to do this right. We loved our kid! We embraced her lifestyle and we shared this with the world. I had

not one qualm during that time about Cami being gay, not one concern. I believed that whatever was going on with her socially, which just didn't seem quite right, would be rectified soon enough when she left our small town and went to college. It was there she would find her people. I was confident in that. In the meantime, I chalked up my nagging concerns to hormones, normal teen angst, and the fact that being gay was different than what most kids were experiencing at her age. I effectively "gagged" that mom voice in the back of my head telling me I was missing something. I wasn't. Everything was fine. We were all fine.

Long before Cami's high school graduation, she had been gifted a fire-safe lockbox by my parents for her thirteenth birthday. They had written the word "GAP" in bold, red duct tape on the outside. My children love to travel. Cami had decided that upon graduation, she would take a GAP year and travel a bit through Europe. Throughout high school she was able to save up the money she needed to travel for eight months after she graduated. So, at the age of seventeen, we drove her to Boston and put her on a plane destined for Vienna, Austria, where she would spend her first three months with family. She then moved on to spend five months in the UK with family there. She would tell you that this was a formative time for her. She had time to explore alone and with family, to experience many cultures, to enjoy beautiful places and also to think. Unbeknownst to us at the time, she was still really struggling with her identity. Something about being gay still didn't feel quite right to her. It was during her time in England that her one close male friend, Lee, took the time to visit her overseas after she had been away for so long; as they spent time alone together, Cami further questioned what she was feeling. Upon Cami's return home, she shared with us a new revelation. As I sat upon my bed with my husband across the room in his computer chair, I heard those words yet again: "Mom... Dad... I have something to tell you, and I don't want you to get upset."

My heart lurched a bit because, as history had shown, these proclamations were always followed by weighty pieces of information. Cami told us that she and Lee had decided to begin dating. I took a moment to process this and then proceeded to ask her why she thought we would be upset. She stated that since she had come out as gay and we had been so supportive the last few years, she thought we might be upset if she came out again as bisexual. I thought about this for a moment. I could see her point, in a way. At fourteen, she had shared this huge realization

about herself with us—something that many would not understand and that could possibly cost her friends and family. But she knew it to be her reality at that moment. She knew that she was not experiencing the same kind of feelings that most of her other friends were experiencing. She didn't fully realize at the time that there were so many other preferences and ways in which people identified. Now that she had grown older, almost nineteen at this point, and she had travelled the world, talked with more of her contemporaries, and seen more people interacting with one another, she realized she wasn't simply gay and only attracted to women. She felt that she might also be attracted to men, and Lee was someone she had grown to trust and to love. So, when she told us they wanted to try dating, I wasn't altogether surprised, nor was I upset. I did suggest to her that it might be possible that she was confusing her feelings of deep friendship and love of a friend for romantic love but that her dad and I were supportive of whatever choices she made.

This relationship began in the late summer before Cami headed off for her first semester of college. I had a feeling that this wouldn't last, and Troy and I discussed it. We were under no illusions that this relationship really didn't change what we felt, at the time, was Cami's truth. She was gay, perhaps bisexual, but unlikely. It just didn't seem to fit what we knew about her and what we saw over the past years. But we also knew that she was young and that this was the time that most kids were still trying to figure things out and to learn more about who they really were and what they wanted out of life. So, we quietly supported her. Kylie was a little less enthusiastic and supportive of this relationship. Kylie had a feeling that it was not going to work out and that Cami was "fooling herself." We encouraged her to be kind, to be supportive, and to let Cami figure it out. That's what families do: love and support. So, we all endeavoured to do just that.

As we all anticipated, this relationship ended just about as abruptly as it began. Cami admitted that we had been right and that her feelings for Lee were not romantic ones at all. He was just a good friend. This break-up occurred during her second semester of college, and again, Cami seemed adrift. Once again, I was worried but tried to push the worry away. She seemed depressed and unhappy again. I chalked it up to the break-up and to a bad roommate situation during her freshman year—simply what many go through their first year of college with all the changes that brings. I had always thought that the most difficult

mothering I would ever have to do would happen when my children were between the ages of birth and eighteen. People warn you about all the things that you might experience and face as a parent upon the birth of your children. They warn you of sleepless nights, how you will feel watching helplessly as your children face illness, disappointment, heartache, and heartbreak. They warn you of the tween years and the teen years and all the angst and struggle that might befall your child and you. You listen to these mothers, and you soak in their wisdom, experience, and advice. You seek their guidance when the difficult days, moments, and parenting decisions come. You lean on those who are older and have been through it all before to help you make heads and tails of the situations that arise. You hope that you and your child make it through these difficult times mostly unscathed, stronger, and more resilient having survived it. But no one warns you about what happens after they turn eighteen. No one prepares you for parenting your child as a young adult. I felt completely unprepared for mothering adult children and even more adrift mothering Cami. I didn't have any friends who were mothering gay or bisexual children at the time. I didn't have anyone to go to, personally, to ask what was normal or to be expected as Cami was sharing her feelings and her journey with us. So, I had to learn to be guided by my own inner voice.

I went back again to the poem written by Gibran and re-read the words: "They come through you but not from you, and though they are with you, yet they belong not to you. You may give them your love but not your thoughts, For they have their own thoughts. You may house their bodies but not their souls, for their souls dwell in the house of tomorrow, which you cannot visit, not even in your dreams. You may strive to be like them, But seek not to make them like you." I clung to these words like one would cling to a life preserver tossed to them in a rushing sea. Cami went back to stating that she was only attracted to women and that being a lesbian did seem to suit her best. She never hid this from anyone she met in college and during her time there began to learn more about the wider LGBTQ community, meeting many people who identified as a variety of different sexual and gender identities. She made friends and seemingly had, finally, found her people after living in a small community where it was a struggle to find people who really understood what she was going through. She also met River, who would become Cami's first partner. It was with River that Cami began to deeply

explore and truly become who Cam is today.

Cami had always been an excellent student, an accomplished artist, and a wonderful writer. Her artwork and prose always concerned my husband because they were so often deep and somewhat dark. I saw the beauty in the pieces. Cami was using her art to express her inner turmoil—a tool of catharsis for her soul. In college, she began writing pieces for her professors that were just as profound but allowed her to truly express, honestly, all that she was going through internally. One such piece that she wrote was not only accepted for publication but won an award for best fiction in her college's annual anthology, *North Star*. I attended the ceremony for this and was so proud to see Cami reading the piece in public, signing copies of the books for people in attendance, and looking comfortable in her own skin for the first time in a long time. I also realized that she had a distinct style now: short hair, pants, men's dress shirt, blazer and tie, and men's dress shoes. This didn't strike me as odd—Cami had shunned typical girls' clothes in favour of more boyish styles for years—but on this day, she certainly looked more male than I had seen before. I chalked this up to her being gay and presenting as more masculine. I was just happy to see her so happy.

One day, a few months later, Cami reached out to her dad and me through an internet chat platform: "Mom and dad, I have something to tell you." Never imagining I would hear those words in this context again, our world, my world, felt like it was crashing in. With River beside her, Cami cried as she told us something that was becoming more and more her truth. She wasn't just gay. She wasn't just attracted to women. She truly felt as though she wasn't really a woman herself. She didn't feel feminine. We had known from the beginning of their relationship that River used "they/them" pronouns and identified as nonbinary, meaning that they did not identify as either female (their sex and inferred gender at birth) or male. We accepted this, and we always respected them by calling them River and not their birth name and trying our best to use their correct pronouns. It really didn't bother me at all. After all, I met River this way. If this was who they felt they were, what they wanted to be called, I had no problem with that. I was, after all, an LGBTQ ally, wasn't I? Accepting of all gender and sexual identities? But, when my daughter, our "Cami-girl," told us that she now felt the same way as River, would like us to stop referring to her as "Cami-girl" or "Cami," and to use only "Cam" or "Camiren" and to use "they/them"

pronouns for her as well, we were floored. I never saw this coming. I had so many emotions at once: confusion, fear, sadness. But almost instantly, I felt ashamed for having these feelings. I sat, helplessly, on the other side of the screen as my child cried, inconsolably, obviously terrified of our reaction to this news, scared to say how she—no, they—felt out loud for the first time. They told us that this had been building for a while and that the counsellor that they had begun seeing a year before for anxiety issues had helped them to work up the nerve to tell us—to share all of what they had been going through for so long. All the angst, the feelings they couldn't decipher until recently, all the fears they had about admitting to themselves that they just didn't feel like a woman and that this was who they felt they were, something in between.

~

In hindsight, here is my truth.

I knew that at that moment, something still wasn't right. At that moment, I wanted to be the mom who loved and supported unconditionally. I wanted to allay their fears, dry their tears, hug them, hold them close, and tell them that everything was okay—that I accepted them, no matter what. In those moments, time slowed down. I stood outside myself, and I saw what was about to happen and what did happen but couldn't seem to stop or fully comprehend. First, I told them that I was absolutely fine and had no problem with this and would make the asked-for changes but would need time and their patience to do so. I would work at not calling them "Cami." I would work harder still at using they/them (which would be the most difficult for me from a grammatical standpoint). But then I saw my husband's reaction. He was not okay with this. It wasn't that he had a problem with the fact that Cam no longer could identify as a woman. His issues were simple and clearcut. He had created the pet name "Cami-girl" for Camiren. He had always called them that, and he simply was not willing to give that up. He also was totally opposed to the use of, in his terms, "generic" they/them pronouns to identify a single person. "My child is not an it" was something he once proclaimed. He would prefer if Camiren would just admit, in his opinion, to what was truly being said—that Camiren had come to the realization that HE was really a trans man. My husband was convinced that this nonbinary classification that Cam was now using was Camiren not coming to terms with what was really going on. I listened as this interaction took place, and I realize now that something profound had

occurred. Troy had secretly known, somehow, that this was coming. He knew, somewhere deep down, that his oldest daughter was on her way to becoming our son. Somehow, he had begun to make this transition in his mind and started the process of acceptance long before I even let myself believe it was a possibility. He truly meant it when he told Cam that he was not going to entertain the idea that they identified as non-binary. Troy would use he/him pronouns; he would accept Cam being a trans man but just didn't "buy" or believe in this "middle ground." At that moment, I was horrified. How could he, we, do anything but accept what Cam was telling us? How could we do anything but work towards doing what Cam asked of us? Cam was distressed at their dad's reaction, adamantly denying that they were a trans man. It was just not possible. This was who they were. They loved us, couldn't we just love and accept this, accept them as this? I reiterated that I did, and that, in time, their dad would too.

Over the course of the next few months, we, as a family, processed this new information. From the outside, I am sure I seemed fine. I was keeping it together. I was calm when my mom called after Camiren had informed their grandparents of this newest revelation. I listened as my mom, lovingly, expressed her love and acceptance for Camiren but also her deep concerns and fears as well. I listened as she told me of my father's reaction, which was also one of love and acceptance but also a struggle to really understand what this all meant and his struggle with using the new pronouns. I listened and tried to stay a bit detached; I gave my opinion and advice about how to proceed in these uncharted waters. But all the while, I was inwardly drowning in fear, sadness, and this unshakeable feeling that I was not holding up my end of the bargain with Camiren. I had said all the right things during our conversation. I had said I was okay with the pronoun change, the dropping of the nickname, and the new nonbinary label.

As I navigated everyone else's reactions, I realized that I really wasn't fine at all. It wasn't that I couldn't accept Camiren. It was that I didn't really want to, and that realization blindsided me and devastated me. I truly had believed I could and would have absolutely no problem accepting any gender identity or sexual preference Camiren shared. I believed with every ounce of my being that I was an LGBTQ ally and that I was too educated, self-actualized, accepting, liberal, forward thinking, empathetic, and on and on to have any problem accepting and loving my

child through anything, no matter what. It turned out it wasn't that simple; it was so much more complicated than that.

During that summer, I realized that something fundamental and permanent was changing and that I was being asked—no, forced—to make a change that I was not choosing for myself. I began to come to terms with what my husband had suspected and verbalized during that conversation with Camiren. We were losing our daughter. She was leaving us. I held on to the idea, for a time, that the use of they/them and the revelation of the nonbinary status were better than fully transitioning to a trans man. I thought that if they were somewhere between feeling wholly female or male, then it might be possible that at some point, Camiren might become Cami again and swing back to living as a female and a gay woman. I wanted to believe that this time Camiren was simply confused. I believed and hoped it might pass. That this would just be a phase. And I hated myself for thinking this—not because it isn't possible for kids to go through phases but because I desperately wanted it to be true for my own selfish reasons. I loved having daughters. It was all I ever wished for before I had them. I never wanted boys. I was so thrilled to be the mom of two amazing daughters. I loved watching the beautiful relationship that my girls had together as sisters. I loved the relationship I had with them both, and I didn't want to lose that. I was also terrified of what it might mean for Camiren's future safety. Identifying as a gay woman could make life a bit more challenging. But living as a nonbinary person, requesting people use these new pronouns, as well as dressing and wanting to be accepted as different could make them a target. The world isn't generally kind to those who live within that reality. As I worked through these thoughts and emotions and had many conversations with my parents, my husband, and my youngest daughter, I began to allow myself to say to Cam what Troy had already said but what Cam wasn't ready to fully admit. Cam was going to tell us, eventually, that they were a trans man. I had tried to push this away, to deny it, but all the signs were there. Cam was just afraid to take the final leap and to make the final declaration because it was just too scary, too daunting, and so life changing.

But it wasn't long until Camiren did just that. I tried for two months to use the new pronouns, to learn more about being nonbinary, and what that meant. But I could hear that little "mom voice" saying that this wasn't it. We had not reached the final destination with Camiren yet.

I could see how all the coming out that had already occurred—that all the angst and conversations and signs I had seen, and some I had unconsciously ignored, were leading us to one final stop on Camiren's journey of self-discovery: "Family, I have something to tell you."

Early in the fall semester of their sophomore year, Camiren shared with me a piece that they had written for a class. They shared it with the whole family. In essence, it was their final coming out. The piece was long, it was raw, and it was deeply personal. In detail and with examples, this piece explained all the things they had been through from the age of twelve that now led them to proclaim who they really were. Camiren was not a gay woman. They thought they were, but this was mainly because they just didn't understand what they were feeling at such a young age. They couldn't find the words to speak of what they were feeling, to ask the questions. They had no one to look to and say, "Oh, there, that's it; that's who and what I am." The closest they could get was that they were a gay woman. But they always knew that wasn't quite right. Then they thought they were bisexual, and they tried that for a while, but that felt less right than being gay, as they weren't attracted to men at all. It wasn't until travelling on their own, until getting to college and meeting so many more people from so many more diverse backgrounds, interacting with more of the LGBTQ community, and having conversations with Lauren that they could finally see, finally define, what it was they were feeling. It was only at that moment that they found the vocabulary to ask the questions and were in a safe space—with friends, a partner, a coworker who had already made the transition from female to male—that they finally knew what their truth was.

Camiren was no longer "Cami-girl." Camiren was not nonbinary; they weren't somewhere in between. They were not "they." Camiren was most comfortable when dressed fully as a man. When out in public, he began using binding on his breasts to keep them as inconspicuous as possible, and he began "packing," or wearing a prosthetic penis. He was "mistaken" by strangers as a man, and people used he/him when speaking to Camiren. It was in these moments he described in his writing that he felt most himself. He felt that he was living authentically for the first time in his life, and it felt good. It felt right. It felt genuine. He felt happy. He felt whole.

When I read this piece, I wept and cried a river of tears. It wasn't sadness I felt; it was relief. Relief for him. It was also joy to feel his

happiness. This was who my child was always meant to be. I had lived through his struggles as a child and teenager. I had seen his unhappiness. I had watched him struggle to figure out why he was different and why he felt different. I had tried to be there for him. I had tried to listen and to understand. But I just had no idea what was really going on. I knew gay. I had resources, experiences, and people like Lauren in my life to lean on and utilize for that. I had no clue about being or living as a trans person. It wasn't a path I could see or even thought my child would ever be on. So, for years, Camiren stumbled along. But now, in this autobiographical piece, I could see what I couldn't before. I read the words. I soaked in the examples he gave of experiences and events in his past that I didn't know about or misunderstood. I realized just how long this transition had been coming. It wasn't a phase. It wasn't an overnight change. It was who he always was but had no way to express. It's like hearing a foreign language: You know that something is being said, but until you learn the vocabulary, until those who know the language help you to comprehend it and to speak it, you are illiterate. It is not until you fully immerse yourself in that language that you become fluent and literate and that your world and eyes are opened to the communication and information that the language and those speaking are imparting.

Reading Camiren's piece was difficult. Accepting that he had been in so much pain and had struggled silently for so long caused me a lot of guilt. I was his mom. I should have known. I should have been able to help, to fix it, and to make it better so much sooner. I struggled with those feelings; I still do from time to time. But I have come to realize—and been encouraged by Camiren, family, friends, and other parents going through what we have—that I need to let go of those feelings of guilt. As Maya Angelou once wrote, "You do your best until you know better, then you do better." I believe I am doing that and will continue to do that as this journey continues.

It took me two more years, to where I am today, to come to terms with where we are now. So much has happened since Camiren officially came out as our trans son. I am grateful that he has continued to find acceptance and understanding from his closest friends and family. We have, as a family, made great strides in not using terms and names that no longer apply. "Cami-girl" is never spoken anymore; instead, we use Cam or Camiren. Most of the immediate family has transitioned to using he/him pronouns with minimal slipups, although they still occur. When

they do, we simply say the right one and move on. I find that the hardest thing for me is saying "my son" instead of "my daughter" and "brother" instead of "sister." I always feel like I need to explain to people that I had a daughter who is now my son instead of just stating what our truth is—that I have a son and a daughter.

~

What I have come to realize is that I am still working on letting go. I am still grieving. I had a perfect, beautiful, and wonderful daughter, whom I loved and adored. I had a typical relationship with my daughter, as any mother who has a daughter can probably imagine. We spoke of things and discussed things her whole life in terms of her growing and becoming a woman one day and, perhaps, becoming a wife and mother. I no longer have that kind of relationship or those kinds of conversations with Camiren. I am learning how to be a mother to a son—how to discuss things and talk about the future the way mothers and sons discuss them. I have not had a lifetime to learn that language, so I am playing catch up.

I am still grieving for the daughter I loved as I learn to accept the new reality of my life without her but make room for life with my son instead. I know for some that this might be hard to understand. It's hard to put into words. My child didn't die. The soul and essence of Camiren are still the same as they ever were. He is still kind, caring, loving, giving, intelligent, and beautiful. But the idea of Cam that I dreamed of for so many years is gone. I had felt for years that something was changing with Cam, but I think I was in denial to fully embrace the truth that was just below the surface. I did what many parents do, I projected onto Cam my hopes for him growing to be an adult woman and all of what I desired for our relationship as mother and daughter. I dreamt of a bride, and a mother, of watching my daughters interact as adults in the same way that my mother and her sisters do. I inadvertently wished for a future more of my design than his. In doing so, I was blinded by what was his reality and truth and unknowingly aided in prolonging the transition, the hopes, dreams, and life that is his to live.

Again, Gibran's words float through my mind: "You may strive to be like them but seek not to make them like you. For life goes not backward nor tarries with yesterday. You are the bows from which your children as living arrows are sent forth, the archer sees the mark upon the path of the infinite, and he bends you with his might that his arrows may go

swift and far. Let your bending in the archer's hand be for gladness; for even as he loves the arrow that flies, so, he loves also the bow that is stable." (33) I am relearning to be the stable force in Cam's life as he takes flight and continues his life journey within this new, authentic reality. Cam has begun testosterone treatments, and his voice is lower; his body looks different since he binds and packs and does all that he can to present as fully male. He resembles less and less the pictures of the little girl in the frames around my house. I am learning to embrace this while I mourn what is lost. I continue to work on letting go and dreaming new dreams with Cam.

Together, we are building a new reality and future. Fortunately, I have a wonderful support system that reminds me regularly to cut myself some slack as I work on all of this. I spent twenty years loving a daughter and dreaming of what her life would be. It is okay to grieve this loss. It is not unreasonable to need time to make this transition. This was not a transition I chose. This was not the life I had envisioned or would have chosen if it had been up to me, but it wasn't. I was given the gift of Camiren. He was given to me as a fully formed human—one to be loved, nurtured, and accepted for who he was born to be. "He came through me but is not from me." He is fundamentally the same person he always was.

He is like the butterfly who begins his life as a caterpillar, perfect in that form. A caterpillar could most certainly live its whole life as one, but for some reason, it doesn't. It is a creature destined and created to live as two distinctly separate beings. It begins life as a creature that sees the world from the ground, crawling and inching its way on the surface of the earth. But then, at a certain point, it spins a cocoon around itself and begins to transform—to begin a life as something wholly new. It emerges from its cocoon no longer a creature tied to its earthly beginnings but one that has grown wings of magnificence and immense beauty. One can still see a bit of the caterpillar it once was if you look closely at the body between the wings, but we rarely do. We watch with wonder and delight as it bursts forth, takes flight, and begins its new life as a butterfly. We watch it soar and fly far above us, seeing the world now from heights that we envy. We are in awe of them, of their transformation, their beauty and of their journey. We don't understand why. We don't need to know why. We just need to enjoy what they have become and the beauty that they bring to our lives. That is how I think of my

journey with Camiren and his transition. He began as my perfect and beautiful caterpillar but was not meant to remain one. He was destined and born to be a magnificent butterfly.

Our family's journey isn't over. Camiren still has big decisions to make in the future about surgeries and whether he wants to transition physically. We are still learning how to navigate these uncharted waters. We have no guidebook. We still make mistakes, use the wrong pronouns, slip up, and call him "my daughter" or "Kylie's sister." I still steel myself for the possible reactions I will get when telling an acquaintance who knew Camiren as Cami about his transition, and I still struggle with whether to tell new friends about our story or let it organically become known. For the most part, everyone understands, is supportive, and tries hard to use the correct name, terms, and pronouns. It really doesn't bother me when people make mistakes. I politely correct them or gently educate them on the topic and move on with the conversation. It is a work in progress. I am a work in progress.

Camiren, Kylie, and I have all sought counselling throughout the process over the last several years, and it has been beneficial to us all. I still worry about Camiren's future and safety. I worry that there will be those who will not accept or who will be openly hateful towards him, and it breaks my heart to think about it. But I know I have no control over any of that. I can only control how I will react and respond to what is presented to me.

The expectations, hopes, and dreams I had of the relationship I would have with my daughter, Cami, is now a book that has been completed. Although I loved that book, and I wasn't ready to shelve it, I have undertaken the mourning process to say "goodbye" to Cami, my daughter, and welcome Cam, my son. This has not been easy as I had always wanted and loved being the mother of daughters. I had no framework, being an only child, on how to be a mother to a son. Being a mom to daughters had become comfortable and known—an extension of who I am as a person, part of my being. It felt uncomfortable and foreign, at first, to accept and use the terms "son," "brother," and "he," and to never again use the beloved term "Cami-girl." It felt a bit like when I have to get used to new running shoes. Being someone who runs half marathons, my shoes must be comfortable and must fit correctly; they must become extensions of me and allow me to glide quickly across the pavement with no thought of them. When they begin to change and

cause pain and discomfort, they are replaced. This process is not one I often relish. It takes time to acclimate to the new shoes, for them to form to my feet and to become a part of me as the others had been. But they always do. They always fit me perfectly, even though they are slightly different than their predecessor.

It took me time to acclimate to all the changes Camiren's transition has caused—from the struggle with names and terms to my feelings regarding the loss of my daughter. I had to actively, deliberately, and often privately practise using the correct name, terms, and pronouns so that I was less likely to make a mistake when conversing with Cam or with others. But as time has gone by, it has become much easier and more natural. It has become a part of me that I fully embrace and accept. I have had to reimagine the future and dream new dreams. My hope is for my son's life to be safe and fulfilling, one in which he can live and love authentically.

There is a plaque that hangs at the bottom of our staircase near our front door. It is circular, white ceramic clay that has my children's handprints imprinted at its centre. I had it made years ago, when they were small, at a craft fair. Below the handprints are their given names: Camiren and Kylie. Above the prints is the word "sisters." When Camiren first announced his transition, I was distressed over the thought of having to remove the plaque or other favourite pictures of mine from his childhood that are hung around our home. However, he graciously said that would not be necessary and that he was fine with these items remaining where they were. Recently, as I walked up the stairs, the plaque caught my eye. The word "sisters" stood out to me and filled me with discomfort. It was not accurate. Not anymore. I felt it to my core. I didn't want to remove it, but I knew it needed to be changed. So, I grabbed a Sharpie and small, white label, and I carefully wrote the word "siblings." I peeled off the new inscription and placed it over the old one. When Cam came to visit, not that long ago, I showed him. His face lit up. Although he understood my need to maintain this keepsake, as it had always been in its very public pride of place within our home, I could see his gratitude and relief at the sight of the change I had made. It was a symbol of how far I had come, how far we all had come in this journey.

Cam is my son. Cam is Kylie's brother. He is Cam. Cam is. This truth now fits me, is a part of me, feels more comfortable, and is no longer

quite so foreign or strange. I am finding my way. I am at peace.

My family has changed forever, and although our story is not a simple one, and this new book is still being written, it is one ultimately based on love and respect. It is one based on the premise and promise that we all deserve to live authentically, to be loved, and that, as one of Cam's tattoos states, "Forever is unconditional."

My love for him is forever.

My love for him is unconditional.

Works Cited

Gibran, Kahlil. *The Prophet*. McMillan Collector's Library, 2016.

Angelou, Maya. *All God's Children Need Traveling Shoes*. Random House, 1997.

Blurred lines,
lonely places,
new boundaries.
This too shall pass.

Story Four

Maternal Expectations

Kate Rossiter

I

I didn't expect my mother to have early onset dementia
I didn't expect my life to be given over to her illness just as I needed
her most: when my own children were babies, when the world was in
calamity, and when my career demanded more than I could give

I didn't expect the level of rage that I carry

I didn't expect the level of rage that she carries

I didn't expect my mother to map her childhood on to mine, erasing
me entirely, replacing me with herself in all my childhood stories

I didn't expect my mother to forget those stories entirely

I didn't expect that my mother would stop being able to identify me
in family pictures

I didn't expect my days to be subsumed and interrupted, the jangling
phone an ode her constant, ruinous needs

I didn't expect my mother to wear diapers at seventy-three

I didn't expect the image of my mother naked, frightened, and
vulnerable, bathed by a masked stranger, to enter my field of vision
with such force as to take my breath away

I didn't expect my mother to cry, constant and inconsolable, grieving her life but without the scaffold of language or time to hold her grief in place

I didn't expect how lonely it would be to prepare holiday meals as the family's lone matriarch

I didn't expect the tidal wave of grief at my own daughter's impending puberty—that I manage both motherless and caring intensely for a mother who no longer exists

I didn't expect to stand at the sidelines of my friends' lives as they casually make plans to drop kids with their own mothers, like the uninvited fairy at the dinner, jealous and rueful

I didn't expect my heart to break so hard every time I see my mother in the facility, pattering about in slip-on sneakers, clothes hanging from her shrunken frame. Didn't expect to find myself in the facility bathroom, clutching the toilet rails, gasping for breath through contraction-like sobs

I didn't expect the rush of anguish at watching a care worker affix a bib around my mother's neck and cut her food into tiny pieces

I didn't expect to demand more drugs, every possible drug to get us out of this mess

I didn't expect my children's total acceptance of their grandmother as a demanding lunatic, the source of their own mother's unending sadness

I didn't expect to throw away my mother's kitchen table because it no longer had a use

I didn't expect to greet my mother's pleas for death with an eyeroll and a sarcastic quip because it's our tenth such phone call of the day, and it's all I can manage

I didn't expect my mother to fall out of love with food, to ignore the cookies I have made her, the same ones I have made for years, her favourites

I didn't expect my spirit to soar when my mother looks at me and lucidly says, "You look good sweetheart! You look lovely today"

I didn't expect to feel so left out of my mother's intimate, loving relationship with her caregiver, the only person who makes our collective lives bearable

I didn't expect to wish for my mother's death, then teeter precariously on the edge of a world in which she doesn't exist, where I can't hear her voice or touch her hands

II

My mother was diagnosed with Alzheimer's in 2016 at the age of sixty-eight, although she had been symptomatic for a number of years. My son was fourteen months old when she was diagnosed, and my daughter was five. Her diagnosis marked the end of our relationship as we had known it for the first thirty-nine years of my life and launched us into unknown territory, where the boundaries that held us both together and apart ripped and bled and refused to heal.

There is a lot that goes unsaid about Alzheimer's and the particular journey that mothers and daughters endure in the face of this disease. Caregiving, which may be horizontal between partners, is often vertical between parents and children. Alzheimer's reverses this relationship and renders its victims increasingly childlike; their caregivers (in this case adult children) must learn to relate to their charge through struggles for autonomy, the increasing failure of language, and the need to make life-altering decisions on behalf of a parent who resists care at every turn.

(As I write this, my mother has phoned three times, sobbing, inconsolable. Her beloved caregiver has left for the day. She fears she will never see her again. As I do at this time every day, I attempt to soothe her over the phone and remind her that the caregiver will be back in the morning. She is tempestuous and overtired. I tell her it's time for a nap and to stay on the phone as she climbs into bed, sniffling.)

For me, this blurring of relational boundaries occurred as I was parenting my own small children. Autonomy battles with my toddler were offset by his increasingly agile use of language, his ability to be independent in the world. But battles for autonomy with my mother were

marked by the opposite—by the erasure of language, her desire to remain independent pitted against the unyielding needs of the disease. I lived with what poet Lee Sharkey describes as "a reluctant knowledge that to do for you is to do to you" (Sharkey). In parenting children, this feels like love. In parenting a mother, this feels like annihilation.

(Mother again. She is demanding something that I can't give. "You're mean!" she spits. "I hate you!")

For years, I fought to keep our boundaries intact, to keep her in the place of the mother and me as daughter. She fought, too. We raged at one another over the phone—each the avatar for the other's terror of disappearing, of losing ourselves to the process of forgetting and the humiliating, exhausting labour of caring and being cared for. In the early days, she wielded her rage like a cutlass, lashing out when I pointed out instances of forgetting and suggested changes to her independent life. Later, I was equally pugilistic; my desire to make her see how impaired and burdensome she was overwhelmed my abilities to remain empathic and patient. Neither of us won.

(Now a phone call from her facility. New meds aren't helping. Wondering if maybe we should try something new? "Anything," I say. Anything that will give her, me, us some relief. Because this is where we are. Her pain is mine to hold and manage.)

It gets easier, I am told. She will lose the ability to speak, to dial, to feed herself. She will be docile. Now that we have thoroughly switched places, now that our new boundaries have scared in place, we wait. Our struggle will end.

(Another call. I let the phone ring.)

Works Cited

Sharkey, Lee. "Read Lee Sharkey's Poem 'Letter to Al.'" *Kennebec Journal and Morning Sentinel*, 24 Apr. 2017, www.centralmaine.com/2017/04/24/read-lee-sharkeys-poem-letter-to-al/#:~:text=Read%20Lee%20Sharkey's%20poem%20'Letter%20to%20Al'%20It,trilling%20the%20high%20note%20past%20its%20measure%20%5D. Accessed 31 July 2023.

We are here.
I am/we are here.
This is my testimony.

Story Five

Beyond the Edges of Order: A Framework for the Motherhood of Becoming

Drisana McDaniel

It was a reading by Dwayne Avery about the "Maternalocene" and the small group discussion afterwards that triggered my thinking about how we survive at all. I was struck, not by the variety of perspectives that emerged in response to the content considering the wide diversity across our group but by how our situatedness shapes our perceptions and directs our priorities as activists. Amid the contemplations of "what needs to happen," "what must happen," and "what should change" while mothering in the Anthropocene, it occurred to me that I did not have much in the way of critique. As a Black mother-worker-activist, I've always found it necessary to focus more on what is immediate. More specifically, I've never experienced the material security and comfort that come with racial privilege. I descend from a lineage of long suffering and have overcome. What is most essential is being able to turn towards what is.

So much of what I have found disheartening is the overemphasis of what may happen in the future and what needs to happen to prevent it. It is not that looking forwards is unimportant because it does not tend to the urgency of the moment. Rather, the problem is that master narratives of what we need to do to change the world drown out the wisdom and teachings of what we have done to survive. I'm interested in the narratives that include our experiences and help us pick up strength and resilience in the face of uncertainty. By we and our and us, I mean

people of colour and those of us claiming queer, because as I see it, we have always been existing beyond the edges of order. In this time of the COVID-19, climate change, and myriad other threats to life here on earth, I am reminded that we are here because we come from a people who were made of something else, which I would not know, if I did not have access to the recitations of those who came before me—those who are finding creative ways to tend to the present moment and those whose practices inhabit the future simultaneously. Our healing is connected to the wisdom and insight therein.

So here, I discuss the motherhood of becoming—a radical methodology of living out loud, of turning towards the historical and futurist archives of Black women mostly and sometimes others, and of curating healing and wholeness with "the alchemy of now," which is a framework that I offer for facing what is our everyday lives. My mothering methodology is not directly about how I mothered my two daughters and my son explicitly; rather, it is about how my experience of mothering has been a primary path of awakening and healing for me, how it is that I am still here and breathing, and how it is that those I birthed continue to have a mother in me. "Becoming" here refers to the process by which one comes into, changes, or grows. The motherhood of becoming, then, is how I imagine myself—always in process, never finished, porous, and not static. I imagine myself flowing through my life experiences as a series of portals, where each portal is an immersion; as I emerge from each, I am transformed in some way, making way for the next.

Queer

We are people of color. The whole system wakes up every day trying to exterminate our bodies and our spirits. Our very survival is queer. We were never meant to survive, and if mothers are part of why we are here (and they are), then they are the queerest of us all.
—alexis pauline gumbs 120

Mothering as a Black, single, never-married woman of three is a queerness of its own in the United States because I am not white, because I have never been oriented towards seeking marriage, and because I still chose to birth and raise three children. As an adjective, "queer" corresponds with the sort that departs from what is basic, typical, and

taken-for-granted. In action, to queer something is to put it in harm's way—to subject it to pernicious conditions and risk. By the white supremacist patriarchal gaslight, I am queering motherhood, first by putting my children at risk and then myself. If I really believed this, I would be in denial of the full complexity of my experiences and the way that I am oriented to the world, an unsustainable feat at best. In *From Feminism is Queer: The Intimate Connection between Queer and Feminist Theory*, Mimi Marinucci reveals how queer is elastic:

> Queering thus refers to the process of complicating something, and it is not necessarily limited to sexual contexts. Indeed, it is queer to do philosophy without making arguments. It is likewise queer to live in ways that challenge deeply held assumptions about gender, sex, and sexuality. Thus, queer encompasses even those who do not identify as homosexual (or even as lesbian, gay, bisexual, or transgender), but find that we are nevertheless incapable of occupying the compact spaces to which our cultural prescriptions regarding gender, sex, and sexuality have assigned us. (xxii)

For me, claiming queer is a declaration of how I am not in harmony with the status quo. To claim queerness is to claim myself and the life that is mine. Between the realization that nothing about the ritual and compulsive pursuit of romantic partnership ever made sense to me and the impossibility of attempting to find true joy by the prescriptive practices of Black respectability politics, I have chosen the margins. I could not articulate this when I had my first child at twenty-two; I did not wake up like this. Claiming queer is the effect of years of grappling with how outside systems ricochet within.

Both/

Do you understand what I'm telling you, child? Respectability is a burden, bigger than any one woman should bear. And poor impulse control is not only acting on every desire; it is also believing you must never succumb to any at all. It is subscribing to the belief that the only men worth having are the ones who care too much about how many men you've had. It is being deceived about God Himself and how He looks at women who govern themselves as though they do not know when to say when. It is this idea that education and career make you

respectable, but only if both yield you enough income never to need the kind of help that requires deep humility.

—Stacia L Brown

First, it was the shock and awe at having conceived at all while not married and not planning to—not even to achieve the protections afforded to those who comply with hegemonic heteronormativity. Becoming a mother was both magic and miracle. I was initiated via an ancient portal, forever changed on the inside, and deeply transformed by the way that my body became more than mine alone. I was broken open in a way I could only describe as poetic. Tender. Fierce. Yet the way that mothering while unmarried is framed as a social problem also transformed me into an object first, "the other" next, and ultimately a subject of obsessive self-surveillance. What I mean is that the blame turned inwards back then before I had the critical thinking skills that I have now and before I had analytical skills and energy to avert the outside gaze. A Black, brown, or poor white pregnant and unmarried body has always been the target of a litany of offences—caricatured as a welfare-dependent drain to the system and the burden of taxpayers and cast away as indulgent and ruined. It would take me years to refuse responsibility for the hardship that is attempting to thrive in white supremacist imperialist capitalist patriarchal heteronormativity.

Through the distortion of the white gaze, an unqualified and vulnerable body with a seed growing in its womb is seen as a site for disruption, despite the magic of a womb that produces life. An unmarried woman -body is reduced to a symbol; I came to know this by feeling into the contrast as the outsider-within. A pregnant body is visible. I had a pregnant and Black body, was made salient by my time spent in primarily white spaces for work and study, where I was the target of unapologetic curiosity, wonder, and disregard. Lauryn Hill's song "Zion" carried me through that first portal that made me a mother, for her telling of how the outsider gaze judged her choice to have her son. Years later, Nina Simone would sing me through the next mothering portal, for her audacity to include joy and paradox in her blues. The wonder of my first daughter was juxtaposed with abandonment, a move, and a promotion. I would come to know the postpartum trauma of handing my daughter over to her father and his new partner for visitations. I would keep with that disordered practice until I could no longer, when I decided to move

closer to my own mother to gather myself. Pressed into a new portal, I turned to community college with two children in tow. I worked full time, so I started slow. One class a semester, then two, until I transferred to university.

Between community college and university, I decided to study sociology and women and gender studies—two disciplines that taught me how to think about my life in relation to societal patterns and norms and ultimately determine what matters most. Before I started classes, I visited the department head of women and gender studies to confess that I was terrified. I had to work, and I had to raise my children. Simultaneously, I had to be true to what was tugging at me—the impulse to know more about the navigating of multiple worlds and the ancestral nudging to stay on this path. This journey of learning about systems of oppression was as essential to my becoming as what I was learning as a parent. I lived in relationship with these excavations. My school projects and life (re)search[1] were bound to each other. For example, for a project for one class, I organized an event to discuss media socialization and body images in girls with mothers at the school that my daughter attended. When I was trying to decide which high school was best for my son, my senior thesis explored why Black male students were more likely to fail out of Charleston County high schools than they were to graduate. When I experienced overwhelming anxiety and depression while working, parenting, and attending university, I designed an independent study to explore the stressors that African American women are exposed to when striving for upward mobility, their experience of psychological distress, and the ways that self-perception and sociocultural expectations influence their choice of coping. This prescient portal begged me onwards and turned me towards myself as I encountered the knowing that would penetrate me with a depth that would become wisdom to guide me on my lifepath.

And/

At times, forgetting stands in for never having known or never having learned something, the difference between staying in tune with the source of our own wisdom and relying on borrowed substitutes, fleetingly fulfilling.

—M. Jacqui Alexander 276.

In a meditation class years ago, the facilitator said, "Dissatisfaction and pain sensitize us and give us point of view." My attunement can be attributed to my situatedness as an outsider-within.[2] As things go, the concurrence of experiencing oppression while working, parenting, and taking college courses developed my capacity for a critical analysis of cultural hegemony. As Sarah Ahmed puts it, I know in my bones how it feels to be "pressed into things, and by things, because of who [I am] recognized as being" (50)—not the norm. I know how normativity smothers, traps, and binds and how social mores can stifle growth and healing. From the margins, I have been empowered, and I have experienced harm: I know exactly how structural oppression works in a culture of domination because I have spent years inside of systems not built for Black women. I have been isolated in spaces where I am both hypervisible and invisible at the same time.

From the inside, it was like trying to swim in freezing cold, rough rapids. It was impossible. Never easy. It was blinding and hard. Something was always sacrificed. With two hands and twenty-four hours in a day, I was either dropping glass balls or rubber ones—something was always broken. Mothering work is ceaseless. There are chores. There is homework and expensive afterschool programs. There is traffic. There are by-the-minute fees for being late to pick children up. There is tuition. I lived in a yet-to-be gentrified community for a decade, so I put one child in a private school for girls located in downtown Charleston and the other in a school off the peninsula. I was late every single day. Sometimes my car broke down. My daughter attended that school four years ago, and I am still paying off that tuition.

This is what we do not hear so much about: the energy it takes to not become a stereotype. How I held my breath each year that my son remained free in his man-child body. How I broke my ass to pay for private music lessons to ensure that he could experience the infinite wonder of himself before the world could overwhelm him with distortions of Black masculinity. How I could never qualify for welfare despite my desperate need for it. How I struggled with the shame of being misrecognized as a pillar of strength when I knew that my family was most vulnerable because we are Black, and our humanity was always regarded last. We are primarily seen as workers in a neoliberal, capitalist system. I journalled about the grief of this recognition after a manager walked in and startled me while pumping my breastmilk in a filthy retail office years ago:

At my feet and all over the carpet, there was my spilled breast-milk. The parts which I had carefully cleaned and put together for the purpose of expressing my milk lay on the filthy floor, now contaminated, and the manager had come and gone. Not a single person in the store other than her knew that I was standing there, and my milk—like my effort and my heartache lay invisible. While I sobbed at my loss, it occurred to me that I work in a space where no one really cares about the labour which is also central to my life: my mothering work. To save myself from spiralling into endless depression, I remind myself that my job is important to sustain my labour of mothering. Still, I am trapped in a culture that seems to care so little about mothers. Standing in my spilled milk in that cluttered tiny office, I am reminded that the mothering work is secondary to being an employee in this society.

Feeling shame kept me quiet about my suffering, not only because I felt powerlessness to do anything about my limitations but because in some way, I felt responsible for my constraints. Defining shame as an "emotional response to misrecognition," Melissa Harris-Perry explains that shame "urges us to internalize the crooked room" (31). My experiences with self-loathing, depression, panic attacks, and feelings of unworthiness were effects of the crooked room within. My recovery, then, has been the result of finding my way out of misrecognition.

Recovery

> God Is Black. God Is Woman.
>
> —BlackShesus (digital creator and founder of BlakWater Production House in Baltimore, Maryland)

My college education is what brought me to activist work. Still, I found that social justice work lacked depth without spiritual inquiry and practice. For this reason, I chose to focus on women, gender, spirituality, and social justice in graduate school, where I have been able to integrate my analysis of the material world with the inner dimensions of my lived experience. My analysis of oppression was incomplete without spiritual contemplation beyond intellectualism. I was yearning for substance to advance my work beyond talk and teaching and to a depth of praxis that

may liberate and heal. In graduate school, I discovered that my inquiries were not uncommon at all. Of the underarticulation of spirituality, Alka Arora asserts, "In fact, the spiritual dimensions of feminists' activism and theorizing have been downplayed if not dismissed in many feminist spaces, particularly in academia" (34). In my graduate program, I learned how to fold spiritual insight and praxis into other ways of knowing, and I found healing. Although graduate school has been a place where I have encountered harm in attempting to keep up with demands that are too many for a mother-worker-activist, it is also where I discovered my standpoint—an uncovering that has activated my recovery. In excavating my standpoint, I have realized the ways that my lifework is the fruit of my spiritual activism, my scholarship, and the community from which I am indivisible.

Finding my way has necessarily included getting lost and integrating what was found along the way. Gloria Anzaldúa describes this process: "Before rewriting the disintegrating, often destructive 'stories' often self-constructed by psychology, sociology, anthropology, biology, and religion, you must first recognize their faulty pronouncements, scrutinize the fruit they've borne, and then ritually disengage from them" (559). For example, I was a feminist until I became a womanist, and then all of that changed once I realized that neither of those is an identity for me. Now, I consider myself a doer of womanist work building from Patricia Hill Collins's description of womanism as pluralist in vision and "always in the making—it is not a closed fixed system of ideas but one that continually evolves through its rejection of all forms of oppression and commitment to social justice" (11). As a mother-worker-activist, I am constantly becoming, now a third-wave womanist thinker, and committed to addressing oppressions experienced by all people—but especially Black, honouring multiple ways of knowing and based on an orientation towards our way of thriving.

Which brings me back to this point: Although we were never meant to survive these systems, we are still here. And while we do not necessarily fly over the real conditions of oppression (although some of us can indeed fly), we do more than just survive. As Dr. Kia Darling-Hammond reveals, we also experience pleasure and joy as moments of thriving. In fact, we heal by increasing self-awareness and deepening our capacity for response-ability by drawing wisdom from the past while creating new possibilities for the future. Ultimately, healing is a recovery process

of multiple ways of knowing based on our subjective experiences, what I refer to as our stories. Our stories increase our capacity to be with what is because they are prescriptive, descriptive, and "creatively generative" (Dillard x); they create worlds and teach us how to cope with life as it comes and how to become our affirmations.

Mining for the/a Counternarrative

> The endeavor is to recover the insurgent ground of these lives;
> to exhume open rebellion from the case file, to untether
> waywardness, refusal, mutual aid, and free love from their
> identification as deviance, criminality, and pathology; to affirm free
> motherhood (reproductive choice), intimacy outside the instruction of
> marriage, and queer and outlaw passion; and to illuminate the radical
> imagination and everyday anarchy of original colored girls, which has
> not only been overlooked, but is nearly unimaginable.
>
> —Saidiya Hartman xiv

The healing salve for me has been my endorsement of the/a counternarrative since the master narratives tend to be most salient and painfully objectifying. My consumption of master narratives early in my motherhood triggered my self-surveillance and self-estrangement, whereas the recovery of lesser-known narratives during my graduate studies enabled me to deconstruct the more stultifying perspectives of my life and (re)construct them in ways that honoured my histories, humanity, and healing. Those master narratives were transmitted as Christian myth and sermons, amplified in that slanderous Moynihan Report and the dead-eyed stories de jour by the Reagan administration in the 1980s —a long shadow that trapped Black single women with children in a schism that we are still trying to disentangle ourselves from. It was my reading the work of bell hooks, Patricia Hill Collins, Zenju Earthlyn Manuel, Layli Maparyan, Audre Lorde, the Combahee River Collective, and more that enabled me to reconcile my multiplicities and recognize that I come from the deep sea of "heterogeneity and not sameness" (Hill Collins 16)— that is, Black women. I remember that the work of my foremothers and cojourners had little to do with the academy and more to do with retrieving and saving our stories and, in turn, holding space for each other. We can retrieve the stories, and we can likewise author

them, as Anzaldúa writes: "You turn the established narrative on its head, seeing through, resisting, and subverting its assumptions. Again, it's not enough to denounce the culture's old account—you must provide new narratives embodying alternative potentials" (560). Thus, the mining for the/a counternarrative enables us to recover what was lost and to live into new futures.

The counternarrative is receipts for the lie: how hooks spells out for us the shape of white supremacist capitalist heteronormativity as that which we are swimming in and how Anzaldúa is exacting when she writes to white America, "We need you to say that you've split yourself from minority groups, that you disown us, that your dual consciousness splits off parts of yourself, transferring the 'negative' parts onto us" (106). The great Audre Lorde reminds us that the erotic was always a wellspring of information revealed by feeling and nonrational knowing, from what comes from within. The/a counternarrative returns us to ourselves.

The Alchemy of Now: A Framework for Living as an Everyday Alchemist

> We all begin with the question, "What am I really?
> What is my work here?"
> —Clarissa Pinkola Estés 101

Making sense of the/a counternarrative has helped me to consider how I might choose spiritual inquiry over the survival acts that we habitually engage to cope with hardships and challenges—e.g., turning away, denial, numbing, and resisting. If our situatedness shapes our perceptions, and our perceptions have implications for how we act in our lives from moment to moment, the alchemy of now is a nonlinear approach that helps us recognize our power to choose how to reconcile with reality and achieve a sense of integration or being-with-ness. Perception matters because we act how we think. For me, the idea of renewing my mind resonates with Layli Maparyan's articulation of womanist methodology: "In the broadest sense, womanist methodology is about the transmutation of energy—mental, emotional, physical, material, social, and environmental energy" (51). In fact, she affirms "the proverbial 'changing

of hearts and minds' is the basic womanist modus operandi ... and takes place on planes and in places that can only be described as 'spiritual' or 'invisible' and it is knowledge and wisdom that 'our grandmothers' perpetually maintained in both theory and act" (52). I do not survive from a level of thinking, and I do not discover thriving from the level of rationality. My activism is sustained by the transformation of my consciousness, and I am suggesting that we can return to those deeper waters when we need to know how to live in the face of systems that every day try to ensure that we do not.

The alchemy of now is grounded by four immersions to serve as touchstones for what can be done to face life as it unfolds: to honour change, embrace paradox, (re)member (Dillard), and invite (re)vival. Counternarrative snippets punctuate these immersions, offering us narrative wisdom and practices that may heal, increase adaptability, transform, and ultimately revive.

Honour Change

We must come through the fires of our lives to experience awakening.

—Zenju Manuel 15

We can choose not to deny or resist reality by allowing change. We can also anticipate change, practise moving with change, and eventually come to have gratitude for it. Embracing change is not necessarily easy. For example, on the topic of human reactions to loss and change, Susan Carter cites the work of social scientist Peter Marris, who believes that "the impulse to defend the predictability of life is a fundamental and universal principle of human psychology." But I believe that this impulse leads to disintegration. In place of creativity and innovation, people ignore or avoid events that do not match their understanding. To maintain distance from novelty, people subjugate, erase, and may even cause harm to those who do not comply with social mores. Fact: Not all of us choose to turn away, deny, repress, avoid, or back down. Not all of us have the choice, and not all of us want to shrink ourselves. I hail from a lineage of ancestors who turned towards situations with faith, magic, and action. I also come from ancestors who could not. I carry both/and in my body, in my bones, and in this now, and I have been presented with a life that has cultivated a particular orientation—to stay, *to stand in, to stay with the trouble*, to stay with discomfort, and to turn towards.

By the way, change has often left me feeling disoriented, but this mixture of feelings is also what helps to reframe the context and experience transformation (Anzaldúa 567). Thus, facing change is an inside job, as Hill Collins notes in *Black Feminist Thought*:

> [But] change can also occur in the private, personal space of an individual woman's consciousness. Equally fundamental, this type of change is also empowering. If a Black woman is forced to remain "motionless on the outside," she can always develop the "inside" of a changed consciousness as a sphere of freedom. Becoming empowered through self-knowledge, even within conditions that severely limit one's ability to act is essential. (111)

Internal conflict is a part of the process of grappling with change. It is also a source of knowing, the wellspring of deeper inquiry, and a cause of expanded awareness.

Of the certainty that change will happen, adrienne marie brown insists the following: "Change is definitely going to happen, no matter what we plan or expect or hope for or set in place. We will adapt to that change or we will become irrelevant" (70). So, we can create and/or discover practices to support our flexibility and adaptability—practices that fortify us and help us to honour change. Ritual community grieving, initiations, and restorative circles are a few examples of how we can meet change with agency and response-ability. In one example of facing change, Kathleen Dean Moore makes a personal ecological oath to honour the earth in "Great Tide Rising." Reflecting on the complexities of living on a devastated planet Earth, Moore encourages her students to tend to "refugia"—places of safety where life endures. Moore suggests: "If destructive forces are building under our lives, then our work in this time and place, I tell them, is to create refugia of the imagination. Refugia, places where ideas are sheltered and allowed to grow" (141-42). I am struck by Moore's idea of refugia as harboured "pockets of moral imagining" (142), which is a way to think both about and through what can be done in a time of disintegration: holding space by singing to the dying, celebrating those holy transitions of seasons, refusing to ignore what is wrong, tending to a personal altar, being part of a healing-centered community, and noticing possibilities as they emerge. This is how we honour change now, not in a future imagined from an abundance of status-quo stories; these are the practices that help us to resolve ambiguity and ambivalence. This is how we stand in our lives.

The Embrace of Paradox

> A paradox: the knowledge that exposes your fears can also
> remove them.
>
> —Gloria Anzaldúa 552

After reading "The Maternalocene: The (In)Fertility of Mother Nature in Postapocalyptic Narrative," I realized that people of colour have never not been surviving impossible and postapocalyptic realities. It has been necessary for me to build a capacity for holding multiple possibilities at the same time to stave off stuckness. Curiously, this capacity is taught out of us, despite our imaginations. In "Another World Is Possible," John Halstead maintains that we are not going to be saved, does not deny that we are doomed, and asserts that we are still discovering meaningful ways to live. The essence of this observation is that we can face despair and keep living when we embrace paradox. Octavia Butler's Lauren is a possibility, an example, for me of what it is like to persist in the face of plunder in *Parable of the Sower.* In conversation with her friend Joanne, who is feeling powerless in the face of apocalypse, Lauren is focussed on how to stay with the trouble:

> "It doesn't make any difference," she said. "We can't make the climate change back, no matter why it changed in the first place. You and I can't. The neighborhood can't. We can't do anything.
>
> I lost patience, "Then let's kill ourselves now and be done with it!"
>
> She frowned, her round, too serious face almost angry. She tore bits of peel from a from a small navel orange. "What then?" she demanded. "What can we do?"
>
> I put the last bite of my acorn bread down and went around her to my night table.
>
> I took several books from the deep bottom drawer and showed them to her. "This is what I've been doing—reading and studying these over the past few months. These books are old like all the books in this house. I've also been using dad's computer when he lets me—to get new stuff.
>
> Frowning, she looked them over. Three books on survival in the wilderness, three on guns and shooting, two each on handling

medical emergencies, California native and naturalized plants and their uses, and basic living: log cabin building, livestock raising, plant cultivation, soap making—that kind of thing, Joanne caught on at once.

"What are you doing?" she asked. "Trying to learn to live off the land?"

"I'm trying to learn whatever I can that might help me survive out there. I think we should all study books like these. I think we should bury money and other necessities in the ground where thieves won't find them. I think we should make emergency packs—grab and run packs–in case we have to get out of here in a hurry. Money, food, clothing, matches, a blanket.... I think we should fix places outside where we can meet in case we get separated. Hell, I think a lot of things. And I know—I know!— that no matter how many things I think of, they won't be enough. Every time I go outside, I try to imagine what it might be like to live out there without walls, and I realize I don't know anything."

"Then why—"

"I intend to survive." (51-52)

In this passage, Lauren makes the intentional choice to learn what she can to survive while admitting that no matter what she does, it will not be enough. Later in the text, she concludes that no one is coming to save them. Lauren turns towards the unknown by actively embracing contradictions. Ultimately, then, my goal is to demonstrate, in stark contrast to the conversation that I described with my cohort earlier—wherein "should" was used to discuss what other people should do to fix and repair the present reality—the only "should" that Lauren articulates is her own, in service to a larger we. This narrative illustrates for me what it is like to turn towards what is with agency.

So too, this is the sort of practice that may transmute ambivalence into resilience. Notably, there is no guarantee that resilience will eventuate. I want to distinguish here between the kind of discourse on resilience that leans towards spiritual bypassing and victim blaming and the kind of resilience that is born from facing discomfort long enough to experience a breakdown, breakthrough, or insight. I am naming resilience as a product of a transformed consciousness—as the fruit of "I

will," "I must," and even "I don't know how, but." What church folk call "making a way out of no way." It is a practice that "cultivates the intelligence to discern, embrace, and live that important, yet malleable, relationship between destruction and sustenance" (Alexander 266). Thus, leaning into contradictions may facilitate creativity and innovation. By extension, active surrender to despair and getting up again may cultivate resilience—the willingness to manage complexity in the face of unknown. Experience is the conduit by which our consciousness can be transformed. By association, resistance to complexity will delay growth and recovery. This too shall pass. Sometimes resistance is a way to slow down a rebirth. Not all labour is fast and quick. What I have learned is that sometimes the capacity to love what is comes after we give up the passive hope of wishing for a way out or to be saved and instead pick up the kind of hope that persists with our willingness to allow the unresolved to be what it is.

To (Re)Member as Recovery

> Crossings are never taken all at once, and never once and for all.
> —M. Jacqui Alexander 290

In Cynthia Dillard's view, "Sometimes we must learn to (re)member the things that we've learned to forget" (4). We can look back to move forward to find a sense of wholeness by recovering what was lost or drowned out. (Re)membering emerges via dreaming, wakeful contemplation, dance, meditative practices, community engagement, the making of art, future journaling, and self-inquiry, and/or (re)search—how we "use our whole bodies, minds, and spirits as tools and sites to ask new questions of the goodness of science, of our multiple histories, of theory" (Dillard 21). (Re)membering, then, is a decolonizing practice of alchemy—how we center our lived experiences with those of our ancestors to discover new meanings and new understanding. Our recovery is born of acts of retrieval, the gathering of retrospections "based on a sense of connective and collective time, from which we both recognize our identities and from which we can transform our identities" (Dillard 8).

Ancestral Reverence and Ritual

Knowing who walks with you then, becomes a spiritual injunctive to
activate a conscious relationship with the spiritual energies with
whom one is accompanied, and who make it possible, in the words of
Audre Lorde, "to do the work we came here to do.

—M. Jacqui Alexander 303

One way we (re)member is through our ancestors. It seems that Black
women have always been calling on our ancestors, which was a prom-
inent theme in the new spirituality of African American women in the
1980s (Hull 54). Having seen people engage their ancestors with fear
and urgency and becoming familiar with ancestor reverence, I have
approached the work of connecting with my ancestral grandmother
with patience and intentionality. Daniel Foor's guidance has been a
wealth of support for my process. In *Ancestral Medicine*, Foor writes, "If
you ever have a sense that a beloved grandparent or parent is looking
out for you, there's a good chance they are" (31). I have a family altar in
place, and it has proven to be a place for peacefully connecting with my
grandmother, healing my relationship with my mother, and healing
forward for my own descendants. To my altar, I bring coffee from my
French press sweetened with cream for my grandmother. There, I burn
sage, work with my crystals, and pull goddess cards. My altar is grow-
ing. There is a picture of me with my newborn Indigo, after having
survived my own trauma with her father; there is a picture of my mother
holding me as a new baby, and there are multiple images of my mother
as a little girl. There are also other elements there: baby's breath, stitch
work by my youngest daughter, Inanna, and a sun pendant that I was
gifted after birthing my son. I am still figuring out what there is to heal
and how to heal. Foor's work is thick with warnings that keep me slow,
patient, steady, and intentional.

I must emphasize that healing is more of an approach and a journey
than it is a method. Therefore, it is not purist and strictly connected to
intactness or to a strong, able body or mind. Rather, it is more than a
process engaged for becoming well by "realignment of self with self"
(Alexander 298), which can be learned from the wisdom narratives
included in this reflection. This is the manner of healing that corre-
sponds with (re)membering. This way of knowing empowers us to stand
in the now, whereby "everything that we do, every experience that we

have, from this large, metaphysical, spiritual perspective, is redemptive" (Hull 175). Like Akasha Gloria Hull, I contend that our lived experiences can serve to liberate us. In fact, encountering this reading years ago changed me in a way that enabled me to take my experiences of oppression less personally, which freed up energy for other considerations—for example, how to build community and nurture my kinships. Just as important, my reference to redemption here is a departure from redemption in the Christian sense, as in to transcend the world (Raphael 89). My endorsement of redemption serves as a metaphor for conversion, a spiritual pivot towards being in the world. As Anthony Pinn explains:

> [This approach] signals sensitivity to and embrace of one's presence. In this way, conversion does not require a change in behavior or interest, but rather a deeper awareness of self, of one's values, and one's weight within the world. This is not the world as one imagines it but as it is with all its warts. Such thinking renders useless a typical black Christian pronouncement: "We are in the world, but not of it." (131)

Redemption as conversion is possible in this world in which we now live, as opposed to a world in the hereafter. How we do anything is how we do everything.

A Call for (Re)vival

> It is queer to find joy and pleasure in the ways this
> culture has made unimaginable.
>
> —tayla elom[3]

(Re)vival is another response to engaging survival acts that lead to self-estrangement and dis-integration. Acts of revival can be active and/ or restorative; they allow us to be held and lay our burdens down, and they also build energy. Revival meetings were, historically, religious experiences that brought enslaved Africans into the generally white spaces in the American South. Of their significance to enslaved Africans, Michael A. Gomez writes: "The revival, then, was important because it afforded the African acceptance as an African. It is very possible that a considerable number of Africans participating in the revival had little or no idea of the substance of the message preached" (252). They created

a space where "they were allowed to enter the revivalist experience on their own terms" (252) and to respond in their own way to the divine—a way that had its roots in Indigenous African religion, generally with movement, dance, and song. Revival enables us to look to the openings, places where we find awe, joy, ecstasy, and ourselves. Many revivals were, and still are, episodic, such as those designed to reinvigorate Christianity and bring new followers into the fold. The revival that belongs to this framework, however, is unique and not fundamentally religious. It is accessible in the everyday—as we need it and when we choose it.

I look for openings amid the chaos and intensity so often that seeking revival has become a way of life for me. These are moments of synchronicity, intentional choices to tap into spiritual practices, rich conversations with a stranger, a spontaneous walk with the dogs, trusting and following my intuition, future journaling, and gratitude practices. These habits are life giving and energizing, and they continually bring me back into alignment. These are tendencies that buffer our experiences of suffering with tenderness.

"We Were Here"

> May we always choose to turn to our life experiences with radical trust, and may our everyday immersions enhance our ability to "trust our own personal and cultural biographies as significant sources of knowledge."
>
> —Patricia Hill Collins 122

In the past, I thought that my way of living was especially hard because I did not follow the rules. I believed that my way of striving and loving and dreaming was improbable because I kept birthing my babies, and I kept loving, and I kept leaving when it was not right. Thinking and overthinking became a trapdoor with no return—one that ensnared me in the sunken place with ever-present rage. In the academy, reasoning and ruminating are ordinary. In white supremacist capitalist imperial patriarchal culture, mothering is not regarded as a process of becoming; instead, it is a conceived of as an institutional role. Yet it is true that I have grown beyond the edges of order, and no amount of thinking alone could return me to myself. After all, as pauline alexis gumbs reminds us, "Our very survival is queer" (120). What saved me is the archives that chronicle our past, present, and future ways of being. In the

archives, I am reminded that the work that many of my foremothers engaged in had little to do with the academy and more to do with saving our stories. I think of them as the hikers in Rebecca Solnit's essay, in which she writes, "Their most important skill in getting lost was their sense of optimism about surviving and finding their way" (10). So, too, it is in the archives wherein hooks insists that "the space of radical openness ... a site of radical possibility, a space of resistance" (19-20). By the archives, we pick up wisdom inside of our histories. Reading the work of bell hooks, Patricia Hill Collins, Zenju Earthlyn Manuel, Layli Maparyan, Audre Lorde, M. Jacqui Alexander, the Combahee River Collective, Toni Morrison, Gloria Anzaldúa, and more has enabled me to reconcile my many multiplicities.

My name is now written in the archives. I am mother-worker-activist: She who recovers; she who makes a way; she who belongs; she who ascended; she who is endarkened; she who is maker of love and life; she who nurtures; she who grows; she who learns; she who goes back to get it; she who shares with others; she who prioritizes rest; she who is self-centering; and she who is spirit embodied. The infinite archives have kept me. The archives have kept us.

Even if you do not know what archives are, you have been attended to by first moans, cared for in libations poured, carried in sacred whispered prayers, exalted in levitations, turned towards in grief, and birthed by the rough draft. Sung here.

We are here.

I am/we are here.

This is my testimony.

Endnotes

1. From Robert Romanyshyn, "Research is a re-search, a searching again for what was once known and is making a claim upon us to re-turn with re-gard for the sake of re-membering" (14).

2. "Outsider-within" is a term coined by Patricia Hill Collins to describe the status of Black women who have an inside perspective on white society because of their proximity to it, mostly as workers.

3. From a comment in an online discussion by tayla elom, a fellow student and mother in my graduate program at the California Institute of Integral Studies.

Works Cited

Ahmed, Sara. *Living a Feminist Life*. Duke University Press, 2017.

Alexander, M. Jacqui. *Pedagogies of Crossing: Meditations on Feminism, Sexual Politics, Memory, and the Sacred*. Duke University Press, 2005.

Anzaldua, Gloria. "Now Let Us Shift ... the Path of Conocimiento ... Inner Work, Public Acts." *This Bridge We Call Home: Radical Visions for Transformation*, edited by Gloria E. Anzaldúa and AnaLouise Keating, 2002, pp. 540-578.

Arora, Alka. "Re-Enchanting Feminism: Challenging Religious and Secular Patriarchies." *Postsecular Feminisms*, edited by Nandidi Deo, Bloomsbury Academic, 2018, pp. 32-50.

Avery, Dwayne. "The Maternalocene: The (In)Fertility of Mother Nature in Postapocalyptic Narrative." *Environmental Activism and the Maternal: Mothers and Mother Earth in Activism and Discourse*, edited by Olivia Ungar, et al., Demeter Press, pp. 141-74.

brown, adrienne marie. *Emergent Strategy: Shaping Change, Changing Worlds*. AK Press, 2017.

Brown, Stacia L. "Respectability Is a Burden." Stacia L. Brown, April 2013, https://stacialbrown.com/2013/04/. Accessed 10 July 2023.

Bryant-Davis, Thelma, and Lillian Comas-Diaz. *Womanist and Mujerista Psychologies: Voices of Fire, Acts of Courage*. American Psychological Association, 2016.

Butler, Octavia. *Earthseed: The Complete Series*. Open Road Media, 2017.

Carter, Susan. "Loss and Change: Holding Ambiguity and Recognizing Loss in Positive Social Change." Lecture for *Spirit, Compassion, and Community Activism* course. Summer 2021.

Collins, Patricia Hill. "Learning from the Outsider Within: The Sociological Significance of Black Feminist Thought." *The Feminist Standpoint Theory Reader: Intellectual and Political Controversies*, edited by Sandra Harding, Routledge, 2004, pp. 103-26.

Collins. Patricia Hill. "What's in A Name? Womanism, Black Feminism, and Beyond." *The Black Scholar*, vol. 26, no. 1, 2001, pp. 9-17.

Dillard, Cynthia. *Learning to (Re)Member the Things We've Learned to Forget*. Peter Lang, 2012.

Estés, Clarissa Pinkola. *Women Who Run with the Wolves*. Ballantine Books, 1992.

Foor, Daniel. *Ancestral Medicine: Rituals for Personal and Family Healing.* Bear & Company, 2017.

Gomez, Michael A. *Exchanging Our Country Marks: The Transformation of African Identity in the Colonial and Antebellum South.* University of North Carolina Press, 1997.

gumbs, pauline alexis. "Forget Hallmark: Why Mother's Day Is a Queer Black Left Feminist Thing." *Revolutionary Mothering,* edited by alexis pauline gumbs, China Martens, and Mai'a, PM Press, 2016, pp. 117-121.

Halstead, John. "Another End of the World is Possible: Practicing the Yoga of Despair." *Another End of the World is Possible.* Lulu.co, 2020, pp. 43-62.

Hartman, Saidiya. *Wayward Lives, Beautiful Experiments.* W.W. Norton & Company, 2019.

Harris-Perry, Melissa V. *Sister Citizen: Shame, Stereotypes, and Black Women in America.* Yale University Press, 2011.

hooks, bell. "Choosing the Margin as a Space of Radical Openness." *Framework: The Journal of Cinema and Media,* vol. 36, 1989, pp. 15-23.

Lorde, Audre. "Uses of the Erotic: The Erotic as Power." *Weaving the Visions,* edited by Judith Plaskow and Carol P. Christ, HarperSan Francisco, 1989, pp. 208-13.

Manuel, Earthlyn. *The Way of Tenderness.* Wisdom Publications, 2015.

Marinucci, Mimi. *Feminism Is Queer: The Intimate Connection between Queer and Feminist Theory.* Zed Books, 2010.

Moore, Kathleen Dean. *Great Tide Rising: Towards Clarity and Moral Courage in a Time of Planetary Change.* Catapult, 2016.

Pinn, Anthony, editor. *Noise and Spirit: The Religious and Spiritual Sensibilities of Rap Music.* New York University Press, 2003.

Raphael, Melissa. *Theology and Embodiment: The Post-Patriarchal Reconstruction of Female Sacrality.* Sheffield Academic Press, 1996.

Romanyshyn, Robert D. *The Wounded Researcher: Research with Soul in Mind.* Spring Journal Books, 2007.

Solnit, Rebecca. *A Field Guide to Getting Lost.* Penguin Books, 2005.

Part Two

Honouring Our Boundary-Busting Foremothers

Time washes over memory,
softens it,
smooths rough edges;
Moments become
Recovered artefacts,
Artfully remade—
Beautiful,
Like beach glass.

Story Six

My Mother's Legacy: Recovering the Gifts of Irreverence

BettyAnn Martin

E ven when relationships end, there are chapters, stories to write and rewrite. This chapter is one of those stories, a story of loss and recovery, of recollection and the perspective gained when we hold the past gently.

The story that I am about to tell is inspired by history, memory, and imagination. For many readers, the narrative of my mother's life will seem quite ordinary and, in truth, it is. Although the dates, names, and places in this story are relatively unimportant, they document a common life but lived with uncommon spirit. My mother's essence and joie de vivre are the more ephemeral elements in this narrative, and, as such, they represent the most elusive wisdom. My mother lived without deference to others' impressions and judgments, and in the choice to free herself, she lived a life that I now understand to be truly dignified—a life of presence, passion, and irreverence.

Her life affirms my own experience that to be truly alive and carry a sense of vitality into our relationships, we are called to challenge limits, test boundaries, and fearlessly align our being with our doing in the world. In this choice, we inspire others to find the passion and joy in their own stories. The meaning of my mother's life—so difficult for me to comprehend as her child—is here recovered through recollections that encourage me as both a woman and mother to regularly challenge my own perceptions, take risks, and remain open to the possibilities inherent in such freedom.

There was a cedar chest that my mother stored in my bedroom as a child. On occasion, when no one was home, I would open the lid and sift through the treasures—items she kept that marked memorable moments—such as letters, documents, and pictures. It was here that I was introduced to Betty Marie Riddell, the woman I had only ever known as my mother. It was here that I discovered black-and-white images of a beautiful, spirited young woman, with an indescribably wry smile. Every picture told a story—some I came to know, and many I was left to imagine. One photo in particular captures her essence: She is sporting a jaunty, oversized hat with a flipped brim. Her gleaming eyes complement a broad smile. She is smoking a pipe. And she stands poised with a fishing rod, ready to cast. Her smile is all mischief, her irreverence captured forever in that image.[1]

Life softened this portrait of raw vitality, just as memory now softens feelings associated with her loss.

~

In later life, as I came to know her, my mother was a vision in powder blue polyester pants and a neon orange acrylic sweater. She was the kind of vision that causes a teenage girl to wince and recoil. She lived out loud—in technicolour. I lived in the silence of my thoughts, deep in the shadows. When her presence drew me into the light, I felt a biting shame. At the time, I was ashamed of her—of the way she dressed, of her general disregard for social decorum, but mostly of her blatant disregard for prescribed ways of being.

She defied convention; she did not bake, she barely cooked, and she was not at all concerned with housekeeping. As a child, I remember going to friends' houses where the snacks would be carefully cut, and well-groomed mothers would eagerly engage polite conversation in immaculate kitchens. When friends came to my house, the table was generally strewn with paint supplies, and using the mustard became a game of roulette, as she frequently repurposed condiment containers to store turpentine and linseed oil. She sang an eclectic mix of ranch songs and Latin hymns. She yodelled on occasion and wrote poetry. Although my mother never described herself as a feminist, her unbridled, creative energy summons a combined portrait of Annie Oakley, Frida Kahlo, and Gloria Steinem.

When I was younger, I desperately wanted my mother to be like other mothers—content with her domestic lot, following the script, and

wearing the costume. I fantasied about a well-dressed matriarch with a fashionable hairstyle and impeccable makeup, with dinner always hot and lovingly prepared. My mother was on the outside of most mother cliques, simply because she wasn't like other moms or the ideal matriarchs about which I fantasised. Her difference bred ambivalence; her difference became my difference, and her exclusion became my exclusion. I wanted nothing more than to fit in, and her life was a constant reminder that I was unlike my peers. There was a strong sense of guilt by association. In truth, I was ashamed of myself and what I had come from, and unfortunately, she became a convenient symbol of my own complex struggle for self-acceptance.

I would not realize until much later that the roles I wanted her to play as my mother were in deep conflict with the person she was as a woman. Until I had a family of my own, I would not learn the importance of keeping a sense of self distinct from the weight of maternal expectations. I learned, through her example, the importance of embracing the freedom to do it differently—to parent off script, despite the way in which nonconformity is inevitably perceived by others, especially our own children. This boundary between expectation and authenticity—between maternal obligation and self-actualization—was the source of considerable tension in my relationship with my mother. With that time passed, I now make meaning in relation to memory, piecing together this narrative to guide a gentle exploration of the true story of the woman I knew as my mother.

~

Despite the shame I felt associated with her difference, I understood early on that my mother was one of the smartest women I would ever know. Formal education, however, was a barrier that insinuated itself regularly into our relationship. After cancer came into our lives, I remember my sister filling out some paperwork—so many details in dying—and I remember her reading out some question to my mother about the level of education achieved. My mother whispered a response, and my sister recorded the secret. My mother was ashamed that I might hear that she did not finish high school. She thought I was more intelligent because I did well in academia, but I knew she was a visionary. She understood and educated me in the nuance and deeper truths that allow for meaningful relationships. She was able to make connections over time and through experience. It was not clear to me early on how

her authenticity would eventually grant me the freedom to be the person that I am today.

I wish she knew how much I value her wisdom.

~

In looking to place my mother's influence in the context of history and my recollected memory, I reflect often on the meaning of her life. In her absence, I am forced to sift through details for the answer to this question, hopeful that relevant truths will materialize. She was the youngest of six children, born to Wellington Riddell and Elizabeth Durand on December 19 1927. She was born at home—37 Bond Street in Dundas, ON—quite by accident, if I recall correctly. My mother regularly shared details of growing up in poverty—a dirt floor and sharing a bed with her lifelong best friend and sister, Agnes. My mother recounted that when her father became ill with throat cancer, she was turned away at the butcher's when she went to collect their regular meat order. It was too risky, she imagined, to extend credit to a family whose main breadwinner was no longer working. My mother's sister Mary would eventually go to live with an aunt. "She was a gorgeous child," she recalled. "So they wanted her." Mary grew up to know privilege in ways my mother would never understand. My mother rarely spoke of Mary and the life that was gifted to her because she had beautiful brown eyes.

My mother went to work in the radio assembly line at Westinghouse during the early days of the war. She was proud of her contribution and her independence. Her brothers Charles and William would make their contribution by joining the war effort overseas. On August 11, 1944, however, her mother received a telegram that forever altered the trajectory of their family and mine:

MINISTER OF NATIONAL DEFENCE DEEPLY REGRETS TO INFORM YOU B41992 CORPORAL CHARLES WELLINGTON RIDDELL WAS REPORTED KILLED IN ACTION SECOND AUGUST 1944 STOP IF ANY FURTHER INFORMATION BECOMES AVAILABLE IT WILL BE FORWARDED AS SOON AS RECEIVED

He is buried in Mondeville, France.

With the delivery of this telegram, my grandmother lost a son, and my mother lost a brother. I did not fully grasp the import of this loss until the death of my own brother, Lenard. My mother often commented

that her mother was "never the same" after Charles died; she began drinking heavily and would continue to seek escape from his loss until her death. There are pictures of my grandmother—beautiful in her youth—and others, after Charlie's death, that document the lingering effects of her mourning.

As a result of witnessing her mother's decline, my mother rarely drank. She fostered a sense of stoicism that was punctuated by moments of intense living. I did not fully appreciate the source of her strength as a child, since the meaning we make of people is generally quite superficial until we are able to connect with their lives through context and empathy. Memory is a gift that enables this process of deeper connection; it lends new perspective and knowing as we move through our own experiences and grasp the struggle in the journey of those who have gone before—loved ones whose lives were touched or altered by the legacy of events beyond their control.

~

My mother met my father after the war. They married shortly thereafter and went on to have five children; I was the youngest of those children, born long after my mother thought her family was complete.

The story is a good one.

She and her sister travelled through Europe in her early forties; she was handed a sprig of heather by a fortune teller in Scotland, who told her she would have another child. Given my mother's age, they dismissed the prophecy as ludicrous and laughed all the way back to their hotel.

I was born in 1971, about a year after their return.

I have kept the heather as a corroborating artefact, a reminder of my origin and our connection through time—our beginning as well as this time past endings.

~

In addition to her role as primary caregiver for her children, my mother became a self-taught artist at the age of thirty-seven. My father was less than supportive of the new venture and suggested that if she ever painted a picture that someone was willing to buy, he would eat it. Despite her prevailing doubt, my mother became a success in her own right, ultimately having a number of works commissioned and eventually flourishing as an art teacher.

My memory takes me back to the names and the mixing of colours as well as the inescapable odour of turpentine. I would look on with keen interest as she would make colour, with her palette knife, always in steady motion. Her hands would then gently bring the brush to paint and the paint to canvas. For countless hours, she would lose herself in pursuit of landscapes, windmills, and tree lines.

Art became her passion, in much the same way expression through story has become mine. Indeed, she was an artist in every regard; she was quirky in ways that suggested both haunting and liberation. She spent weekend afternoons watching Bob Ross paint happy little trees on PBS. She invited stray cats to wander through our home as the door was generally open to facilitate adequate ventilation. She sang loudly and without provocation. She shared prophecies of a future without water, and she openly conversed with her mother who had passed away when I was only two years old. Sometimes while painting, she would openly reflect on her life, her learning, and her relationships, in much the same way that I am reflecting here.

Perhaps, in her monologues, my mother was working to resolve the tension she detected in our relationship. I always felt my mother wanted me to be stronger, and I, longing for demonstrations of tenderness, regularly resisted her will. I realize now that her intention was to grow resilience, and her resolve to model strength developed in response to a life of challenges, some of which I have shared, and some I will never know.

~

My mother was her own person, an outlier by every standard. I desperately wanted her to be and do all the things that seemed appropriate for a good mother. Selfishly, I wanted her to care in all the ways I was conditioned to believe that a mother should care. I now realize that my mother did care, not in all the Martha Stewart-inspired ways I desired as a child, but in ways that reflected her own unique vitality.

When I was young, she was my guide leader and basketball coach. I do not think she had a particular aptitude for either of these roles; she just wanted to be there. She taught that showing up—being present—in ways that are personally meaningful is the greater part of parenting, and sometimes, when we do not have all the answers, it is all we have to offer. Through the strength of her example, I have learned there is no right way to be there for our children, and, in some ways, learning to

show up for ourselves is often just as valuable a lesson.

This journey—to understand self in relation to mothering—is a process that begins with reflection. It involves negotiating the past—that is, reflecting upon the meaning of legacy—in relation to the present as well as understanding the connection between current relationships with children and their future re-memberings. Awareness of this multidimensional temporal space inspires a consciously fostered attitude of irreverence grounded in a shared history.

Far from idealizing the experience of growing up in the wake of my mother's demonstrated exuberance, I now reflect on the meaning I have created and continue to construct regarding the tensions that evolved in relation to her struggle to define herself beyond limitations. From her, I carry forwards little practical knowledge of the domestic and normative aspects of mothering. I have taught myself to bake because I enjoy the calm of combining ingredients and the anticipation of a desired outcome. In the end, I produce something tangible that provides momentary pleasure.

As with baking, storytelling and writing offer satisfaction through sharing. This story—her story—is my creative offering; it is a reflection on the essence of my mother's legacy and what it means to myself and my children as we grow together in our understanding of her and each other.

~

In keeping with the process of growth through an acquired depth of understanding, I reflect on the perceived lack of tenderness in my relationship with my mother. Consciously or unconsciously, I think my mother believed that life was difficult and that the real work of living demanded a bravery she was not quite sure I possessed. I think she wanted strength to be her endowment, above all things, and I have grown to be strong in the ways she believed were important. Along the way, however, I have balanced strength with gentleness—a smoothing of rough edges—guided by the intention of compassionate understanding.

And so, between her strength and the learned experience of empathy, I endeavour to strike a balance and blaze my own trail. Liberated by my mother's example and my own intuitive sense of care, I am empowered to mother differently, to risk life outside the lines, and to indulge my identity as a woman—not to the exclusion of mothering but rather through a constant negotiation of the boundary between the two.

Having lost my mother at the age of nineteen, I learned to manage on my own. The painful awareness of her absence has been a part of my daily reality for almost as long as I can remember. Her loss forced a self-sustaining sense of competence, although the absence of her care is deeply felt. In many ways, I have had to learn to care for myself; this necessity has further cemented my growth by enabling a liberation to venture forwards in solitude, without fear.

My mother was right: Life is difficult.

We require a sense of deep resilience and perseverance to nurture ourselves and our relationships. We also require a strong sense of freedom to live a life of design, in addition to the courage and irreverence to bring that design to fruition.

~

As I continue to sift through black-and-white photos of my mother, I see a confident, vibrant young woman posing for the camera. There are photos of her in the embrace of an old boyfriend, photos of her with my father, young and in love, and photos of her as a young mother. In one image, she holds a chocolate cake with bunny decorations fashioned from marshmallows. A similar cake is featured in other photos, held by her mother—a birthday tradition. In several other photos, my mother poses with children perched upon her lap.

Later in chronology, there is a photo of me sleeping in a bassinette on location, a tribute to my mother's continued artistic interest amid the demands of childrearing. There are several stories of her setting out to paint while carting me around as a baby resting on a pillow in a cardboard box on the floor of her car. My mother was all of these women— coy, domesticated, creative, and determined. These pictures hang together now through the connections I imagine as I string stories together in a quest for coherence.

Although I impose order for the sake of my own comfort, I remain open to the possibility that these stories do not cohere and that they are perhaps beautifully dissonant in ways I will never know. Some truths remain buried—secret and unknowable—despite artefacts and our best efforts to preserve memory.

~

My mother commanded a room when she told stories; she had a presence that transfixed listeners. Many of these stories I heard several times, but

the retelling was a spectacle that could not be resisted. In the formative years of my young adulthood, my mother's passion and spontaneity planted a seed that would lie dormant for countless years. I realize now that I would not be here, telling this story, had she not indelibly imprinted something powerful upon me.

Most of the stories my mother told were fashioned from life events that took on epic proportions when she found an audience. My mother artfully remade memory in the creative construction of flawless narrative arcs; she fashioned meaning and beauty from the mundane. One of her favourite narratives was the story of my birth, which she told with enthusiasm and a deep sense of pride. I came into the world fully breech, weighing ten pounds and fifteen ounces. My mother was forty-four at the time. In her recollection of events, she recalled the doctor sweating profusely—exhausted in his efforts—until the time of my arrival.

There were, however, stories that my mother never told.

She never spoke at length of her brother's death or the pain she experienced in the discovery of my father's infidelity. I came to understand that these silences represented the deepest hurts: stories that took shape in the form of feeling beyond words.

~

In writing this story, I contribute to the narrative of my mother's life and gift to the world. Early on, I resisted the legacy and gifts of her irreverence. I fostered a deep commitment to maternal propriety, fuelled by the will to establish myself in opposition to her example. It did not take long, however, for me to realize that the way mothering is socially conceived and the ways in which women and children have been conditioned to understand the institution of motherhood are both incredibly detrimental to the possibilities inherent in intimate relationships, not to mention personal freedom.

My mother had known something after all.

It is funny how realizations evolve in retrospect, rarely amid real-time situations. Our capacity for reflection through the passage of time enables us to embrace memory in its full complexity and to derive meaning beyond immediate context.

As I struggle to negotiate my own boundaries related to self and selflessness, I am amazed at the level of consciousness required to be faithful to both my vision of autonomy as well as my intuition regarding the nature of empathetic relationships. Alive relationships exist beyond

expectations and boundaries. This learning inspires a conscious effort to ensure that my children and I approach each other with levels of understanding that develop through an appreciation for who we are and who we may become. Open spaces allow for possibility within our relationships and enable the freedom to test boundaries, traverse unfamiliar ground, and actualize according to our own dreams and desires.

~

Without my mother's guidance these past thirty years, I have guided others in various situations, causes, and relationships as if seeking within myself an image of the guide I so desperately needed. The courage to insinuate myself into all manner of new situations—the learned necessity to trailblaze—is an empowered way of being that I now attribute to her influence. I am thankful to her for the confidence to envision a future beyond the constraints of convention—a conscious, creative project limited only by imagination.

~

In the sharing of stories, we engage memory through a process of reflection; in doing so, we free ourselves and potentially free others. Writing this story has enabled me the opportunity to reconnect with the woman I only partially knew and appreciated as my mother; in reconnecting with her, I take pride in the beauty of her unique character and simultaneously connect with a vision of her that I glimpse in myself.

~

All stories, however, must account for the inevitability of endings.

At the age of sixty, my mother developed a cold that never went away. After several medical appointments and a follow-up x-ray, my mother was told she had nine months to live. She turned to the resident radiologist, who cried as she relayed the news, and said, "You have the most beautiful eyes." I would hear this story after the fact, as my mother concealed the details of her illness from me for some time.

In the days of her dying, my mother's body lay in weakness, but her mind remained strong. We took turns sitting with her. Memory upon memory returned to her, many of which she would recount in a state of semi-consciousness. They told us that it was the effect of the morphine.

One night, she relived a memory that took shape at the age of fourteen. She called out for my father in a distress that communicated a need

and dependence I had never witnessed in her before. On a more lucid day, she turned to me and said, "Now I understand: All he ever wanted was to be needed." The revelation marked a moment of vulnerability and strength. It was a moment of openness—an awareness guided by gentle empathy and a pursuit of meaning beyond endings.

Although my mother's strength waned in her final days, her dignity did not. She learned to lean on others, to familiarize herself with a wasting body, and to confront the reality of mortal pain with grace. She spent several days lingering between life and death. It was her heart—the nurse told us—as it was still too strong to release its hold on life. We spent that night saying our goodbyes, giving her permission to let go—giving ourselves permission to let go. Our entire family was re-united and lived together in those final days. Siblings with busy lives found time to sit bedside for days; there were moments of hurt, but there was also laughter. Sharing and connecting, despite the deep pain, are my strongest recollection of that time together. The connection was a source of great joy for my mother; she watched as her children supported each other in an awareness of the inevitability of loss.

In those last days, I remember bathing my mother. I had never cared for her in loving, gentle ways as she had cared for me as a child; I am thankful for this experience—for her willingness to receive and for the opportunity to serve in ways she had given to me. In these moments, her learning and our relationship came full circle; she accepted vulnerability and allowed me to nurture. There was dignity in our exchange and much love on both sides.

My mother never spoke of her fears of dying. She saved all her questions for the nurse who visited regularly. After my mother's passing, it was several days before she returned for a quick visit to check in on our family. We shared how thankful we were that she was able to stop by. She replied, "I have a much harder time visiting, and I have to wait a little longer when it's someone I've grown to care about." Although we were not surprised, it was comforting for us to know that my mother had made a meaningful connection in those final days.

~

Through the lens of the past, I remain present in relationship with my children; I see the power in my mother's example and how my connection with her continues beyond the ending of her life. My original need to differentiate myself from her had little to do with my lack of respect

and more to do with what I felt her role in my life should be. Unfortunately, that expectation was the source of a lengthy disconnect. As I get older and seek meaningful relationships with my daughters and son, the will to heal that disconnect deepens.

~

As I sift through photos of my own, I wonder what my children will make of me and my irreverence—this legacy that seems to have grown through our family. Will they perceive it as some genetic weed that must be uprooted, or will they come to respect and nurture its presence in their lives, observe the intricacies of its effects over time, and see the expansion of self made possible through its abundant gifts?

I come across a picture of myself on a milestone birthday. I am wearing a black cocktail dress and a jaunty hat decorated with flowers; over top of the dress, I am modelling a coconut bra. My head is tilted, and I see something of the wry smile I detected in my mother's pipe-smoking photo. The realization settles in: We are the same, she and I.

I recently read, "Anyone who has never been in trouble has never lived" (Natale 21); I believe there is deep value in this concept of meaningful life through enacted liberation. This idea resonates because feeling and being alive involve transcending the monotony of life by finding the beauty and expansiveness in everyday experiences. My mother's identity reflects this deeper knowing—the permission we give ourselves to explore self beyond boundaries. Whether it is jumping the fence, smoking the pipe, or wearing the coconuts, being alive is about testing the limits of what is permissible. And, more importantly, it is about redefining the limits of what is possible by exploring the potential of who we might be.

~

While writing this chapter, as if manifesting its meaning, my youngest daughter came to me wearing a shirt culled from my past. It was from a Jann Arden concert I attended over twenty years ago. Across the chest was one simple line: "I've got a good mother." I was moved to see her wear it and humbled that she might think the lyric applied to her perception of me. We ran errands together that day; we spoke of graduation plans. Our connection was palpable.

My daughter planned to wear Converse sneakers with her formal grad regalia—a touch of irreverence. I commented that I am proud to have a daughter who is courageous enough to be herself despite the pressure to conform.

She said, "It's a curse and a blessing."
She is only thirteen, but I think she gets it.
I replied, "It is, but it is so worth it!"
We spent the remainder of the ride in silence. I revelled in the liberating implications of her choices while she looked thoughtfully out the window.

~

And so, the cycle continues...

My children are often embarrassed by my presence, the way I dress, and my openness with others. My older daughter regularly expresses her mortification with my attire, and her displeasure takes me back to my early response to my mother—her powder blue pants and neon orange sweater. But I persist in my difference and trust in the deeper knowing. Having now made the connection between past, present, and a possible future, I consciously blaze a trail. I choose to model an irreverence, softened by the gentleness that comes through empathy.

~

My mother perceived her value to be beyond arbitrary expectations of motherhood, and I am indebted to her for this gift. I wonder if my mother was conscious of her example and of the ways she would move through me and how I would continue to feel through her despite the brevity of our time together.

Such a valuable lesson and legacy she has bequeathed—the power and courage to recover myself. Through memory, I recover the gifts of her irreverence and grow in both certainty and gratitude that I am who I am because of her—free.

I am unabashedly and unapologetically who I am because she was my mother.

May there always be a chapter,
Ever a beginning.
Despite loss,
May we find connection
Through memory;
And write those
Stories
That make
Us feel
Whole again.

Endnotes

1. See cover photo.

Works Cited

Natale, Frank. *Mastering Alive Relationships.* Wiz-dom Unlimited, 1992.

To my mom,
my story is dedicated to you.
You are the house that built me.

The House That Built Me

Darlene Tetzlaff

You leave home, you move on.
And you do the best you can.
I got lost in this whole world
And forgot who I am.

I thought if I could touch this place or feel it
This brokenness inside me might start healing.
Out here, it's like I'm someone else.
I thought that maybe I could find myself.

If I could just come in, I swear I'll leave.
Won't take nothin' but a memory
From the house that built me. (Lambert)

A few years ago, the country singer Miranda Lambert released the song "The House that Built Me." The title reminded me of the tiny house where I grew up. It was four-hundred square feet in size, sided in asphalt brick with single pane sash windows, and heated by a wood stove that stood in the middle of the house. The song brings tears to my eyes, as it reminds me of the hardship my family endured and the imprint those early experiences have had on who I have become as both a woman and mother.

By some standards, we were poor. For many years, there was no running water; when that luxury finally came, it was cold water only. Our toileting facilities were in a dilapidated outhouse behind the shed. My brother and I slept in bunk beds, and my mom and dad slept on a

pullout couch in the living room.

We had a roof over our heads, and our parents loved us, but I know that there were some who took pity on us. I admit that in my teenage years, I was ashamed, and I did not always share where I lived. My close friends did not care and looking back, we were blessed that our country neighbours were kind people.

I now find joy in these humble beginnings. I will never forget where I came from. And although I spent much of my life, particularly through my education and career, trying to prove that I was worthy, I never felt entitled or took anything for granted.

The story of who I am began in this little house—the house that built me.

~

My father woke us up early in the morning to get ready for school by turning on polka music on his beloved stereo system. He sometimes ran the electric broom to get the house moving. In hindsight, it was an interesting tactic to get us out of bed for school. Mom had already left for her job at the canning factory in the summer or the tobacco factory in the winter; Mom always worked outside the home while dad farmed our fifty acres in cash crops.

On Sunday mornings, while Mom, my brother and I went to Sunday mass, my dad dug out his accordion. He played polka and waltz music until we came back home, and then he packed it all up until the next time we left. We sometimes quietly arrived home and sat on the step to listen to him play.

Faith, that is what I learned in the house that built me.

~

Living in small quarters is difficult. There was really no place to hide when someone was upset. Our only choice was to go outside and walk until you felt strong enough to return.

Strength, that is what I learned in the house that built me.

~

My mom was born in Dover Centre, in a small shanty just outside of the town of Wallaceburg, Ontario, in 1926. She was the first child of Joseph and Sylvie. Her parents were Belgian immigrants who worked in the tobacco and sugar beet fields. Her sister Cecilia was born four years later.

On February 25th, 1936, tragedy struck the family. Early each

morning, my grandmother got out of bed to start the coal stove for cooking and heating the house; that morning, the stove and house caught fire. Despite severe burns, my grandmother got outside to help Mom and her sister escape through the bedroom window. Mom recalls with vivid detail that her mother had life-threatening burns over her entire body except for her hands and feet. Somehow, Sylvie reached the neighbours for help. The last words Mom remembers hearing her mother say were, "It hurts." Sylvie lived but a day, enough time for my grandfather to return home from Delhi Township and say goodbye. At the age of ten, my mom and her six-year-old sister were left without a mother for guidance. They would learn many things the hard way.

My grandfather decided that Mom and her sister Cecilia would live with family in Belgium until he could establish a home for himself and his daughters. Mom was sent to live with her uncle, and Cecilia lived with their maternal grandmother. The sisters faced harsh rules in Belgium. Students attending the Roman Catholic school had to attend school mass on Sunday. Mom remembers that her aunt and uncle preferred to go to a different mass, and as a result, Mom was teased by her classmates and had to write lines, "I must attend school mass." In response to bullying, she was instructed by her guardians that she had to learn how to fight her own battles. However, as a matter of principle, Mom was sent to another school by her guardians. Her former classmates were not allowed to speak or play with her.

Tragically, on September 25th, 1971, Mom's sister, Cecilia, drove her car across the railroad tracks near her home and was killed by an oncoming train. Their father passed away only a month later with a broken heart. I remember sitting in the funeral home, my brother and I seated on either side of my mom. Someone expressed their condolences to her, saying, "I am so sorry. You've lost your whole family." Without skipping a beat my mother responded, "Oh no I haven't. I still have my kids." I was a mere ten years old at the time; I will never forget that moment.

Resilience, that is what I learned in the house that built me.

~

Women and mothers often find themselves taking care of everyone and everything; learning from the best, I mastered this expectation to an extreme. Over the years, my work ethic became part of an impulse to prove my worth. If a job needed to be done, I would do it. If others were feeling overwhelmed, I would step in. I burdened myself with a

responsibility for all things, but I have realized that there was a price to pay for these physical and emotional labours.

Although my determination is rooted in my history of hardship, it is also the site of my grounding and capacity for reflection and change. I have learned to watch for the warning signs—to pay attention to when body and mind need rest and redirection. As I work to reset my life in the aftermath of career and childrearing, I have come to understand the importance of tending to my personal needs and boundaries.

I have always felt incredibly guilty taking time for myself to recharge and reset. I could never allow myself to do this until my work was done and the kids' needs were met. There was little time left in the day for self-care. Frustration mounted as my body sank into a sedentary life-style, and my health became compromised. There was so much to be grateful for, yet I became silently miserable. The irony is that perfection-ism is relative. As I poured my energy into the business of work or other things, my health, self-worth, self-esteem, and family relationships were compromised. It was difficult for me, like my mother, to acknowledge that taking care of my own physical and mental health makes me a stronger person. Turning the lens of care inwards helped me to gain fresh perspectives and renewed energy to meet the competing demands I faced as a professional, partner, daughter, and mother.

I am grateful for that coworker who told me to exercise my "no" muscle, to challenge the boundaries of expectation, and to accept that I could not be everything to everyone. I gave myself permission to say "no" and to stop. I started to observe others clearly setting workload boundaries and how colleagues would actually adjust their requests to accommodate these expressed limits. The trick, I have realized, is to make sure you say "yes" to the right things and to extend yourself in ways that have meaning. I have learned that while so much seems im-portant, the needs of my children and family are paramount and really the only ones that count. I am still learning the importance of my own needs. I do not always get the balance right, but I am working on it.

As a mother who had a career outside the home, raising three chil-dren was a challenge. I wanted my kids to have opportunities in educa-tion, in extracurricular activities, and have the survival skills they needed when they left the family home. In the small town of Tilbury, Ontario, long hours at work meant that being there for my kids was not always physically possible. Later in my career, I worked two hours away

in Detroit and Troy, Michigan in the United States. After a ten-to-twelve-hour day, I would cross the border back to Canada to check in with my family and take care of their needs. Balancing this was tough over this period of six years.

Guilt.

My career was important to me, yet my absence affected my kids.

Guilt.

I admit that my work fulfilled my own self-worth and gave me a sense of purpose. Part of that purpose, however, was to ensure that my kids would have a good start in a competitive world. Even after retiring, I still find myself rationalizing all of this and dwelling on the past even though I understand that it is time to celebrate my life and look forward to what is to be.

Survival, that is what I learned in the house that built me.

~

With the upcoming birth of my first two grandchildren, I reflect on the influence of a grandmother I never met, her influence on my mother and my mother's influence on me. I am a proud mother of three beautiful people: two daughters and a son. They are as different from one another as day and night. The late teen and preteen years were especially difficult; these years often felt like the great parental rollercoaster ride.

Our daughters were born six years apart, and they did not get along. Although mothers are compelled to try and fix things, I struggled to accept that I could not fix this relationship.

Helplessness.

Filled with frustration, I said, "Someday, you will love each other, and this will pass. Someday, you will be best friends." We eventually got through the ups and downs of those early years, and their relationship has grown into the friendship I hoped it would.

Nevertheless, a mother always feels the guilt of what she should have done or the regret of what she did not do. I have told my children that there is no playbook made for each mother or each child.

I have made mistakes.

My husband and I have learned along the way.

I hope my children understand.

I am grateful for who they have become.

I am grateful that they seem to know themselves sooner than I ever thought possible.

We are still healing from our mistakes, or the perception thereof.

Healing is required when kids still believe tough love was meant to hurt them. I am not ashamed to admit to my children that sometimes I did not get it right. As mothers, we do what we feel is best at the time, all with good intention, to protect and to teach. Ultimately, the love we give through our honesty is the greatest teacher. Children may harbour resentments for a time; this is a chance mothers take. I have learned the value of standing your ground for the long haul. Despite resistance, children are really looking for your truth as well as honest and consistent love. I realize how fortunate I am to have happy and successful children, and I am filled with gratitude as I watch them navigate their early adulthood. They will fall sometimes and learn. I will be here as they need me.

Forgiveness, that is what I learned in the house that built me.

~

We have built a much larger home on the land my mother and father farmed. My mother lives beside us, still in the house that built me. She has been alone since my father passed away nineteen years ago. Her closest companion is Kit Carson, a stray cat she took under her care 11 years ago. At the age of ninety-six, she continues in the role of caregiver and treats him like a king. In return, he gives her purpose, despite her daily limitations.

In 2010, after settling into my first post career pause, the "little house" got a face lift, as we expanded my mom's living quarters from four to six hundred square feet; it is a small and simple space where she could still have her independence but feel supported by those who love her. After three months of construction, Mom moved back into her home. I will never forget that day. As she looked around at the renovations— which included a galley kitchen, utility room, and indoor bathroom—she exclaimed, "I never thought I would be living in a palace." We were thrilled to offer this small luxury to thank her for all the sacrifices she made for us.

Humility, that is what I learned in the house that built me.

~

My mother often reminisces about her childhood and shares some pretty tough stories. The trauma is as clear as the day of the fire. With the loss of her mother at such a young age, Mom lost the opportunity to learn about womanhood and seek guidance from the very person a young girl would expect to seek out. One day, she looked at me with proud eyes

and said, "I don't know how you and your brother turned out to be so educated. I didn't have the chance to continue in my schooling. I didn't have my mother around to show me how to be a mother." In these words, she was trying to figure out whether she could give herself credit for raising her children.

Mom has taught me more than she will ever know. I hope she appreciates how integral a role she played in the house that built me. I learned so much by her example as well as through her faith, empathy, and resilience.

Even at ninety-six, she faces life with the same humility, resilience, perseverance, and positive spirit as she did in times of trial. And so, we often remind Mom of the wisdom she offered as we were growing up. We help her to work through times when she second guesses her role as mother and confronts the feelings of not being enough and of not being worthy.

I will always hear her voice saying, "Don't worry. Sometimes there is a bend in the road; eventually, it will straighten out."

Wisdom, that is what I learned in the house that built me.

~

Won't take nothin' but a memory
From the house that built me. (Lambert)

~

I will carry my mother's wisdom as I continue to experience life through the memories formed and lessons learned in the house that built me.

Being a mom is hard.

You are constantly second guessing yourself,
Wondering if you are reading your children right.
There is no playbook, I say.
Each child is different.

You want to lift them up,
Every time they fall.
You feel guilty
When you decide they have to fall to figure it out.

Then the guilt comes.

But it's okay.

Tell yourself, "It's okay to say you got some things wrong."
Tell your children that you did the best you could.
Tell yourself, "It's okay to say you got some things right."
Tell your children what good people they've become.

The day comes,
Sometimes,
Many years later,
When they will call or reach out,
And you hear their words,
"Mom, can I talk to you?"
And your heart is full,
Because they came back to you,
even if it was just to have you listen.

When the time is right
Tell them you are proud of them.
They need to hear it.

When they are willing to share what they are going through,
Hold space for them
To look at themselves
and how they grew up.
Ask if what we taught made a difference in who they are—
The good and the bad.
Be ready to hear the answer.
Be open enough
To learn
And continue to love.

Works Cited

Lambert, Miranda. "The House That Built Me." *Revolution—2011 Limited Australian Tour Pack*, 2009.

We all suffer in some way
whether we are aware of it or not.

The Whole Story[1]

Susan Picard

> Life—as we come to it and as it comes to others—is filled
> with narrative fragments, enacted in storied moments of time
> and space, and reflected upon and understood in terms of
> narrative unities and discontinuities.
>
> —Jean Clandinin and Michael Connelly 17

My mother tells me two different versions of her thoughts about becoming a mother. In the first version, she is a young child, has two baby dolls, and wants nothing more than to be a mother herself. This is plausible, given that her first two children were named after those same two dolls. Sometimes, she wonders if it was more of a desire to become a grandmother, as she has many fond memories of a loving grandparent taking her out to the country to visit local farms (where she decided at the tender age of five that she would become a farmer) and including her in all the activities of life. Her early fascination with children and motherhood is supported by the story she tells of sneaking out of boarding school at the age of twelve to get home in time to be with her mother when her younger sibling was due to arrive. Sneaking out involved buying a train ticket with money she had squirreled away from her grandparents, presenting it to her headmistress as evidence that her mother expected her home, and then taking a train across war-torn Germany. This speaks to her determination. The fact that the train had to stop many times for its camouflage to properly conceal it from the bombers flying overhead demonstrates her fearlessness. When she finally

arrived in Berlin at midnight, she had to walk home in total darkness, as all the windows and street lamps had been blacked out to make the city invisible. This detail only further shows her confidence in confronting the unknown. And when her little brother was born, she tells me, she fell in love for the first time. Years later, when she discovered she is pregnant, despite being a recent immigrant to Canada with very few resources, she is overjoyed.

> We know what we know because of how we are positioned.
> If we shift our position in the parade, our knowing shifts.
> —Jean Clandinin and Michael Connelly 17

In the second version, there is no way that she wants to be a mother. In the early days of the war, she remembers seeing the bodies of young soldiers having their dog tags removed to be sent home to their mothers. She remembers her mother leaving the basement after the air raids were over to check the house for incendiary bombs to make sure it would not burn down around them. She saw her mother's face as she was placed on a train to Czechoslovakia when Hitler ordered all the children out of Germany. She remembers her mother's fearful face observing a fighter plane come out of nowhere and fire shots at her. (She had been instructed to get some bread for lunch for her mother and brother who were sitting in the garden.) She recalls her mother's protective posture when the Russians came into their home to stay before Berlin was divided after the war. She wonders what her mother had to do to bring her food to the hospital when she was held there for many weeks when she contracted diphtheria from a vaccination, its weakened virus infecting her body, already depleted from poor nutrition throughout the war. And she recalls the tears on her mother's face when she was taken to Sweden to live with her father after the war to help him in his infirm condition and thereby giving her mother one less mouth to feed. "There was no way I was going to be a mother," she told me one day in the kitchen while kneading bread. "What changed your mind?" I asked. She looked at me, smiled, and said, "It was the farm." Knowing how much she loved the farm and the work of producing almost all the food our family needed makes this story believable as well.

And the whole story doesn't start with once upon a time.

And the whole story doesn't end in a great big lie.

And the whole story doesn't fit on a page.

And you don't get disillusioned with age.

No, the whole story just gets bigger all the time...

I cannot say whether I always dreamed of being a mother or not. As the youngest child of six, I knew that I loved to be mothered and was lucky enough to have a second mother in the form of my eldest sister, who remembers me as the living doll that appeared in her life at the age of ten. I suspect that much of my care fell to her as the mistress of the house when my mother was busy on the farm. Almost three years younger than my next older sibling, I also received three years of undivided attention from my mother when the rest were off at school. She was brilliant at keeping me entertained while completing her many chores throughout the day. As I grew older, I had the opportunity to care for and entertain many of my nieces and nephews who began appearing around the age of fifteen, which I enjoyed and profited from on many occasions. I also benefitted from having my mother all to myself once all my siblings had left home, enabling me to do many things and have many conversations that my older siblings did not. Seeing all the things that my childbearing siblings could no longer do allowed me to fully appreciate not being tied down, which motivated me to complete my education, travel extensively, pursue my many interests, and even buy my own home—all without the burden or distraction of children.

As we study the forms of our own experience, not only are we searching for evidence of the external forces that have diminished us; we are also recovering our own possibilities. We work to remember, imagine, and realize ways of knowing and being that can span the chasm presently separating our public and private worlds.

—Madeleine Grumet xv

Another version of this story could be that it took me a long time to find a man who would be a good companion on the parenting journey. Awkward and shy, I did not date much in high school, and when I finally did, it tended to be older men with their own reasons for seeking out a

SUSAN PICARD

younger woman. By twenty-one, I was disillusioned, world weary, and broken by relationships and the men I had encountered, so I decided to focus on a career. I gained a better understanding of feminist issues after working as an income security social worker and crisis counsellor in a women's shelter. I saw firsthand the vulnerability of women, particularly mothers, in relationships, economics, and under the law. In exploring music as a potential career, I also discovered how opportunities are limited when you have responsibilities like children. In addition, I experienced how going on the road and seeking support for your aspirations came with its own vulnerabilities and complications. As I aged and met many of my goals, I began to wonder what would come next.

I was thirty-one when I met an honest man who was not afraid of commitment. It was then that I started dreaming of children. I longed for that deep connection with him and the opportunity to love a child so that they could become a light in the world. Suddenly, all I could see around me were bellies and babies, and I wished fervently for my own. When I was finally pregnant and blessed with my own baby, I felt an overwhelming sense of forgiveness for my many doubts. The slate had been wiped clean, and I found an opportunity to love the world back into a beautiful place.

And when I see you lying there

I see myself without a care.

I'm relying on the world out there

To please be kind and treat me fair.

And now I'm in my mother's shoes

And I see the things that she had to do.

And I feel the love that pulses through

Every single vein inside of you.

And I know that this is how my life began

Held within the love of my mother's hands.

My mother tells me that she started timing the contractions while she was weeding the strawberries after supper. At thirty-two years old, I was number six, and she had a good sense of how much time they would need to make the forty-minute drive to the hospital in town. She also knew that if she did not finish weeding, it probably would not get done,

162

as the hospital tended to keep the mother and newborn for several days, perhaps knowing that many of these rural women would be back in the barn or fields as soon as they were home. She has little to share about the actual delivery. I suppose that by the time you are on your sixth delivery, they all flow together, so I pick up little fragments, which may be from my birth story or one of my siblings. The most notable is the tale of the nurse who suggested that my mother bottle feed her baby, as nursing would not be as beneficial. The nurse went so far as to tell my mother that they would feed the baby in the nursery while my mother got some rest. The idea was ludicrous to my mother, who would have had to get up and start a fire in a wood stove in the middle of the night to heat the bottle instead of just reaching over to the cradle that was wedged between her bed and the wall and lift the baby to her breast. The nurse was forceful about the benefits of baby formula, but my mother was equally, if not more so, forceful: "Bring me my baby now, or I will get up out of this bed, get dressed, take her from the nursery, and walk home." She nursed all six of her babies.

~

It was the Christmas of 1958 when my parents moved to the farm where they would raise their family and create a life for themselves. It was about one hundred miles northwest of Edmonton, where my father worked as a delivery driver, on the far side of the Athabasca River, which at the time had to be crossed by ferry in the summer and over the ice in the winter. Several miles after crossing the river and following ever increasingly narrow roads, their farm was nestled in an aspen forest, where the small house and log barn had been abandoned for many years. They had hoped to move onto the farm in the spring, but circumstances had made that option impossible, so they packed up their three children—aged three, two and one—as well as some livestock they had managed to accumulate (fifty chickens and three cows) and took possession of their farm. Since my father had to return to Edmonton for his job, they spent the Christmas holiday making the house as livable as possible by blocking all draughts, gaining access to the well, and getting the woodstove ready for the firewood my father had cut down from the surrounding forest.

"Wait a minute," I said to her one day as we were reminiscing together. "You had three kids in cloth diapers, no running water, a wood stove in which you had to burn wood that hadn't properly dried as well

as chickens to be fed and cows to be milked, while Dad returned to Edmonton to drive a delivery truck? How on earth did you do it without going crazy?" Knowing that she had grown up in an affluent family in Germany, I could not begin to imagine how she would have made the adjustment. I had grown up on that same farm and was certain that I would have given my father the heave-ho had he left me in the middle of nowhere under those circumstances. My mom looked at me with a gleam in her eye and said, "Are you kidding? I was living the dream!" The fourth child arrived at the end of August.

> And the whole story well it isn't just about the facts.
> And the whole story doesn't start and end in the past.
> No, the whole story it doesn't take aim
> To target heroes or levy blame.
> No, the whole story just has so many questions to ask.

My contractions started shortly after my water broke around 3:00 a.m., a month and a half before I turned thirty-six. I woke my husband whose bleary-eyed response remains fixed in my mind to this day. The reality had sunk in. This was happening. We got to the hospital around 6:00 a.m., when the contractions were about two minutes apart, at which point they promptly stopped. The on-call doctor checked us out and advised us to wait and see if the contractions would start again, and if not, they would induce the baby in the afternoon. We questioned this suggestion, as we attended our prenatal classes with a lovely nurse who advised us not to feel like we had to rush things if the water broke without contractions. The doctor and nurse began telling us about studies they had read where the risk to the baby was much higher once the water broke and suggested we not risk losing our baby. As we were tired and nervous, fear won out, and we waited at the hospital. At 4:00 p.m., they hooked up the oxytocin drip to induce contractions. When they were slow to start, they upped the flow. My mind and body had no time to prepare for how quickly the contractions would come, leaving little time in between to recover. I was worried that I would pass out from their intensity, so they gave me an epidural but did not check to see that I was fully dilated and able to push. Suddenly, my lower body went numb, and I could no longer push. They pulled my daughter from my body.

> As interloper in an anthropology of experience, a poetics of
> place wants to insinuate itself in this milieu by starting with what
> makes us the same, the commonalities of sentient beings as seen
> through the great diversities of our collective meaningful existences.
> Being action oriented, it strives to know such things in every way
> possible and to defend them where they promote greater harmony in
> the Assembly of All Beings.
>
> —Ivan Brady 1003-04

I was able to hold her for a moment, but they were quickly concerned that her fluid levels were low and rushed her to neonatal intensive care (NICU). I begged my husband to go with her while the doctor helped me deliver the placenta and sent me to a room in the maternity ward for the epidural to wear off. It was 7:00 p.m. As I napped, I had the strangest dreams in which my legs were large lumpy noodles, and there was a baby somewhere. My husband faded in and out of my dreams until he disappeared. At 3:00 a.m., I sat up in my bed with a primal force. Where was my baby? I should be with my baby! I made my way out of my bed and was directed to where she was in the NICU. There was an enormous bandage on her head, where an intravenous was attached, and a nurse was about to feed her from a tiny bottle. "What are you doing?" I asked. "We need to try to feed her," the nurse said. "But I am going to breast-feed my baby," I responded. The nurse looked at me doubtfully but brought a chair beside where my daughter was. After I had positioned myself, she gently lay her in my arms. The breastfeeding did not go well. My daughter was weak, and my body was still in shock. I agreed to feed her a little formula, but only until I recovered enough to breastfeed. The nurse urged me to go to bed and rest, and I asked her when the next feeding time should be. She responded that they would feed her every three hours and that I could feed her again after I had a good rest. "No one but me will feed my baby!" I told her. And for the next three days, I was at the NICU for each feeding time, enduring the doubt from nurses and lactation consultants, as my daughter and I slowly figured out breast-feeding. In the end, no one fed her but me.

And when I see you lying there
I see my mother, without a care.
She's relying on the world out there
To please be kind and treat her fair.
And now I'm in my grandma's shoes
And I feel the love that pulses through.
And I wonder just what I should do
As the tides of war draw close to you.
And you know there's nothing that I wouldn't do
If it came to that, I would die for you.

My grandparents left Berlin for Sweden in 1933, not long after my mother was born in late 1932. According to my mother, they left due to an attack on her father after he refused to participate in singing a folk song sanctioned by Hitler at a local pub. He was beaten so badly by Hitler supporters that his kidneys were damaged, something that would trouble him until he passed away of liver failure at the young age of forty-two. My mother would later find out that the men who beat him had been part of a group of friends that he and my grandmother had spent time together with in his youth. Then there is the story of the time she was away at one of the schools she was required to attend and got sick. Her grandfather was able to care for her while her classmates were moved by train to a safer location in another part of the country. She was the only one who survived, as the train was bombed enroute. I know this story and all those from the war from my mother. My grandmother does not speak of this in her memoirs, which begin with tales of a wonderful childhood, interrupted by the First World War—a time in which most of what they owned, she recalls, was traded for food. She does tell the story of an exciting courtship with the son of a rich family who relocated to their neighborhood in 1923. She also recalls the exotic guests she met at their home, in addition to recounting many adventures that she was able to have because of being included in their family activities. This part of her memoir ends thus: "Then the unavoidable happened. We got married." When I first read the memoirs, I thought it meant that they had fallen in love. Years later, my mother tells me that she arrived only six months after the wedding.

~

My grandmother's recollections of mothering begin in 1944, as she cared for her young daughter and newly arrived infant son through the war:

> Day and night, the sirens howled and that meant down into the shelter with the baby buggy and necessary items. I put a tray over top of the buggy and pillows to shield him from the plaster that fell from the ceiling when the house shook as the bombs hit closer and closer…. We sat down there, listening to the bombs explode and the roof panes tumble off the roof. Your heart is in your throat, and you wait helplessly. After the all clear, [there is] the usual trek through the house and garden [looking for bombs]. The fire engines howl, some of the houses are burning, smoke is everywhere.

She finally left Berlin to stay with her in-laws, who were staying at an inn in a small village, which had its own challenges:

> I was sent out by bike with a backpack to buy food, any food I could get a hold of. A bike trail went along the forest to the next village where there was a store. When I got to the trail, I heard and saw a low flying airplane heading directly for me. It was flying so low that I could see the men sitting in the cockpit. Anxiety and panic wasn't something I could let get a hold of me; we needed food. So, peddle on and buy groceries. My backpack filled up, and I returned home. When I reached the first little houses of the village, people lay dead in their front yards. They probably thought the planes overhead were German. Those were the first casualties the mayor and his men had to bury. Later, many soldiers had to be buried too.

As I read through her memoirs, I cannot begin to imagine what it must have been like to face the last days of the war. There were decisions to make about whether to split up the family for safety or face the armies about to descend. She decided to stay and wait for the armies. First, there is a story of the German army destroying bridges and teaching young boys to use weapons designed to blow up tanks. Then, the Americans who shout and poke my grandmother with a rifle when she cannot raise her hands due to holding her baby son. Then, the English who are friendly and fish with her father-in-law. Finally, the story of the Russian soldiers' arrival and that of a highly decorated Mongol soldier who stays

in her house. My mother remembers that he might have been a little in love with my grandmother, who was quite beautiful, and so stayed with her to protect her from the Russian soldiers who were known to rape women as they moved over conquered territory. When he saw her bottle feeding her baby, he motioned to her breast, but she shook her head. My mother told me that my grandmother had refused to breastfeed in front of him. He, however, believed that she could not because of poor nutrition, so the next day, he brought her bread and bacon so that she could eat and nurse her baby.

The whole story it isn't just mine.

My brothers and sisters they all have a line

And my mother and father are part of it too.

And your grandparents, they're all connected to you.

And you know your Daddy is part of this song

And his whole family is coming along.

And this isn't how the story ends

No, I think it's just beginning again.

No, this isn't how the story ends.

No, I think it's just beginning again

And again and again and again.

It seems to be the special task of a historian to show the tortuous road of human development and social progress through the ages. In our studies of the past, it is certainly not the very course and sequence of events which fascinate our imagination and elevate history to... a main source of wisdom. The crucial matter seems to be our ability to interpret historical events in a way which makes past achievements and failures meaningful to us, to our own search for meaning and purpose. This meaning, which a historian assigns to specific fragments of the past, requires a theoretical and even a philosophical viewpoint and perspective. It is a manifestation of a historian's individuality, depth, and personal growth. The concept of human development and its dynamisms, grounded in the theory of positive disintegration,

may in many ways assist historians in giving new interpretations, richer and deeper meaning to the past.

—Kazimierz Dabrowski 125[2]

I am a historian only in the way that I have loved my mother's stories of how she came to be during a difficult and well-documented time in history. That she took the disintegration of the nation and the affluent home she grew up in as an opportunity to choose and cherish the life of a pioneer in the Canadian wilderness has both confounded and astounded me. That she has evolved into someone that I would consider to be living true to her personality ideal speaks to the deep respect I have for her capacity for compassion, forgiveness, and acceptance as well as her levels of commitment, confidence, and determination. I have been told that I am lucky—that not all mothers have allowed their challenges as daughters, women, and mothers to influence their mothering in the ways that I have been mothered. I have seen evidence of this in how many women are drawn to her and her honest and authentic companionship. In this way, she has been someone I endeavour to emulate. The most difficult part of being her daughter is perhaps the feeling that I have always fallen short.

This feeling is not distinctly mine. As social worker, teacher, sister, aunt, and friend, I have met many mothers who struggle with what it means to be a good mother. As nurturers to the next generation, there is a profound sense of responsibility to raise the future and no shortage of opinions about how this should be done—check out the parenting section of any bookstore or library. Industry and advertising prey on our insecurities, whereas public education seeks to take responsibility for more and more learning and experiences that once fell to the family alone. The rise of social media has meant that mothers and daughters compare their lives with others, often leading them to a profound sense that they might have missed out on something. I once looked to feminism to ease this sense of frustration, but I found that within feminism, there are still more differences that divide us. While my gender and context give me a unique claim on what it means to be a mother, there are as many or more differences than there are commonalities. In *Women's Ways of Knowing*, Nancy Goldberger asks the questions, "How are we to learn to live with each other when there are such apparent differences

among us—in life-style, language, religion, worldviews and ways of knowing, values and strategies for living? In a pluralistic world, can individuals and communities justly set criteria for what is right, what is true, and what is good without demonizing strangers?" (170). She adds, "A better understanding of how different people and cultures know and make truth claims is vital as we seek local solutions to a host of global problems." (17). As I add my story, my mother's, and her mother's to the landscape, I wonder how well I truly understand what is embedded in me. As I explore and share these stories, I recognize that I am "part of the present landscape and the past landscape and acknowledge that [I] helped to make the world in which [I find myself]" (Clandinin 24).

> Personality may also be described as a self-chosen, unique organization of structures and dynamisms with a distinct identity and direction. The development of personality consists in the formation and growth of preeminently human qualities of a conscious and dramatic nature, in particular, autonomy and authenticity.
>
> —Kazimierz Dabrowski

My husband passed away from a glioblastoma brain tumour one month before COVID-19 shut down the world. In the months that followed, I learned what it is to be a mother through difficult times. It is not my grandmother's journey—through a world war where bombs fell around her home, soldiers passed through her village, and she lost husband and father. It is not my mother's journey—where she immigrated away from a home devastated by war to take on living from the land alongside her husband and providing sustenance and security for her children. But their stories continue to live in me; they offer some guidance as my little family navigates through the ravages of grief and the fear of a virus that shut us off from opportunity and connection. What I have learned from my mother and grandmother is that when life becomes a difficult path rife with difficult decisions to make, the only peace comes from looking within ourselves and finding our deepest values. We must choose our way into the future, one day and one decision at a time. We must be guided by both the connections we have to those we love and the trust we have in ourselves. It is through this process that we become the necessary autonomous and authentic mothers that a changing world needs.

When I doubt myself and my connections, I remember those precious moments when I held each of my daughters to my breast, and we looked into each other's eyes; I knew then what it meant to love and hold sacred their trust. The gift we give our daughters, those potential future mothers, is our authenticity through "the need to find an adequate new conceptual expression for new insights into reality which cannot be adequately expressed by means of former concepts and distinctions" (Dabrowski viii). When the world falls apart, we do not need to piece together what was, for that version of reality has shown us its limitations—not ours.

~

I once asked my mother how she had evolved into such a peaceful presence despite all the trauma she dealt with—surviving war, living through an occupation, and leaving her country at fourteen. It did not take long for her to respond. "I knew as a child," she said, "that I was loved." I too know that I was loved and never more deeply and fully than when I first held my daughters and felt the weight and wonder of motherhood. When the world around me distorts what it means to love, I turn to Tara Brach, who asks us to "imagine a world where we as humans see and trust and revere the gold within all beings" (244). She continues: "Imagine how we'd help each other live true to ourselves, how we'd comfort and accompany each other, how we'd celebrate and create beauty together" (244). But the answer to all the world's problems is not simply love; it is the ability to forgive ourselves and others when we forget what it means to love in this way. Memory can tell us many versions of the same story that may lead us away from the path of love for ourselves and others while competing political, economic, cultural, and social narratives offer us other versions of who we should be. It is our capacity to forgive ourselves that unlocks the limitlessness of our capacity to love again.

And this isn't how the story ends.
No, I think it's just beginning again,
And again, and again, and again...

Endnotes

1. The song "The Whole Story," which is woven throughout this piece, was written shortly after my first daughter was born and was inspired by the intense connection I felt to my mother when gazing into my daughter's eyes. It was recorded by my band The DandyLionesses in 2007 and is available on Spotify.

2. The theory of positive disintegration describes personality development as a multilevel process in which an individual with developmental potential cultivates their own hierarchy of values in response to changing life circumstances that make it difficult to continue with the status quo of what is, requiring them to take on what can often be a difficult struggle of striving for what could be through living true to their own, self-selected values.

Works Cited

Brach, Tara. *Radical Compassion.* Penguin, 2019, U.S.

Brady, Ivan. "Poetics for a Planet: Discourse on Some Problems of Being-in-Place." *Handbook of Qualitative Research,* edited by N. K. Denzin and Y. S. Lincoln, Sage Publications, 2005, pp. 979-1026.

Clandinin, D. Jean and Connelly, F. Michael. "Narrative Inquiry." Jossey-Bass, 2000, Hoboken, NJ.

Clandinin, D. Jean. "Engaging in Narrative Inquiry." *Routledge,* 2013.

Dabrowski, Kazimierz. *The Dynamics of Concepts.* Gryf Publications Ltd., 1973.

Goldberger, Nancy. "Looking Backward. Looking Forward." *Knowledge, Difference and Power: Women's ways of Knowing,* edited by N. Goldberger, et al., Basic Books, 1996, pp. 1-21.

Grumet, Madeleine. *Bitter Milk.* The University of Massachusetts Press, 1988.

Picard, Susan. "The Whole Story." Performed by The DandyLionesses on *The Whole Story,* Independent Release, 2007.

Knowingly and unknowingly—
mothering outside the lines of the patriarchy
immense gratification, satisfaction, and joy.

For my mother who taught me
how to live life on my own terms.

Story Nine

Resilient Independence: A Single-Lone Mom Reflects on Her Mother's Legacy

Natasha Steer

Introductory Understandings

As my nineteen-year-old son grows into a young adult, I have become curious about the way my mother lived—and continues to live—her life. Perhaps this is because my son is growing up, and I am entering into a new phase of single-lone motherhood. Perhaps it is because I have more space and time to consider the many threads that connect to my life and have recognized that my mother is one of the most important of those. Or perhaps it is simply because I am older and more curious about my past—a past that I previously accessed only through a child's eyes. Whatever the reason, as I learn about and contemplate my mother's experiences, I cannot help but notice how much they both do, and do not, resemble my own.

My mother and I both became single-lone mothers during our pregnancies. It is for this reason that I use single-lone motherhood as a framework to examine both of our experiences. As single-lone mothers, we have both experienced meaningful fulfillment, empowerment, and joy. We have also experienced challenges. As Motapanyane notes, "The social stigma and economic hardships associated with lone motherhood in heteropatriarchal contexts have been shown to have ... detrimental effects on women. Chronic stress and fatigue can cause a number of health ailments" (3).

Our experience of single-lone motherhood makes us similar; the cultural context and time make our lived experiences quite different. What is most significant is that both of our stories challenge dominant narratives of single-lone motherhood in heteropatriarchal contexts.

In part one of this chapter, I examine my white mother's experience of singlehandedly raising a biracial daughter in the late twentieth century alongside my experience of becoming a single teen mother at the beginning of the twenty-first century. Juxtaposing and exploring these two generations of single-lone motherhood leads me to the second part, in which I reflect upon the ways in which my mother's journey has affected my own parenting journey and life path.

Autoethnography as a Method That Binds

In this chapter, I use autoethnography to share personal reflections on different periods of my own and my mother's life. Such an approach links aspects of our own lives to broader social contexts and change and demonstrates our negotiation of our own identities (McAdams), which offers a counternarrative to dominant social and cultural themes of irresponsibility, victimhood, and neglect related to single-lone mothering.

To ensure my memory of my mother's story was accurate, I recorded and transcribed a conversation with my mother in her home during the summer of 2020, which lasted approximately 150 minutes. During this conversation, I discussed some of my interpretations and encouraged my mother to elaborate further on certain memories for purposes of clarity. My mother consented to my presentation of her life history and offered comments on the chapter as a whole.

Part One: Two Generations of Single-Lone Mothers

Both my own and my mother's identities as single-lone mothers were shaped in some form by the dominant cultural narratives at the time. It was within these cultural narratives that we processed experiences and articulated responses. My mother navigated the world as a white woman in her late twenties while raising a biracial child; my experiences as a racialized single teen mother were quite different.

My Mother's Story

When my mother discovered she was pregnant in 1983, she was already closely connected with my father's Fijian family and their Muslim religion. Having moved to British Columbia, Canada, and away from her own British family located in Ontario, my mother felt at home with this second family—a family to whom she had been connected with since her teenage years. It is in this context that my mother first shared news of her pregnancy, and within my father's family, the most pressing concern became that she was not married. My mother shared: "I was quickly married in the Muslim faith. The week before I got married, someone told me there was going to be a double wedding—and I was going to be in it."

It was after the religious ceremony that my mother discovered that to stay in British Columbia with my biological father would mean an abusive lifestyle for both of us, so she left, making the decision to raise me as a single mother. Eight months pregnant, my mother boarded a plane to return to Ontario and her own family. She admitted, "I was scared to tell [my dad] ... because I wasn't married [legally] I guess.... I was like, 'Oh, gee... he still doesn't know.'"

It is a running joke in our family that in the end, my mother never mentioned my existence at all. Even when contractions started in the middle of the night, she told my grandad only, "It's time." He must have figured it out on his own at some point because, thankfully, my grandad knew enough to drive my mother to the hospital and was supportive from that moment forward.

As a single mother in the 1980s, my mother became the epitome of hard work in order to raise me and give us both a good life. As Elizabeth Bruno notes, "The single mother 'saint' ... is the super labourer" (387); this was the most favourable version of single motherhood available to my mother at the time, and she embraced it. Through hard work, my mother found empowerment in her single mother identity.

Often working five or more jobs at a time, my mother was our sole financial provider, and she did not shy away from this. When I asked her about the different jobs she was juggling, my mother talked about working for "[the] Red Cross ... going into people's homes because I went back to school to get my PSW [personal support worker].... I worked in a retirement home [as a secretary].... I also worked for a credit card company.... I was working as a salesperson in the malls ... in between,

I helped some seniors [by cleaning their homes], and I also helped a girl with special needs ... there were so many things."

My mother was fortunate to have the support of my grandad to take care of me—my grandmother died before I was born—and he did this often. Nonetheless, there were also times I went to work with my mother. At the gym where she worked as a secretary, I played in the daycare room, which was often empty, though occasionally, there was a baby to play with. When I was a little older, and my mother worked at a retirement centre, I crossed the street to wander the little strip mall and amused myself until her shift was over—not unlike when she was working in malls themselves. And on Sundays at the flea market, I joined her and learned to sell products as I connected and chatted with friendly strangers.

Out of necessity, my childhood was enveloped by the work my mother did. As I reflect on this now, it was not something that I disliked; I never doubted that my mother would take care of me. Not one to shy away from hard things, my mother knew what had to be done and did it. With no money from child support and the knowledge that none would come, my mother entered the workforce and worked harder than anyone I knew. Although to me it often appeared effortless, I understand now that was not the case.

This hard work was not only reserved for outside the home. When I was five years old, my mother used her savings to purchase a house that needed significant renovations and proceeded to complete the majority of the work herself. Combining home ownership with an already deep well of existing creativity, my mother constructed everything, including our living room curtains, the wooden microwave stand, and our living room table.

I can still see my mother kneeling in the kitchen, the carefully chosen pile of ceramic beige floor tiles beside her, as she carefully smeared the mortar before laying the next tile down. Growing up, I frequently came across my mother working on a new project—whether that was tiling our kitchen floor, building a wooden gate outside, or repairing or painting some part of our home.

"I remember a man who came around to give me a quote to pave the driveway – he told me that I'd need to pay him everything up front, as he'd finished a job for another single mother who hadn't paid him. I refused. He did the job anyways."

My mother was incredibly resourceful. Still, there were a few jobs around the house that she could not complete on her own. Replacing the hardware floors and installing new windows were two such jobs. However, when it was time for my mother to employ additional resources, she would shop around, ensuring that her hard-earned money went as far as possible. When the workers arrived and would consistently ask to speak to "the man of the house," my mother would patiently reiterate that she was the one in charge and they would be dealing with her. Sometimes, this resulted in further, more persistent demands to speak to her husband. This never resulted in her business—only her frustration.

I have long been curious about how my mother navigated her single motherhood in a time and context when it was less socially acceptable. How was she able to process her experiences of single motherhood in the 1980s and 1990s? How did she navigate a society that actively condemned single mothers? What tools did she have to do so?

Whereas I use language to write about my experiences, my mother used—and continues to use—language to speak in the moment. When I asked her what tools she used to push back against the discrimination she faced, my mother began to laugh, stating simply, "my mouth." I asked her how she used it, and she replied, "I just kept talking.... I didn't give [negativity] the time of day.... If they gave a negative [point of view], I'd put a positive spin on the situation." It is also safe to say that what I construct with words, my mother constructed with her hands. My mother shaped and built our lives to offer me a greater level of privilege than she had. Because my mother laid the groundwork for empowerment, I had a solid foundation upon which to build an empowered life for myself.

In the beginning, my mother did not have any friends who were also single mothers, so she went to a self-esteem group specifically for such women. In this group, mothers discussed the necessity of work as sole caregivers and financial providers for their children. This is the realm in which my mother said she faced most adversity and needed the most help. My mother shared the following.

The group ... [taught us how] ... to be assertive ... so that maybe if you came across some obstacles ... jobs or anything.... Because the biggest thing back then was you have a child, you're not going to get a job, that's the biggest thing.... So being assertive [helped for job interviews]... you don't have to discuss if you

have any children. You can say, "You're not allowed to ask that question."

It is strange to hear my mother reflecting on a time in which she was not yet assertive and needed to learn such skills. Knowing her now, it is hard to imagine.

Not all single-lone mothers experience the same level of success that my mother did. Her story illustrates one single mother's perseverance against increased challenges and the need to learn additional skills in order to navigate unjust and systemic disadvantages faced by single-lone mothers.

When reflecting on how much, if at all, raising a biracial child affected my mother's parenting, she admitted "not at all," which perhaps explains my unresolved relationship with race, specifically regarding early internalized messages that race was not an influence in my experiences as either a mother or a daughter. Many years later, this is important work that I am continuing to work through.

My Story

As public discourse has evolved over the years, some versions of single-lone motherhood have become more acceptable than others. When I became pregnant in the early twenty-first century, I felt acutely aware that my version was not one of them. As a racialized nineteen-year-old, my single-lone motherhood fell into the version of teen motherhood as a social and moral problem: I was viewed as a lazy, immoral teen (Bruno). This meant that I suffered different presumptions and stereotypes, and I was acutely aware of them. Deborah Byrd notes the following:

> Quite a bit of the research on teen mothers—as well as much of the coverage in the media and the news industry—focuses on the negative outcomes of teen motherhood—for the mother, for the child, and for society at large.... As McDermott and Graham so succinctly observe, young mothers tend to be "viewed as both an 'at risk' group within society and 'a risk' to society," a risk that must be monitored and controlled lest the disease (rejection of patriarchal, racist heterosexist norms) spread to other young women. (491-92)

I experienced this attempt at control before my child was even born, when I was called into the vice-principal's office at my high school. She

began her welcome by telling me that because I was pregnant, I may as well just drop out of school—it didn't look like I was going far, anyways. She further announced that my mere presence—my body itself—was setting a negative example for the other teenage girls in the school. I remember watching her speak, trying to arrange my face into one of detached curiosity as I endured this conversation. I calmly replied that I would indeed be continuing my classes at school. I left her office, went to the girls' washroom, and vomited.

Despite this rocky start, I know with certainty that single-lone motherhood changed my life for the better. Noting that considerably less attention has been paid to the positive effects that pregnancy and motherhood can have on young females, Byrd states: "Relatively few scholars emphasize that teen motherhood can be life-enhancing.... We need more qualitative research that gives voice to the many teens who have become more academically ambitious, more responsible, more concerned with having healthy relationships and a healthy lifestyle *after* becoming pregnant or giving birth" (492).

I have long understood that unlike my mother, I grew into my adult self alongside my child; in many ways, my son and I grew up together. My son was largely responsible for all the important decisions I made— he was the centre of all that I did. Nothing was done unless I believed it benefitted him, whether that was attending university, choosing or not choosing a partner, or moving overseas.

Going to university and studying feminism deeply affected how I processed my experiences of single-lone motherhood. In many ways, my choice to pursue postsecondary education was facilitated by my mother and her ongoing determination for me to choose and pursue a career that I loved.

With my son attending daycare on campus, I was often immersed in two worlds simultaneously. I carried not only my book bag but also a diaper bag as well. I chose my path through academia for my son as well as for myself. If I am honest, I also chose it because of those who believed that as a single teen mom, I would not be able to put myself on such a path.

I saw myself in Jennifer Ajandi's research of single mothers attending university, where "many single mother students became activists and advocates against oppression and structured their families to be active in social justice issues" (421). She further notes:

Many of the co-participants in the study were already studying in critical fields such as Social Work, Women and Gender Studies, Aboriginal Studies, Diaspora Studies, and Sociology, or wanted to move into "helping professions." As they put it, having these difficult and rewarding experiences in their lives made them aware of how marginalized people are denied access to resources and are stigmatized in society. Their own struggles gave them a unique perspective with respect to understanding of, identification with, and empathy toward those experiencing barriers. (423)

It is perhaps because of the challenges I experienced as a teen single-lone mom that I was primed to experience a high degree of empathy towards those who experience injustice, which led me to pursue a Master of Education in Social Justice Education and to advocate for change in both my professional and private life.

My research about single-lone motherhood in patriarchal contexts also helped me to process my experiences and my lone-mother identity. Examining the structural barriers and discrimination that so many mothers encounter pushed me to write about my own experiences of single-lone motherhood. I do this because I believe sharing true and nuanced accounts of single-lone motherhood can help disrupt damaging—and often unsubstantiated—constructs and narratives of single-lone mothers and their children.

> As we gear up for our rafting experience, the Balinese guide makes his way over to us. "Where's his dad?" he asks. I point to myself. "I'm his dad," I reply.

I have also processed my experiences through my life choices and by seeking out ways to live that feel authentic—even if unconventional. I had not encountered examples of life abroad as a lone mother, so I forged my own way: moving to Asia when my son was eight and travelling continuously, visiting our fiftieth country together when he was fifteen. As I noted in "Single Teen Motherhood and the Good Mother: Feminist Responses":

My son and I were privileged in these experiences, though we experienced them on a shoestring budget that ensured life was still more affordable than owning or renting a home back in

Canada. Such a budget brought with it its own anxieties and burdens. Our travel was always pre-empted by copious amounts of planning time and effort on my part. There was never any escaping that; as a lone mother, it would always be true. (71)

I rejected the notion of finding a partner and a permanent home to settle down in, preferring instead the freedom and joy that came from wandering the globe. I chose to actively live in a way that ensured I could not be pressed into a stereotypical single-parent mould—to give my son the entire world so there could be no doubt in anyone's mind, including my own, that I was enough. In a sense, I also sought to illustrate that one must not always follow the socially prescribed path as though it were the only legitimate one. Rather, I chose to bring my son in closer and to do the opposite of settle down. As I think about the choices I have made, I wonder whether I would have lived this life if my mother had not so positively modelled for me what a single mother is capable of.

Not long after arriving in Sapa, Vietnam, my son and I stepped outside to meet our guides— two H'mong women who offered to share glimpses into their lives amongst the rice terraces. As was often the case when travelling. One of the women inevitably asked where my husband was. "I don't have a husband," I replied, and the two women immediately let out whoops of joy. "No husband, that is good, very good," they complimented me. I admitted that it had been going very well for me, yes.

Differing Perspectives

When reflecting on how my mother and I have each navigated our single-lone motherhood journeys differently, my mother said to me, "You want to fix systems, whereas I just wanted to move on." It is true that I tend to look at the larger picture of how and why discrimination against single-lone mothers occurs. I examine the different barriers in place and raise my voice, or pen, to protest against them—whether they be media misrepresentations, structural barriers in the legal system, or the overall lack of support for single-lone mothers and their families. My mother was, in large part by necessity, more individually focussed. As she put it, "I didn't have time for people to have negative thoughts about me—I had to work, I had to look after you."

My mother did not have the time, social context, or formal education that I later did to step outside of her own individual experiences to look at how single mothers were unfairly treated as a whole. What she did have, however, was the willingness, resourcefulness, and strength to do what she felt was best. Whereas she was predominantly immersed in our journey, I swept outwards, largely because I had a framework to do so—a direct result of my mother's decisions and support for me—and, at least to some degree, a society that more willingly allowed for such criticism.

Part Two: Ripple Effects

Regardless of our different life experiences and views about single-lone motherhood, my mother continually encouraged me to become an empowered woman and parent. Although there are parallels in our parenting journeys, I did not become a single-lone mother because my mother was one. As I have written elsewhere: "My single parenthood had a lot less to do with how my own single mother raised me or what type of person I was and a lot more to do with the biological father of my child, who chose to leave when I was pregnant" (Steer 156).

It is tiresome how often single motherhood is attributed to some perceived failing on the part of the mother (or the mother's mother) who stays to do the hard—and deeply rewarding—work of parenting, as opposed to that of the absent biological father. I no longer wonder at the origin of my ability to steadfastly and contentedly remain a single-lone mother. I credit this to being raised by my own single-lone mother—an experience that left me feeling incredibly well rounded, secure, and loved.

As a child, I had a front-row seat to my mother's constant demonstrations of strong independence and resilience. Seeing firsthand what she was capable of somehow taught me that if she could be a successful single-lone mother, then as her daughter, I could, as well. Teaching me resilience, modelling it to me directly, and paving the way for me to follow in her footsteps is part of my mother's legacy.

Writing this chapter has provided me a greater understanding of how my own single mother became my inspiration for raising my son. I can see now that I have raised my son similarly to how my mother raised me. It has given me some comfort to know that an approach that worked so well for her has, to the best of my abilities, been replicated in a sense, with many of the same values that were passed down to me by my mother.

I reflect now upon my mother's path and how her experiences helped prepare her to support me in navigating a similar path. I also reflect upon my grandfather's embrace of a child he was never directly told about but still held the day she was born and loved every day since. I think about how he welcomed his daughter and granddaughter into his house and how he helped to raise and shelter me as my mother later would my son—but that is a different story for another day.

So, I cannot help but believe that perhaps my mother and I were meant to be single-lone mothers—that having this family structure modelled to me so directly was a major reason why I knew that I could not only raise my child alone but also raise him well. Perhaps my mother was meant to be a single-lone mother so that she could later help me navigate that path myself. With such assurance already in the foundational years of my own childhood and having been raised in a household where I received everything I needed and then some, it was not a question of if I could do it or if I would be good enough, but rather if I wanted to do it this way.

New Understandings

As Lee Murray states, "Single mothering is complex and messy, and it is also wonderful, rewarding, and even desirable" (189). It was my own wonderful childhood that ensured I never questioned that my son would grow up to be a well-rounded and incredible human, regardless of the number of parents or genders he encountered in our household. And so, I continue to challenge the dominant discourse and myths surrounding single-lone motherhood and suggest, instead, that households such as ours are marked by knowledge, strength, and empowerment:

> We need to create a new narrative of single mothers that reflects the strengths and possibilities of single mothering; challenges the dominant discourse and recognizes the positive impacts of the experience; recognizes that children can thrive in single mother households; supports the positive characteristics of single mothering, as opposed to the negative consequences of single mothering put forth by the dominant discourse; and recognizes single mothers and their children as legitimate family units. (Murray 189-90)

Indeed, I know from personal experience that, despite the additional challenges that single-lone mothers are forced to navigate, single-lone mother households are just as constructive and healthy as two-parent households can be (Ajandi). Perhaps, as we continue telling our stories, we can discover not what is missing in our families, but what can be found.

Works Cited

Ajandi, Jennifer. "Single Mothers by Choice: Disrupting Dominant Discourses of the Family through Social Justice Alternatives." *International Journal of Child, Youth and Family Studies*, vol. 43, no. 4 2011, pp. 410-31.

Bruno, Elizabeth. "Her Cape Is at the Cleaners: Searching for Single Motherhood in a Culture of Self Sufficiency." *Mothers, Mothering and Motherhood across Cultural Differences*, edited by Andrea O'Reilly, Demeter Press, 2014, pp. 385-412.

Byrd, Deborah. "Young Mothers and the Age-Old Problems of Sexism, Racism, Classism, Family Dysfunction and Violence." *Mothers, Mothering and Motherhood across Cultural Differences*, edited by Andrea O'Reilly, Demeter Press, 2014, pp. 487-505.

McAdams, Dan. *Stories We Live By: Personal Myths and the Making of the Self.* William Morrow, 1993.

Motapanyane, Maki. "Introduction." *Motherhood and Single-Lone Parenting*, edited by Maki Motapanyane, Demeter Press, 2016, pp. 1-16.

Murray, Lee. "The Lone Ranger—Then and Now.". *Motherhood and Single-Lone Parenting*, edited by Maki Motapanyane, Demeter Press, 2016, pp. 177-92.

Steer, Natasha. "Great Lakes to Great Walls: Reflections of a Single Mom on Young Motherhood and Living Overseas." *Motherhood and Single-Lone Parenting*, edited by Maki Motapanyane, Demeter Press, 2016, pp. 155-76.

Steer, Natasha. "Single Teen Motherhood and the Good Mother: Feminist Responses." *Coming Into Being*, edited by Andrea O'Reilly, Fiona Joy Green, and Victoria Bailey, Demeter Press, 2023, pp. 57-73.

Small choices—
defy imagination.

Story Ten

I Hope You Dance

Zoe Oliveira

Foreword: The following stories will in no way matter to anyone else. That is the point.

~

"You all danced," my boyfriend laughed. He was, undoubtedly, right. Among the many things that my mother has passed down to my younger sister and me, a love for music (and the singing and dancing that comes with it) was undoubtable. I was lucky enough to grow up in a house where the kitchen doubled as a dance floor, spontaneous singing was met with applause, and music blasted unashamed from various speakers and radios. Despite the varied interests and hobbies my siblings and I have taken on as we grow, this has not failed to change.

This moment was a prime example of that. We were soaking up the early sunrays of summer in the backyard; my boyfriend and I were seated in the sun, my mother was attempting to hide from it on the porch swing, and my sister was in charge of the music from her seat by the pool. The four of us were not at all involved in conversation; we were barely even looking at one another (although I do promise we quite enjoy one another's company) when the song came on.

But the reaction when it did was instantaneous. It was a familiar beat—a nostalgic, sudden instrumental kick, which led right into the heart of the song. Had it not been for my mom, and her mutual love of singing, dancing, and chick flicks, I doubt we would have ever recognized the 1960s Motown tune. Thankfully, *Dirty Dancing* and its stellar soundtrack are no foreign concept in my household.

I do not know who reacted first; as I said, we were hardly paying one another any attention. It was my boyfriend who noticed it: the way that three of us reacted with the same, swaying arms and snapping fingers when the opening notes poured through the speakers. He laughed, amused by our shared thought process, and at the time I did, too, because who would think that a minuscule moment, in the span of an entire day, would matter in the grand scheme of anything, let alone parenting?

In all likelihood, to anyone else, it does not matter. But to me, my sister, and my mom, it did. It does. And that tiny notion, that idea, made all the difference.

~

In elementary school, I remember being given a survey to fill out. It asked how many nights per week you had dinner as a family. My pencil smeared through the bubble marking the "five nights plus" option. I remember being shocked to learn that that was not something other kids in my class did regularly—that dinner as a family was not a frequent occasion in everyone's household and that they did not sit, talk, and learn about one another's day or debate and discuss news and events.

My mom was born in Canada and grew up in Portugal before moving to Toronto when she was sixteen. As was such for many young girls in Portugal in the 1980s, my mom was religiously taught the importance of keeping a household, cleaning, cooking, sewing, laundry, shopping, gardening, and the like. She worked as well upon moving to Toronto in the spring of 1990 and continued to do so until she had two children, my brother and me, and was no longer able. It was at that point she and my dad decided that he would work, and she would stay at home with us.

Thirteen months after giving birth to me, my mom would give birth to my sister. She would not return to work for nearly twenty years, by which point, all three of us were grown and more than capable of taking care of ourselves. Within those twenty years, my mom never failed to be present, which some might assume obvious given that she stayed at home. But I would beg to differ. At no point was my mom required to ask what we learned at school or how our days went. There was no rule that says she should make us smoothies or ensure we had healthy snacks. She never had to help with homework, did not ever formally agree to being told a plethora of random stories from school, and certainly did not have to expel any additional energy dancing with us, singing, or playing, especially not when she had a million things to do herself.

I am not an argumentative person and am never the first to rush into conflict. But if anyone were to make the argument that stay-at-home moms do not work, I would be the first in line to rebut, armed with a list of stringent arguments speaking to the never-ending work of mothers. A list that my mom undoubtedly would give her opinion on—a list she happily would have listened to despite having a never-ending to-do list of her own.

In all her effort and grace, my mom made the miniscule moments that do not count for many, count for us. I will take on anyone who tries to tell me that was worth nothing.

After all, the little things can be the big things.

~

When my mom was living in Portugal, she was a part of her church choir, where she nurtured her talent, and love, for singing—a love that was dutifully passed, in every natural way, onto my brother, sister and me.

Long before iPhones and Bluetooth speakers, music flooded my family home in various ways. There was my mom's extensive CD collection, the stereo, as well as various radios. When we were little, we started small; while my mom was cleaning, she would play CDs and patiently teach us how to dance to Portuguese music across her bedroom floor. The same Christmas CDs have been played so much in my house that to this day, when I hear the closing notes of "I Want a Hippopotamus for Christmas," I am automatically waiting for "Silver Bells" to play next. Long car rides to visit relatives were flooded with songs from the 1970s, 1980s, and 1990s and when my sister and I got into *Glee* and their many covers, my mom faithfully joined us.

It is almost no wonder that upon entering high school, my sister and I would become involved with the school musical productions. Naturally, after several years of consistently attending the shows, my sister jumped right in as a lead in the cast. As the shyer one of the family, I did stage crew before joining the cast the following year.

Regardless of the roles we played, my mom was undyingly supportive. She picked us up, as well as other castmates, twice a week after 9:00 p.m. rehearsals. She listened to our rehearsal woes and religiously sang along to the same soundtrack for the eight months spent preparing for the performance.

Every show night, I could count on looking up (regardless of whether

I was standing on stage or working the soundboard) and finding my mother in the crowd. There, she would not only be applauding and cheering but also singing along to the very words we sang, and through that, she taught me one of the most important lessons of all: You show up for the people you love.

Side note: to this day, despite both my sister and I having graduated from high school, my mom still watches our performance recordings, and will happily listen- and sing along- to the songs.

~

As a stay-at-home mom with three young children, my mother never failed to make life interesting. She was busy—that was undeniable—but never so busy that she could not feed our imagination. I was young, but for whatever reason, I have a vivid memory of her helping us make paper-towel tube snakes that could coil around our arms. I can recall her sitting in the pool, a woman who does not like the water, and happily rating our dives on a scale of one to ten, as if we were in the Olympics and not our backyard. I remember the joy of serving her in my imaginary outdoor restaurant and how she actually paid for her grass meal. One can only imagine the never-ending stream of children's movies that she watched over and over and over.

One memory stands out to me in particular from many years ago, when we lived in Oakville. In all honesty, I do not remember planning the picnic. I do not remember why we were having one or what we were going to eat. All I remember was my disappointment because it rained. I remember standing in our living room and looking out the window at the world painted in shades of grey. Instead of letting the picnic dream fade away or trying to distract my siblings and me with another activity, Mom simply laid out the picnic blanket on the living room floor.

Like I said, the details of this memory are fuzzy; I do not remember what we ate, although I can imagine it was some mixture of kid-friendly snacks, and I do not remember how long we were there. I do not remember why the picnic was important or what we talked about as we sat on that polka-dot blanket in the living room. Quite frankly, I do not think it matters. The moral of the story is exactly what I remember and exactly what my mother taught me that day: You sometimes have to picnic, and maybe even dance, in the rain.

~

For the past several years, now that I am older, grocery shopping has become a task that my mom and I do together. When I was a kid, there was not necessarily a choice; we were too young to be at home alone and had to tag along. But as I got older, marathon grocery trips to various stores in town were something I joined willingly.

I attribute this willingness to several factors. First and foremost, I do not feel as though my mom should have to go alone. During the summers, when I was home from school, I was available and willing to help with the careful selecting, bagging, and loading and unloading process that is grocery shopping for my family. To this day, I am still the proud packer of our freezer, which is not always an easy feat.

Second, I rather enjoy the time spent with my mom. It allows us to talk and hardly ever just about the items on our shopping list. Driving from store to store and hunting down our desired purchases creates ample time for conversation. Everything from school, the future, dinner plans, relationships, family get togethers/drama, party planning, and life in general has been discussed along the freezer aisles and in produce sections of various stores, and although that may sound silly, I can firmly attest to the good it has done us.

Last, shopping with my mom meant learning for myself. I know to test the shopping cart for wayward wheels prior to being halfway down an aisle and becoming frustrated with its rogue tendencies. I know one should grab produce first and frozen items last, but that frozen items should be the first past the cashier, followed by heavier items like cans and boxes. I know to pack eggs on top of any bag and that bread should be packed last to avoid squishing it. I know that reusable bags save both money and the environment, and although absolutely none of this seems important in terms of life, I would argue that it is.

Test the shopping cart before you grab it.

Think before you act.

Grab frozen items last.

Be understanding when things are sensitive and treat them respectfully.

Place eggs on top of heavier items.

Take great care of what is valuable to you.

This is why we so studiously grocery shop in the first place. This is why my mom does anything in the first place, regardless of whether it is singing and dancing in the kitchen, labouring over a family dinner, or picnicking in the living room. You take care of what is most valuable to you, and in my mom's house, that is always the people you love.

And one day, in my own house, I hope to teach my children the very same thing.

~

Postface: The above stories matter to those who matter to my mom. That is the point.

Part Three

Paying Homage to Our Literary and Popular Culture Boundary-Busting Mamas

Psychological tensions,
surprise elements,
confusing plotlines.
A necessary exposition and extrication.

"They Both Begin with Blood, Pain, and Terror":

Transgressing Normative Motherhood in and through the Contemporary Psychological Thriller, *The Perfect Mother* by Aimee Molloy, *Little Voices* by Vanessa Lillie, and *Little Disasters* by Sarah Vaughan

Andrea O'Reilly

The intent of this collection is to explore how and why mothers transgress normative motherhood, reclaim their experience of parenting and womanhood, and rewrite possibilities for future generations of mothers. This chapter considers how three contemporary mother-writers employ the genre of the psychological thriller to position their mother protagonists as "boundary-busting mamas" and portray mothering outside the lines of conventional motherhood. The three novels examined are *The Perfect Mother* by Aimee Molloy (2018), *Little Voices* by Vanessa Lillie (2019), and *Little Disasters* by Sarah Vaughan (2020). Often referred to as "mum noirs" (Allen; Corcoran; Sullivan), the three novels examine "the dark side of motherhood," with an emphasis on the especially difficult early days of motherhood (Corcoran). Mum noirs have been accused of "pregsploitation"—that is, portraying pregnant and postpartum mothers as "wildly impulsive, unable to control themselves,

... the villain of many stories" (Andersen) and psychopaths and stalkers. Such portrayals could result in, as Jane Sullivan notes, "blaming the victim or causing readers to become insensitive to mothers' real needs and challenges." As Vicky Allen emphasizes, however, "What is important in these books is not so much the overall message, but the way they evoke certain feelings and dislocations in the transition [to motherhood]." This chapter considers how three mother-writers transgress normative motherhood through evoking and excavating troubling and troubled maternal feelings and how the genre of the psychological thriller renders these dislocations of normative motherhood possible.

Reflecting on *Little Disasters*, author Sarah Vaughan argues as follows: "Motherhood is an area that is ripe to be explored in psychological suspense and crime fiction. After all, it begins with blood, pain, and terror." She asserts that "Nowhere is the willingness to be brutally honest clearer than in psychological suspense which often probes the darkest reaches of our psyches and delights in tackling taboo subjects." Thus, all three authors probe the maternal psyche to reveal what patriarchal culture denies: maternal ambivalence, anxiety, apprehension, aversion, regret, reluctance, indecision, and uncertainty. Molly, Lillie, and Vaughan employ the tropes of the psychological thriller genre to convey and confirm these tabooed maternal sentiments to validate and vindicate the mothers' experiences of them and to critique and challenge the normative institution of motherhood, which denies and disparages them in its idealization and naturalization of maternity. I intend to show how psychological tension—particularly maternal dread and anxiety as experienced by the mother protagonist—an element of shock or incomprehension, through what I am calling the "deviant baby trope," and a plot twist at the conclusion of the novel make possible a mothering outside the lines that transgresses the scripts of normative motherhood.

The Perfect Mother: "The House Is Haunted"

The Perfect Mother recounts the interactions of a group of new mothers who all gave birth in May; calling themselves the "May Mothers," they often gather at a local park, communicate through an email newsletter, and offer one another friendship and support. The narratives of these stereotypical mothers are highlighted throughout the novel: Frances, the "Miss-Eager-to-Be-Liked" group mascot, who is a stay-at-home

mother (7); Collette, "the pretty trusted friend who is a writer" (7); Nell, who is British, cool, eschews "the books and expert advice" (7), and works as a curator at an art gallery; and Winnie, the quiet, aloof, and beautiful single mother who we later learn was a famous actress as a teenager. One evening, while the mothers spend time away from their children to celebrate the Fourth of July at a local bar, Winnie's baby, Midas, who was left under the care of a babysitter, is kidnapped from her home.

Frances, Collette, and Nell serve as the novel's narrators; the epilogue is narrated by Winnie. Seven short chapters are narrated by an unknown member of the May Mothers group, whom we later learn is Scarlett. Aimee Molloy explains that the inspiration for the novel came from her own experience with her September Mothers Group: "I had no family around to help, and very little experience with infants and this group became my lifeline.... I was blown away by the generosity and encouragement the mothers showed one another" (BookTrib). Molloy often wondered what would happen if a baby went missing: Would the mothers band together to find the baby? Although the novel is marketed as a thriller, Molloy describes her book as "a quiet meditation on motherhood" and explains that her intent was to explore "the pressures women face after becoming a mom" (BookTrib) and to offer "a feminist look at what it means to be a woman today" (Abby). I suggest that the thriller genre enables Molloy to authentically explore women's experiences of mothering and deliver a feminist critique of normative motherhood.

Lily Meyer argues that *The Perfect Mother* conveys two horrors: "[an] it-could-happen-to-anyone kidnapping of a baby, and a second one.... Every woman in *The Perfect Mother* is haunted and hunted by the pressure to be exactly what the title suggests." The psychological tensions of maternal anxiety, apprehension, doubt, and guilt are conveyed and developed through multiple perspectives and characters, which Molloy explains "are probably all elements of me and my own anxieties about motherhood" (qtd. in Greenblatt). From Nell's guilt about having to return to work when her baby is a few weeks old, Collette's worries about her baby's development, and Frances's loneliness as a stay-at-home mother, the novel explores, as Leah Greenblatt notes, "the pressures women face—from within and without—to pull it all off." Frances reflects that "It had been months since she'd been by herself for more than fifteen minutes" (158) and Collette ruminates, "Why does everybody

like to tell new mothers what we're about to gain? Why does nobody want to talk about what we have to lose?" (69). When Nell returns to work and a colleague asks how she is doing, Nell wills herself not to cry in public, limiting her tears "to the fifteen minutes three times a day she'll spend on the toilet, staring at photos of Beatrice [her daughter] as she pumps her milk" (145). Later, Collette, in tears, says to Scarlett: "To be honest, I'm a little overwhelmed right now. The baby's been up at night a lot, and it's difficult because Lowell [her husband] needs his sleep" (198). When Scarlett looks at Collette with a horrified expression, she reflects how she must look "standing in IKEA, wearing a stained and wrinkled top she pulled from the laundry basket, her hair a mess, growing hysterical in the rug section" (197). Later in the novel, when the media suggests that if Midas is found, he should be taken away from Winnie because she is not fit to be a mother, Collette reacts: "Don't they know how hard all of this is? The pressure of just keeping these babies alive. The task of loving someone like this, and how easy it is to fuck this up.... Some days I honestly think I'm going to fall apart. I'm so bloody tired" (177). Indeed, as Winnie comments to Frances, "These May Mothers try very hard to make it look easy, but don't let them fool you. This isn't easy for any of them. Trust me" (53).

The pressures mothers face, as Greenblatt notes, are from within and without: Alongside the interior guilt and doubt, there is exterior blame and judgment. In *The Perfect Mother*, the character Patricia Faith, a cable news reporter, enacts and symbolizes, as Molloy explains, "a composite of all the judgement that [mothers] often feel and all the pressures put on us to live up to a society's ideas of what being a mother means." When a photograph surfaces of the May Mothers drinking at the bar the evening Midas is kidnapped, Faith asks the following on her news show: "What does a photo like this mean? Does it, and should it change the story? A new mother, just a few weeks post-partum, and she leaves her baby at home to act like *this*? Is *this* the definition of modern motherhood?" (143). For Faith, a missing baby, while tragic, marks "the chickens coming home to roost on this idea that women need to 'have it all'" (144). Moreover, each chapter opens with insipid advice and assumptions from the May Mothers newsletter, suggesting on day fifty-three, for example, that "co-sleeping creates a very special bond. Plus, who doesn't love a good middle-of-the-night snuggle or two?" (67) and on day fifty-five that your "baby's first smile will make you leap with joy

even if you've had your worse night ever" (100). The novel interrupts and disrupts the social narrative of normative motherhood as conveyed in the moralizing newsletter's advice and assumptions, Faith's censure and in the mothers' interior psychological tensions of lived motherhood. And its real and messy truths.

The thriller genre's convention of using psychological tension makes possible authentic renditions of mothering alongside a critique of normative motherhood. I suggest, however, that in this novel, these aims are most fully and forcefully conveyed and delivered in the two other genre's conventions: the element of shock through what I have termed the "deviant baby trope" and the surprise ending. Indeed, the plot, as Elizabeth Holly comments, "exposes the pressures of being the perfect mother which is unobtainable but drives women crazy (literally and figuratively)." Scarlett is the perfect mother in *The Perfect Mother*. After Collette cries in front of Scarlett at their chance meeting in IKEA, she questions herself: "Why did I do that? Scarlett is so put together, so confident—a house in Westchester. Buying new furniture. Yet another mother with an easy baby and seemingly ideal life" (198). As the other mothers mentally suffer in trying to be the good mother of normative motherhood, Scarlett goes insane in her pursuit of the ideal. By the end of the novel, we learn that it was Scarlett who kidnapped Winnie's Midas and that the baby she brought with her to the May Mothers gatherings was in fact a porcelain doll. In the end, we learn that Scarlett's baby, Joshua, suffocated during delivery; Scarlett felt tremendous guilt: "I was so careful during pregnancy. I did everything I could to keep him safe. I don't know what happened. I didn't mean to hurt him" (299). Scarlett did not register the death of her child and made Winnie's kidnapped baby a surrogate for Joshua; her plans were to go somewhere where "they could lose themselves, start over ... [and] never be found" (274). With this revelation, the reader realizes that the unnamed narrator is Scarlett, the woman who "tried to be a good mother; did her best" (81) but feels great sadness, failure, as well as "the guilt of being such an imperfect mother" (171). As the point of view shifts to Scarlett upon the arrival of the May Mothers in her apartment, we learn that Scarlett was both abused by her father and abandoned by the father of her baby, a married man and Scarlett's psychiatrist. Scarlett discloses that she was the one who sent the picture of the mothers at the bar to the media and who both discovered and circulated Daniel's (a father

member of their group) criminal record to cast suspicion on him for the kidnapping of Midas. And, finally, Scarlett confesses to murdering Hector, a groundskeeper for Winnie's family estate, who arrived unexpectedly at the family home to discover Scarlett there with Midas. As readers, we come to realize that the novel's opening fourteen-month retrospective chapter was written by Scarlett from her prison cell; she explains that she went to the May Mothers meetings "hoping to find something in common [with the mothers] that might help lift the darkness of these first few months; that it will get easier" (9). But Scarlett realized that things did not: "I've been blamed for that Fourth of July night. But not a day goes by that I don't remind myself of the truth. It's not my fault. It's theirs" (9).

Scarlett is a woman, Meyer explains, "who is driven insane by expectations—her own and everyone else's." She continues: "She's so desperate to be a perfect mother that she ends up possessed by perfection. She hallucinates, dissociates, and commits terrible crimes in its service. And for a long time, no one can tell. Her friends find her performance of motherhood intimidating" and "to the rest of the world, she's just another Brooklyn mom." That this normal and ideal mother is, in fact, a kidnapper and murderer—who is driven insane by her pursuit to be the perfect mother—and that no one notices or suspects that she is mothering a doll in a carriage is certainly a searing critique of normative motherhood. Significantly, by the end of the novel, Nell, Collette, and Frances come to create lives for themselves outside and beyond the lines scripted for them by the narratives of normative womanhood and motherhood; Nell stands up to her boss when he tries to fire her; Collette gives up her job as a ghost writer to return to her own writing; and Frances chooses to use formula for her second baby, telling her friends, "I'm doing it differently this time. No more perfect mother" (316). As Meyer elaborates, "Molloy uses the drama of the kidnapping plot to shake readers awake. Her real goal is to show us the demons of motherhood in broad daylight, to make us admit the house is haunted." Through the thriller genre conventions of psychological tension, the shock of the phantom baby, and the surprise ending—in this case that the ideal mother is indeed a kidnapper and murderer—The Perfect Mother undoes its very title.

Little Voices: "The Terrors of Motherhood"

Little Voices is told from the perspective of Devon, a new mother who is experiencing postpartum depression and whose close friend Belina was murdered the same evening Devon went into labour. The plot centres on Devon's attempts to exonerate her friend Alec who has been charged with Belina's murder and to find out the who and why of her death. Devon constantly hears voices that judge and blame her as an unfit mother. As Lillie explains in an interview: "I wrote about a struggling new mother because I was one. I had a newborn who fought sleep at every opportunity, and I was both elated and terrified by the shape of my new life and title: Mom. I really longed for a story that focused on this strange and euphoric (and often scary) phase of life" (qtd. in K. L. Romo). Lillie emphasizes that she "needed to write about it and express it" (qtd. in Yvonne). She continues: "You're naming a problem. There's power to that. Maybe it's that it takes the power away from the emotion. You can take it back and get some sense of control" (qtd. in Owens). Lillie explains how her own difficult experiences along with the prevalence of postpartum depression made her want to read a book "about the psychological complexities new parents face: terror and elation, exhaustion and euphoria, isolation despite constant physical contact, loneliness while never being alone" (qtd. in Yvonne). When asked to succinctly describe her novel, Lillie responds, "The terrors of motherhood" (qtd. in McDonald). Not surprisingly then, Lillie charts the "difficult paths motherhood takes us down through a dark and twisty thriller" (qtd. in Yvonne). As a lover of the thriller genre, Lillie explains that she "wanted to see a new mother at the heart of a thriller: to take the difficult and scary parts of being a new mom and explore them within that genre" (qtd. in Peterson). Reading recent thrillers with mothers as their central characters—such as The Perfect Mother, which has new mothers solving a crime—affirmed for Lillie that people want to read these stories (Romo), so Lillie wrote this novel about a new mother "pumping milk for her baby and solving a crime at the same time" (qtd. in Peterson).

Like The Perfect Mother, Little Voices employs the maternal thriller's conventions of psychological tension, the surprise element of a deviant baby trope, and the twist ending to authentically convey Devon's maternal feelings and develop an astute critique of normative motherhood. With Little Voices, this is most fully and forcefully developed through the portrayal of the psychological tension experienced by Devon as the novel

"pits her desire to be a good mother against paralyzing internal doubt" (Romo). After a traumatic birth, an emergency caesarean section, and the birth of her daughter, who weighed just over two pounds, Devon is discharged from hospital eight weeks after she and the baby almost died. She is unable to breastfeed and must pump her milk (the significance of this is examined later in the discussion of the twist ending), which makes her acknowledge that "Pumping was the only action that signified my new-mother status" (8). After the birth, Devon begins to hear a voice "that is shocking and unsettling but not unfamiliar" (9). She explains: "It's older and wiser than I remember. These are new, vicious judgements about my motherhood failings. The worse part is, sometimes, the voice is right" (9). Devon becomes convinced that her baby hates the look of her, her smell, the taste of her breast milk. She wants to be a good mother more than anything and does not accept this failure. The judgment of the voice and the self-blame it evokes are relentless. When Devon enters her daughter's nursery, the voice asserts: "No photos on the wall. Changing pad isn't secured to the table. She'll be needing three-month clothes soon. Other moms, good moms, they'd have it done. You don't love her enough" (10). Later when Ester, her daughter, wakes during the night while her husband continues sleeping, the voice admonishes her: "You wanted this before either of you were ready. Before you deserved to be a mother" (65). When Devon first visits her friend Alec, the voice warns: "He'll see what a terrible mother you are. What an awful child you had" (22). As she reflects on her postpartum body, which does not feel like her own, Devon's mind "is invaded by the voice," causing her to feel "a double punch of guilt as she wanted to be a woman who sees herself as strong because of what she endured" (29). Because of the voices she hears, Devon is portrayed and positioned as an unreliable narrator. But, as Lillie explains, this was intentional: "As a new mom, I felt unreliable. Not only because of my own doubts, but because of society as a whole. Every decision was an opportunity for judgement, from how I fed my baby to how my baby slept to whether or not he should have a damn hat on his head. I had no idea what I was doing" (qtd. in Romo). It is the very unreliability of Devon's perspective, caused by the doubting voice, that allows the novel to capture and convey the psychological tensions—the disorientations and apprehensions—women experience as they become mothers. The voice both enacting and signifying Devon's postpartum psychosis allows the

author, as Kathy Morelli emphasizes, "to accurately and compassionately depict its symptoms: the anxiety, the paranoia, the delusions, the crippling self-doubt, the fear, and the shame."

Following her visit with Alec and her promise to him that she would find out who killed Belina, Devon remembers that the last time she and Belina met, Belina had left her day planner on the bench. Devon is convinced that Belina left the day planner as evidence to clear Alec and point to the real killer; although the voice warns: "You'll never be able to do it" (45), Devon is determined to prove that she can do it "with a certainty I don't have but will need to resurrect" (38). Before the birth of her daughter Ester, Devon was a lawyer specializing in tax fraud. With resolve, Devon recalls that version of herself: "I picture her process, how well she operated" (49). Later, when Devon watches a news story on the unsolved murder with clips of Belina, she feels remorse for not doing more to help her but then tells herself: "I have to hold my breath to get control. I fight these emotions. I fight this voice" (54). Nevertheless, after promising Alec that she would help him and trying to find her new self to do so (65), the voice reproaches Devon: "Five days of failure. Five days of being selfish. Taking time away from your too-tiny baby. For what?" (65). However, as Devon's investigation continues, the voice is less heard, and when it is, its criticism is less about Devon's mothering and more about her current investigative work and the sexual assault she experienced as a child. Indeed, Devon investigated Belina's murder because she wanted to be closer to who she was before: I hope he [her husband] sees the old me. Realizes that she's still there" (17). Lillie was drawn to this idea of returning to yourself: "I longed to read about a journey of a woman returning to herself because a lot of what stressed me out about being a new mom (which I loved) was that my life was suddenly radically different. The person I was before seemed far away, and I missed that version of myself, so I wanted to explore how we uncover our new self that is near who we were before" (qtd. in Romo). Devon returns to her old self precisely to solve the mystery of her friend's death. In this, Lillie explains her protagonist's purposes: "She wanted readers, particularly those who are parents, to feel empowered by her journey as well as sympathize with her struggles" (qtd. in McDonald).

Significantly, as Devon's gradual return to her old self quiets the censorious voice and gives her the confidence to undertake the investigative work, the solving of the crime delivers Devon to a new self. This

transformation is achieved and signified through the maternal thriller conventions of the shock of the deviant baby trope and the surprise ending. Devon brings her baby, Ester, with her, wrapped in a snuggly, when she confronts Ricky, the man who had actually murdered Belina. Devon stabs Ricky and leaves him to bleed on the floor; she then drops the police wire she was wearing and Ester to the floor and realizes that "All the voices have stopped" (310). Instead of her baby on the floor, there is a doll that Devon had believed was a baby for the last two months.

The following chapter opens with Devon's reflection: "The voice was wrong. I am not a terrible mother. In fact, I'm not a mother at all" (311). Devon finally remembered that her daughter died in childbirth: "And then everything went black" (313). Devon had cried for her daughter for weeks until her husband Jack said, "Do you want to hold our daughter?" (313). Jack explains to Devon that he did not know what else to do: "I needed you to come back to me ... and when I handed you that doll you were there for the first time since she died" (313-314). Significantly, Devon responds: "You did the right thing. *I am here now*" (my emphasis, 314). The final chapter concludes with Devon wrapping the doll in a blanket one last time, kissing the top of her head, and dropping her into the water. In the epilogue, Devon tells us that "the voice has stayed silent, but she has not" (319). Now in therapy, Devon understands that she experienced postpartum psychosis and that her childhood trauma of sexual abuse caused her to see Ester as real. The novel concludes with a postscript on the prevalence of postpartum depression, a link to resources, and the words: "There is no reason to suffer in silence and solitude. It's not your fault, and you are not to blame."

In *The Perfect Mother*, Scarlett knows that her baby is not real and the trope of the phantom baby and the surprise ending—that the perfect mother Scarlett is a kidnapper and murderer—are employed to refute societal myths of the perfect mother. In *Little Voices*, meanwhile, the phantom baby and the surprise ending—that Devon lost her baby and was instead mothering a doll—are utilized to show the psychological harms this perfect mother myth inflicts upon women. When Lillie is asked what she would like readers to glean from the novel, she responds: "Most of us are doing our best, no matter what the voices in our head (or that opinionated lady at Target) says" (qtd. in Romo). In other words, as *The Perfect Mother* undoes its title, the little voices of the novel so named reveal how injurious the pursuit of being this perfect mother is for women.

Little Disasters: "Just How Close to the Edge Motherhood Can Push You"

Little Disasters follows the ten-year friendship of Liz, a paediatrician, and Jess, an affluent stay-at-home mother, whose friendship is tested when Jess brings her baby daughter Betsey for a visit to the hospital. Liz is the attending doctor and becomes suspicious of Betsey's injuries and reports the incident. The novel centres on an investigation of the accident and the gradual and unexpected revealing of the truth. A secondary plot is Liz's traumatic family history and her mother's troubled life, which reveals themes of neglect, abuse, and infanticide. The novel is narrated from the perspective of Liz, Jess, and Ed, Jess's husband. The two storylines, Amanda Barrett argues, "highlight the pressures mothers place on themselves to achieve parenting perfection, the lack of support for mothers, and postnatal depression." Sarah Vaughan, when asked to describe her novel *Little Disasters*, replies, "It is a psychological drama about the darkest reaches of motherhood, about judgement, and about the redemptive power of friendship" ("I Was Meticulous"). In an interview, Vaughan explains that the novel was inspired by her second pregnancy: At nineteen weeks, she was diagnosed with pelvic girdle, which left her bedridden, in chronic pain, and requiring her to quit her job as news reporter. Without her career, Vaughan felt as if she had lost her identity (Cartwright). She also experienced postnatal anxiety and mild maternal obsessive-compulsive disorder, which included intrusive thoughts and, thus, for Vaughan, "it didn't require a huge leap of imagination to be able to think from the point of view of Jess" ("I Was Meticulous"). And while she did not have the extreme, disproportionate thoughts of her protagonist, Vaughan understood how she could: "I was so riddled with doubt and my sense of self was so diminished.... Suddenly, I had nothing to show for my days" (qtd. in Mendez). Vaughan's daughter also suffered from colic and, as she explains in an interview, "I know that feeling of desperation when nothing you try seems to help. Then you realize that parenthood is a leveler—it doesn't matter how in control you were before" (qtd. in Cartwright). *Little Disasters*, Vaughan emphasizes, "explores just how close to the edge motherhood can push you" (qtd. in Cartwright). The novel, thus, for some readers, such as critic Casey Newman, is less a thriller and more "a heartbreaking portrayal of motherhood and how so many things need to be fixed ... to [better] support mothers."

However, I argue that *Little Disasters* is a psychological thriller that employs the genre's conventions to, in Barret's words, "rip open the modern practices and potential myths of present-day parenting." Like *Little Voices*, the novel uses psychological tension as enacted and signified by Jess's postpartum psychosis, and like *The Perfect Mother* and *Little Voices*, it employs the shock elements of the deviant baby trope—in this novel an abused baby—and a twist ending precisely to probe "the darkest reaches of motherhood" ("I Was Meticulous"). Indeed, *Little Disasters* uses thriller conventions to, in Vaughan's words, reveal the "deep and alarming shadows of motherhood" (qtd. in Mendez) and expose the facade of normative motherhood.

Rebecca Munro argues that "Vaughan turns the genre on its head by asking us to consider what it means when the villain lives inside our heads." Like Devon from *Little Voices*, Jess's mind is filled with toxic thoughts: *"You're a bad mother. She'd be better off without you"* (3). She begins to imagine and visualize harming her newborn daughter, Betsey. When she is on the stairs holding Betsey, Jess "was rigid with fear" (88). The narrator continues: "She sees herself dropping Betsey and watching as she bumps, down each step.... Her delicate skull bashes against each slat, until she comes to rest.... The vision consumes her as she stands there, swaying" (88-89). Later, she visualizes "plunging the knife straight into Betsey's tender crown, or her eyes, or her heart" (90) and imagines "the steel pans that hang from the ceiling rack ... falling, even *flying* across the room like child-like missiles" (90). Jess takes precautions, such as wrapping the kitchen knives in tea towels and keeping Betsey away from the kettle's scalding water. But even then, Jess knows that "she could never guarantee Betsey's safety because the greatest threat to her baby is *her*" (90). When her friend Mel confides to Jess that she is sometimes rattled and absentminded with her baby, Jess thinks but cannot say the following: *"Yes, but did you ever imagine killing your baby? Did you check and double-check that you hadn't overdosed her on Calpol; that you hadn't poured bleach into her bottle; that she wasn't being suffocated by soft toys in her crib? That you hadn't inadvertently smothered her?"* (93). Later, when Jess's sister comes to stay with her as Jess's case is being investigated by the police, the protagonist reflects: "This has always been one of my biggest anxieties: the thing that taps into my belief that I am a hopeless mother, incapable of looking after my babies. *The children could be taken away from us*" (109). And she later wonders: "And maybe they

are right to do so. Because I did something terrible, didn't I?" (114).

Significantly, and like *Little Voices* and *The Perfect Mother*, a traumatic birth is central to the plot of *Little Disasters*. Although Jess's daughter Betsey, her third child, does not die in childbirth as do Devon's and Scarlett's, Jess experienced a massive hemorrhage during labour (47). Later, when she is visiting Betsey in hospital, the memory of the traumatic birth "comes in a flash ... knocking her off balance" (182). It was the most horrific sensation of her life; she became "a rag doll—limbs pulled this way and that, and her body an appliance to be delved into" (183). After her surgery, Jess confesses that "It wasn't the pain that made her yelp ... but her overwhelming sense of inadequacy" (183). Although Jess had wanted a natural home birth, she recognizes that "without massive intervention, she would have killed her longed-for baby" (183). From this birth, Jess realizes that "she was potentially destructive and powerless, all at the same time" (185). And like Devon, Jess's traumatic birth is connected to, and likely the cause of, her postpartum psychosis. Indeed, Jess's memory of the powerlessness she experienced in birth interfaces with "the crushing impotence" (185) she feels at not being able to help her injured daughter. Indeed, Jess believes that if it had not been for her, "Betsey would never have had her skull fractured" (185).

Jess's narrative is told only after suspicions about Betsey's accident are shared in Liz's and Ed's narratives. When Jess arrives at the hospital and a bump is discovered on the back of Betsey's head, Jess mentions that her daughter had hit her head while crawling. However, Betsey's injuries do not match the incident described by Jess, and Liz questions why Jess waited six hours to take Betsey to hospital and only mentioned the accident as an afterthought. She further wonders why Jess is being so evasive and defensive "as if there's something that she needs to hide?" (27). Liz reflects, "Under the glare of the fluorescent strip lights, Jess seems more vulnerable, less assured. And very different from the woman I first met ten years ago, who buzzed with excitement at the thought of having her first child" (13). However, Liz tries to reassure herself that "With any other parent these would be red flags but Jess is a long-time friend and loves her children beyond all else" (30). As well Mel, a friend of Jess and Liz, exclaims: "Jess is so child-centric, so calm and yogic, she's the *very last* person who would harm her kids" (75). However, Liz's suspicions do not subside, as she remembers a gathering with their mother friends when Jess shared the news of her third pregnancy and

confessed that she got pregnant on a whim and was slightly apprehensive about how she would cope with three children (177). Liz thinks: "Jess is so controlled and careful that I can't imagine her taking a decision like this so recklessly and muddling through isn't something Jess does" (177-78). Liz recalls another evening when Jess, in extreme drunkenness, confided the following to Liz: "I don't want the responsibility of having any more children.... I think I'd probably kill them if I did.... I think it might just push me over the edge" (275). Similarly, Ed, Jess's husband, thinks: "I have no doubt that Jess adores our children even if she hasn't appeared to enjoy motherhood, or be as engaged with it, since Betsey's birth" (65). He wonders whether "there is something [Jess] is trying to hide" (80). "Unable to shake that suspicion away" and realizing "how little he knew about what the woman lying beside him *did* for fifteen hours a day" (84), Ed opens Jess's laptop to discover in its search engine the question "*Why do I want to harm my baby?*" (86). Liz's and Ed's reflections, which convey doubt and unease, augment the psychological tension of Jess's postpartum psychosis and seem to confirm that Jess indeed has harmed her baby.

However, as with the other two novels, *Little Disasters* employs the psychological thriller trope of the surprise ending to undercut and unravel the assumed conclusion of the novel and the expectations of normative motherhood. The afternoon before Betsey is taken to hospital, Jess is alone with the three children, and fearing that she will act out her visualizations of smashing Betsey against the mantelpiece, she tells her two sons that she is going to the store for milk and leaves the three children alone. When the storekeeper asks where the children are, and as Jess realizes has been gone longer than promised, she runs back home all the while thinking: "*You're a bad, bad mother*" (193). Later that evening, Ed returns home to find Jess asleep in her bed and Betsey in the crib having just been sick; the baby screamed and writhed when he tried to comfort her (63). Worried it may be meningitis, Ed wakes Jess, and she takes Betsey to the hospital. At the hospital, a CT scan shows a skull fracture, and Jess's explanations for how it may have happened are evasive and contradictory. As Liz is interviewing Jess, she surmises that "her look of blankness is really an expression of denial, motivated by fear" (59).

However, as the novel concludes through the plot twist of the psychological thriller genre, we learn that it was Jess's friend Charlotte who

harmed the baby. When Jess is at the store, Charlotte comes to visit Jess to discover the children home alone. She tells Franklin, Jess's son, that his mother is a *"silly, naughty* mummy*"* (401), and as Charlotte is changing Betsey's diaper, Franklin kicks Charlotte in anger, which causes the baby to fall from the changing table. Charlotte warns Franklin that if he tells anyone, his mother will go to prison (404). We also later learn that Charlotte has remained in love with Ed after they briefly kissed in college, and when she meets Ed twenty years later, she fantasizes that they will reunite. However, when Jess announced her third pregnancy, "Charlotte experienced the most irrational rage, not just because she had struggled to have one baby and Jess was effortlessly fertile, not even because Jess dared to appear ambivalent about this child; but because, on some barely acknowledged, completely irrational level, she knew Ed could never be free now" (392).

At the end of the novel, the police are considering charging Charlotte, and she and her husband have removed their son from the school Franklin attends. Like Devon from *Little Voices*, the novel concludes with Jess in therapy after having been diagnosed with extreme postpartum anxiety and maternal OCD. Although Jess is initially reluctant to be so labelled, something in her brain clicked: *"This was a recognized condition? Other people felt like this, too?"* (369). And like *The Perfect Mother*, *Little Disasters* concludes with the mothers together empowered and connected, and ends with Liz's reflection: "I want to remind us all to cherish this. These highs of motherhood that sustain us; that buoy us up when we're exhausted, or anxious, or it all feels like a bit of a struggle; these perfect, necessary moments" (420).

Jess's narrative, as Sonja van der Westhuizen notes, "is an eye-opening account of what many women silently struggle through on their own: the constant feelings of incompetence and unrealistic demands on yourself." Indeed, as Anne Mendez comments, "Women have written to Vaughan saying that *Disasters* helps explain these deep and alarming shadows of motherhood." The women say: "I've never read anything about this before, and I realize I'm not going crazy" (qtd. in Mendez). In reading this novel, as Vaughan explains, "they realize they are not alone anymore" (qtd. in Mendez). I suggest that as *The Perfect Mother* undoes its title and the little voices of the novel so named reveal how injurious the pursuit of being this perfect mother is, this novel exposes all the little disasters caused and created by normative motherhood.

Through the conventions of psychological tension, the shock of the deviant baby trope, and surprise endings, these thrillers convey and confirm that what is to be feared and confronted is normative motherhood itself.

Conclusion: "Compelling Suspense to Show the Extreme Difficulties of Early Motherhood"

This chapter examined how three contemporary mother-writers transgress normative motherhood through evocating and excavating troubling and troubled maternal feelings and explored how the genre of the psychological thriller renders these dislocations of normative motherhood possible. The thriller's conventions of psychological tension, the surprise element of a deviant baby trope, and the twist ending create uncertainty, instability, inconsistency, volatility, variability, and unpredictability. And in so doing, these conventions capture and convey what patriarchal culture denies: maternal ambivalence, anxiety, apprehension, aversion, regret, reluctance, indecision, and uncertainty. Moreover, not only do these three psychological thrillers make possible the representation of tabooed maternal sentiments through its genre tropes, but they also validate and vindicate these sentiments to critique and challenge the normative institution of motherhood that denies and disparages them in its idealization and naturalization of maternity. Indeed, as Vaughan notes, these conventions "make for compelling suspense, as the reader is misdirected while being exposed to an honest exploration of the extreme difficulties of early motherhood" ("Why Motherhood"). That it takes acute psychological tensions, shocking surprise elements—kidnapped, phantom, and abused babies—and confusing plotlines and twist endings shows how hidden the extreme difficulties of early motherhood have become in patriarchal motherhood and how necessary it is to expose and extricate them. Indeed, and as Vaughan notes, "Perhaps in a world where the picturesque posts of mommy bloggers are still an aspiration, this harsh reality check is very much needed" ("Why Motherhood").

Works Cited

Abby. "Author Q&A: Aimee Molloy, *The Perfect Mother*." *Crime by the Book Blog*, 30 Apr. 2018, http://crimebythebook.com/blog/2018/4/30/author-qa-aimee-molloy-the-perfect-mother. Accessed 10 July 2023.

Allen, Vicky. "Mum Noir: Writers Like Ashley Audrain Look at Motherhood's Darkness." *The Herald*, 2 Feb. 2021, https://www.heraldscotland.com/life_style/arts_ents/19032652.mum-noir-writers-like-ashley-audrain-look-motherhoods-darkness/. Accessed 15 July 2023.

Anderson, Dana. "'Pregsploitation': The New Controversy in Media." *Purple Revolver*, 9 July 2020, http://www.purplerevolver.com/movies/tv-series-and-shows/128263-%5Cpregsploitation%5C-the-new-controversy-in-media.html. Accessed 15 July 2023.

Barrett, Amanda. "Book Review: *Little Disasters* by Sarah Vaughan." *Mrs. B's Book Reviews*, 27 Dec. 2020, https://mrsbbookreviews.wordpress.com/2020/12/27/book-review-little-disasters-by-sarah-vaughan/. Accessed 25 May 2021.

BookTrib. "*The Perfect Mother*, Author Aimee Molloy on Blending Genres, Motherhood and Kerry Washington." *Early Bird Books*, 8 May 2018, https://earlybirdbooks.com/aimee-molloy-interview. Accessed 15 July 2023.

Cartwright, Helena. "Bestselling Author, Sarah Vaughan's New Novel, *Little Disasters*, Draws on Her Own Challenging Experiences as a Mother." *Woman and Home*, 29 Apr. 2020, https://www.womanandhome.com/us/life/books/author-sarah-vaughan-novel-little-disasters-356358/. Accessed 15 July 2023.

Corcoran, Caroline. "When Mums Go Bad: How Fiction Became Obsessed with The Dark Side of Motherhood." *Grazia Daily*, 27 Jan. 2021, https://graziadaily.co.uk/life/books/mum-noir-domestic-psychological-thriller/. Accessed 2 Jun. 2021.

Greenblatt, Leah. "Aimee Molloy on her lauded new thriller *The Perfect Mother*—and the Upcoming Kerry Washington Movie Adaptation." *Entertainment Weekly*, 4 May 2018, https://ew.com/books/2018/05/04/perfect-mother-aimee-molloy/. Accessed 15 July 2023.

Holly, Elizabeth. "*The Perfect Mother* by Aimee Molloy." *Elizabeth Holly*, 29 July 2019, https://elizabethholly.com/the-perfect-mother-book-review/. Accessed 15 July 2023.

"I was Meticulous about Doing My Research: Q&A with *Little Disasters* Author, Sarah Vaughan." *Better Reading,* 13 May 2020, https://www. betterreading.com.au/news/author-related/i-was-meticulous-about-doing-my-research-qa-with-little-disasters-author-sarah-vaughan/. Accessed 25 May 2021.

Lillie, Vanessa. *Little Voices.* Thomas and Mercer, 2020.

McDonald, Christina. "Author's Corner—Interview with Vanessa Lillie." *Christina-McDonald.com,* 25 Sept. 2019, https://christina-mc-donald.com/vanessa-lillie/. Accessed 15 July 2023.

Mendez, Anne. "Special Feature: *Little Disasters* by Sarah Vaughan." *The Lit Bitch,* 19 Aug. 2020, https://thelitbitch.com/2020/08/19/special-feature-little-disasters-by-sarah-vaughan/. Accessed 15 July 2023.

Meyer, Lily. "Aimee Molloy's Maternal Horror." *Los Angeles Review of Books,* 13 June 2018, https://lareviewofbooks.org/article/aimee-molloys-maternal-horror/. Accessed 15 July 2023.

Molloy, Aimee. *The Perfect Mother.* Harper, 2018.

Morelli, Kathy. "Book Review: *Little Voices* by Vanessa Lillie." *Birth Touch,* 4 Jan. 2021, https://birthtouch.com/2021/01/book-review-little-voices-by-vanessa-lillie/. Accessed 15 July 2023.

Munro, Rebecca. "*Little Disasters* by Sarah Vaughan." *Book Reporter,* 21 Aug. 2020, https://www.bookreporter.com/reviews/little-disasters. Accessed 15 July 2023.

Newman, Casey. "Book Review: *Little Disasters* by Sarah Vaughan." *Hell Raisers,* 28 Jan. 2021, https://thedevilstrip.com/2021/01/28/book-review-little-disasters-by-sarah-vaughan/. Accessed 15 July 2023.

Owens, Zibby. "Vanessa Lillie, *Little Voices.*" *Moms' Don't Have Time To... Podcast,* 9 Oct. 2019, https://zibbyowens.com/transcript/vanessalillie. Accessed 15 July 2023.

Peterson, Julie. "An Interview with Vanessa Little, Author of *Little Voices.*" *Dead Darlings,* 26 Nov. 2019, https://deaddarlings.com/interview-vanessa-lillie-author-voices/. Accessed 15 July 2023.

Romo, K.L. "Up Close: Vanessa Lillie." *The Big Thrill,* 30 Sept. 2019, https://www.thebigthrill.org/2019/09/up-close-vanessa-lillie/. Accessed 15 July 2023.

Sullivan, Jane. "How Mothers Are Turning to Murder and Mayhem." *The Sydney Morning Herald,* 2 Oct. 2020, https://www.smh.com.au/culture/books/how-mothers-are-turning-to-murder-and-mayhem-20200924-p55ywl.html. Accessed 15 July 2023.

van der Westhuizen, Sonja. "*Little Disasters* by Sarah Vaughan." *Crime Fiction Lover,* 7 Apr. 2020, https://crimefictionlover.com/2020/04/little-disasters-by-sarah-vaughan/. Accessed 15 July 2023.

Vaughan, Sarah. *Little Disasters.* Simon and Schuster, 2020.

Vaughan, Sarah. "Why Motherhood is a Fertile Subject for Crime Fiction." *Crime Reads,* 21 Aug. 2021, https://crimereads.com/why-motherhood-is-a-fertile-subject-for-crime-fiction/. Accessed 15 July 2023.

Yvonne. "In Conversation with Vanessa Lillie, Author of *Little Voices.*" *Fiction Books,* 25 Sept. 2019, https://www.fiction-books.biz/new-authors/in-conversation-withvanessa-lillieauthor-oflittle-voices/. Accessed 15 July 2023.

Boundary busting mothers—
an overlooked and quiet role
leadership for the next generations
in the most difficult of circumstances.

Story Twelve

Creating a Champion for Women: The Transgressive Maternal Practices of Andrea Dworkin's Mother, Sylvia

Valerie Palmer-Mehta

Radical feminist Andrea Dworkin (1946–2005) took the public by storm with her fiery oratory and revolutionary prose decrying heteropatriarchal oppression during the second wave of the United States (US) women's movement. Penning nonfiction books like *Woman Hating* and novels like *Ice and Fire*, "Dworkin was a lucid, scarily persuasive writer" who wanted "nothing less than a total reimagining of the world" (Oyler 3, 8). Dworkin questioned all dimensions of cultural life where she believed "woman hating" was present, prompting Janice Raymond and Patricia Hynes to call her "a teller of truth" who understood the "urgent need for ... the political will to act against the global sexual exploitation of women and children" (21, 24). The vilification she endured because of her challenges to deeply rooted social conventions demonstrated both her mettle and the consequences women face when they operate outside of normative roles. It also is instructive of why so few dare employ their voices to similar ends; indeed, one might argue that there are no comparable feminist orators or writers of her ilk today. But how did Dworkin become this feminist icon? More specifically, where and how did she develop the strong, oppositional identity upon which her approach is based?

I believe the answer to this question lies with her mother, Sylvia

(Spiegel) Dworkin (1914–1991), who challenged Dworkin in ways that cultivated within her the strength and tenacity required to rewrite women's role in public culture. Dworkin has pointed to the physical and sexual violence she personally experienced, the stories of abuse female family members endured in a Nazi concentration camp, and her exposure to radical feminist writings as germinal to her growth into a feminist (see, for example, Dworkin, *Heartbreak* 117-120; Dworkin, *Our Blood*, 5-6). These pivotal influences undoubtedly contributed to her perspective, but I argue that Dworkin's life experiences with Sylvia also added meaningfully to the foundation of her unique approach. Drawing on her personal and public discourses, I argue that Dworkin's contentious but mentally invigorating relationship with her bold, tenacious, and truth-telling mother became the touchstone upon which she would build her oppositional, truth-based ethos and which enabled Dworkin to develop what Dan Michman calls "strategies of perseverance in challenging and dehumanizing circumstances" (194). Sylvia was Dworkin's first penetrating critic and debate partner and fortified her with the resilience, argumentation skills, and critical thinking abilities necessary to survive a life filled with complexity, which set the stage for her resistance to Western norms surrounding gender.

This inquiry into Sylvia Dworkin's boundary-busting approach offers a unique opportunity to investigate the maternal practices of a Jewish mother who helped create the foundation from which the second wave's most intrepid feminist would spring. To explore Sylvia's maternal approach, I examine Dworkin's personal correspondence with her mother, gained from archival research at the Schlesinger Library, and her published works that reference her mother's influence. In taking this approach, I view Sylvia's mothering practices principally through Dworkin's eyes; it is this point of view that enables an understanding of how Sylvia's transgressive maternal practices were absorbed by, and impactful to, her.

Scholars have argued that rigid stereotypes of the Jewish mother have precluded our ability to identify alternative representations of Jewish maternal practices (Lehman, Kanarek, and Bronner 6). Jessica Prinz, for example, posits that US audiences are overwhelmingly presented with a stereotype of the Jewish mother that is marked by qualities such as "excessive worrying about her offspring; overprotecting them; taking excessive pride in them; nagging them, inflicting guilt and food upon

them; and smothering them" (198). Marjorie Lehman, Jane Kanarek, and Simon Bronner register a similar image of a fretful, doting Jewish mother who serves not only as a "guilt-inducing presence to her children" but also as a well of bountiful love and devotion (6). In a context informed by such cultural representations, Joyce Antler asks us to consider the degree to which "the Jewish mother stereotype miss[es] the complexity and diversity of real Jewish mothers" (*You* 3). This investigation, therefore, not only illuminates how Sylvia prepared her daughter to possess the strength and resilience to survive the challenges of her life, but also provides a different pathway to understanding actual Jewish maternal practices and contributes to Jewish maternal studies.

Biographical Information

The daughter of Hungarian Jewish immigrants, Sylvia Spiegel was born in Jersey City, New Jersey in 1914 (Dworkin, *Our Blood* 2).[1] She was part of a large working-class family of seven children—five girls and two boys. As a child, Sylvia suffered from rheumatic fever, a debilitating inflammatory disease affecting the heart, brain, and joints. This illness was the chief cause of mortality for US children and teens in the 1920s, with the only cure at the time being salicylates and extensive bed rest; those hospitalized typically stayed for three to six months (Bland 1190). This hardship in her early care would have lasting consequences. Dworkin observes that "there is no way of knowing of course if my mother's heart would have been injured so badly had she been born into a wealthy family" or "if she would have received different medical treatment had she not been a girl" (*Our Blood* 2).

Sylvia's social class and gender also influenced the opportunities to which she would have access. Although she had a natural affinity for reading, Dworkin observed that "since she was a girl, no one encouraged her to read books ... no one encouraged her to go to college or asked her to consider the problems of the world in which she lived" (Dworkin, *Our Blood* 2). Further, due to the financial position of her family, and the broader impact of the Great Depression, it was expected that Sylvia would work as soon as she completed high school in the early 1930s (2). This left little time or space for Sylvia to pursue her own intellectual or personal interests. Instead, she and her family were focussed on surviving a particularly turbulent decade in the US, when employment rates

were higher than twenty per cent.

Although Sylvia's realm of opportunities had been circumscribed by the expectations of her family and the broader culture, growing up in the 1920s and coming of age in the 1930s enabled her to witness meaningful cultural changes. When she was a child, US women gained the right to vote, and when she was a young woman, Amelia Earhart took her famous flight across the Pacific. Meanwhile, developments in technology enabled the first US-licensed commercial radio broadcast by Pittsburgh's KDKA in 1920. Over seven hundred commercial radio stations would be in place by 1926 and in 1929, *The Rise of the Goldbergs* (1929–1946), a radio serial, debuted. This popular long-running radio show was the first serialized comedy-drama to explore Jewish family life. As noted below, it would expose Sylvia to a strong representation of a Jewish mother in the figure of Molly Goldberg, who became the "standard by which Jewish mothers were measured" (Antler, "Bond" 199). Although Sylvia's approach to mothering was no doubt shaped in part by her own mother's attributes and limitations, each generation is influenced to some extent by the popular culture imagery to which they are exposed. Since television would not reach half of US homes until the mid 1950s, radio would be a dominant force for transmitting cultural values and ideas when Sylvia was coming of age.

In 1943, Sylvia married Harry Dworkin, the son of Russian Jewish immigrants, and she gave birth to her daughter, Andrea, in 1946. Sylvia's early illness, combined with contracting pneumonia during the pregnancy of her second child, Mark, in 1949, impacted the health of her heart and the quality of her life. As a result of these health challenges, Dworkin tells us that Sylvia's life became a "misery of illness" during which she would experience "heart failures" and "toxic reactions to drugs that kept her alive" while she struggled to work as a school secretary and perform her role as a wife and mother (*Our Blood* 1-2). Meanwhile, Harry, a guidance counsellor, would take on a second job at the post office to help pay for Sylvia's mounting medical bills. Both Harry and Sylvia used all the resources at their disposal to care for their children while trying to survive their challenging circumstances.

In the late 1950s, when Dworkin was twelve, Sylvia had heart surgery followed by a stroke. Reflecting on the experience as an adult, Dworkin remembered that her mother "emerged from her heart surgery and the stroke that robbed her of her speech ... standing up and giving orders"

(*Our Blood* 3). One may view Sylvia's resilience in the face of daunting health obstacles as remarkable. As a child, however, Dworkin was not impressed: "I had no sympathy for my mother. I knew she was physically brave ... but I didn't see her as any Herculean hero" (4). In contrast to cultural images of Jewish mothers as a well of bountiful love, Dworkin observed the following: "We had a very hard time with each other. I didn't know who she was, or what she wanted from me. She didn't know who I was, but she had definite ideas about who I should be" (3). Both mother and daughter were brave, bold, and obstinate. As someone who was not the centre of attention in her own household growing up, Sylvia gave as much attention to her daughter as her health would allow.

Although they may have struggled in their connection with one another, it was a relationship that both would work to preserve. When Dworkin left home for college, travelled abroad, and got married, they maintained contact through letters and the occasional long distance phone call. Their regular correspondence was important to Dworkin. Indeed, when Sylvia's letters slowed, her daughter censured her: "MOTHER? WHERE ARE THE LETTERS FROM YOU? FALLING DOWN ON THE JOB? WRITE I DEMAND WRITE. IT IS SUCH A JOY TO GET YR LETTERS" (Dworkin to Harry and Sylvia Dworkin, Nov. 8, 1965).

In 1969, when Dworkin was twenty-three, she would reflect on her parents' meaningfulness to her. Newly married, Dworkin shared her appreciation with Sylvia and Harry: "You are very important to me. You live in this house with us, even though you are unaware of it ... you are part of my identity, so much in me comes from you" (Dworkin to Harry and Sylvia Dworkin, May 28, 1969). Their correspondence allowed Dworkin to express her gratitude and struggles; meanwhile, Sylvia used this space to continue to provide feedback on Dworkin's life, as would any mother. Dworkin's perspective on the feedback can be gleaned from a letter she wrote when she was twenty-six: "I didn't mean to 'let you have it' mom—Just ... try[ing] to be clear about the source of my confusion. I don't mind when you express your opinion. I don't much like being the source of all that worry.... But I feel much better writing to you" (Dworkin to Harry and Sylvia Dworkin, Sept. 18, 1972).

Sylvia was right to worry about Dworkin: She had fled her first marriage due to the brutality of her husband and was struggling to survive in Europe. Her husband's sustained physical abuse and

Dworkin's frustration with her parents' inadequate response to it would become the subject of not only Dworkin's correspondence but also her public writing. Knowing that her public critique of her parents' reaction to her battering would hurt them, particularly Sylvia, who felt embarrassed by the public discussion of their personal lives, Dworkin provided a forewarning: "I have an essay [in *Mother Jones*] of which I am very proud, but which I am afraid will upset you and cause you pain.... [But] I hope ... you will be proud of me ... and my commitment to helping other women" (Dworkin to Harry and Sylvia Dworkin, June 15, 1978). Despite the public airing of their private grief, Dworkin was interested in her mother's thoughts and perspectives, even as she may have resisted and critiqued them, and their connection remained strong until Sylvia passed in 1991.

Sylvia's own parents, Edward and Sadie Spiegel, were part of a large influx of immigration by Eastern European Jews at the end of the nineteenth and beginning of the twentieth centuries. Drawing on Irving Howe, Antler argues that endemic to this first generation was the idea that the "Jewish mother remained the emotional 'heart of the family'" and mothers received "'deferential, if not reverential'" regard as the keepers of home, tradition, and spirituality (*You* 15-16). These perspectives were informed and amplified by popular culture representations of the Jewish mother that existed in Sylvia's time, to which I turn next.

Representations of the Twentieth-Century Jewish Mother

As the first generation of foreign-born immigrants gave way to an assimilated second generation, intergenerational conflicts ensued. The second generation (into which Sylvia was born) "cast off the older, anachronistic familial supports—particularly the embrace of motherly love—all the while mythologizing it" and hanging on to it closely (Antler, *You* 16). This generational shift cultivated both conflict and guilt; consequently, in the 1920s, popular culture was rife with images of the "loving but abandoned Jewish mother" (16). Jewish artists imbued their representations of Jewish motherhood with an "extraordinary energy and sympathy, but often with an obsessive and confining control seen as necessary to the immigrant struggle for survival" (17). Antler calls this "compelling, but problematic" representation the "Americanized 'Yiddishe Mama'" (17).

By the 1930s, the Great Depression was wreaking havoc on life in the US, complicating images of the Jewish mother type (Antler, *You* 17). One such representation was the infamous Bessie Berger of playwright Clifford Odets's *Awake and Sing* (41). Eschewing the "sentimental, self-sacrificing, mournful 'Yiddishe Mama,'" Berger was "calculating, cruel, and selfish" (44). Although the overall image that Bessie conjured was not flattering, she possessed some positive qualities: She was resourceful, understood the intricacies of human nature, and was dedicated to looking out for the survival of her family (42). Her belief that the only way to be successful in the US was through the acquisition of material wealth, however, led her to be manipulative and unkind, ultimately abandoning Jewish values (43). Reversing traditional roles and destabilizing family solidarity, Bessie was depicted as "a domineering matriarch who replaces the father as the linchpin in the family" (41) as the family attempted to assimilate to US culture. In a sense, Bessie's matriarchy was perceived as a threat to the Jewish family even as she ensured their survival (45). This representation served as a cautionary tale for viewers like Sylvia, who were reminded of the importance of transmitting appropriate values from one generation to the next and knowing their place. Sylvia was, in fact, a strong supporter of progressive and Jewish values and she shared them liberally with Dworkin— sometimes to Dworkin's dismay. Additionally, Sylvia had a strong presence in the home, but her marriage was an egalitarian one, which was notable for the time. Harry was dedicated to tending to her health and wellbeing, and he lovingly took on a meaningful caretaking role with the children.

Although multilayered representations like Bessie's existed, it is the kind-hearted Molly Goldberg of the popular radio serial *The Rise of the Goldbergs* (1929-1946) and the subsequent television program *The Goldbergs* (1949–1956) that Antler calls the twentieth-century prototype of the Jewish mother (*You* 47, 70). The program brought a comedic lens to the "differences between the 'old world' immigrants and their American-born offspring," and its lead character, Molly, "became a cultural touchstone, a figure who combined old world wisdom, new world common sense, and a mother's humanity in confronting the complexities of American life" (Jewish Women's Archive). Created by Gertrude Berg (née Tillie Edelstein), a second-generation daughter of Jewish immigrants from Russia and England, Molly was an accessible and widely

popular persona who straddled intergenerational lines and tensions familiar to Sylvia; she would be a dominant figure in popular culture from the time Sylvia was a teenager until she reached her forties. By eschewing controversial topics and presenting the "family as a sea of domestic tranquility," Molly achieved the status of "everybody's mother" (Antler, "Bond" 201-2). In this representation, Sylvia would be exposed to a maternal figure who showcased "benevolent wisdom" "calm problem solving," and an "elevation of moral values over financial gain" (Antler, *You* 52). Advertising for the show would amplify these qualities further and highlight the fact that she was "not a 'dominating' character," like Bessie Berger, "although she maneuvered ... other characters to convince them of the right ways" (52). Like Sylvia, Molly represented a Jewish mother who was seeking the best for her family. Sylvia, however, took her own nonidealized and nontraditional maternal pathway based on her own convictions and circumstances. She ensured that her daughter had access to opportunities that she never had while also advancing controversial ideas and opinions in a straightforward manner. At the same time, she challenged Dworkin's thoughts and perspectives—providing a context for her to confidently argue and stand up for her own truth and to develop into the champion for women that we know today.

The Making of a Radical Feminist: Sylvia's Bold Maternal Approach

Although Sylvia was a meaningful figure until Dworkin's mid-forties, she could not or would not perform the stereotypical role of the doting, sentimental, and smothering mother. Dworkin surmised: "I had been raised really without a mother, and so certain ideas hadn't reached me. I didn't want to be a wife, and I didn't want to be a mother" (*Our Blood* 3). She and her brother, Mark, would be farmed out to family members during Sylvia's episodic illness, since her father was working multiple jobs to pay medical bills (Dworkin, "Interview"). As Dworkin would later say, "My father had really raised me although I didn't see a lot of him" (*Our Blood* 3). In a role reversal, she ascribed her father Harry with traditional maternal characteristics, calling him "the great heart in our family" (Dworkin, "Interview"). She also referred to him as "extremely gentle and caring, respecting women and children, listening to us, [and]

responding intellectually and emotionally" (Dworkin, "Interview"). In a sense, her father took on the stereotypical maternal role in the family, offering Dworkin the emotional support and comfort typically attributed to Jewish mothers, while her mother took on the role of critic, guide, and disciplinarian.

To her credit, Sylvia was determined to stay involved in her children's lives even as she struggled through a litany of health challenges. In particular, she contributed to her daughter's intellectual development in ways that Dworkin did not fully recognize until she was much older. Reading as a favoured pastime was an indulgence Sylvia was not enabled as a young person; it was, however, one to which she would ensure her children had access. Although Dworkin credits her father for teaching her "how to think," it was Sylvia who introduced, and frequently brought, Dworkin to the library, encouraged her to read (what could be considered a pivotal precursor of thinking), and provided her with written permission to read books prohibited to children, something many mothers, even today, would not be willing to do (Dworkin, "Interview"; Dworkin, *Our Blood* 4). Dworkin recalled that although they had "some conflicts over the particular books which I insisted on reading... she never stopped me from reading them" (Dworkin, *Our Blood* 4). Sylvia's willingness to provide ample (and, at times, humorous) feedback to her daughter—and her daughter's willingness to respond in kind— resulted in tensions in the mother-daughter relationship. Dworkin would affirm this when she said the following: "Eventually she would tell me that the worst mistake she had made in raising me was in teaching me how to read. She had a mordant sense of humor that she rarely exercised" (Dworkin, *Heartbreak* 24). Dworkin indicated that her mother's true misstep was not in teaching her to read; instead, tongue in cheek, she advised that Sylvia's real failure was in telling her not to lie: "Whether the issue was segregation or abortion, I ... was going to deal with it, and my vehicle was going to be the truth" (25).

As Dworkin grew up and left home, she corresponded regularly with her parents. Although she suggested that her mother's approval was not important to her, her correspondence suggests the opposite. At the age of nineteen, Dworkin was living alone on the island of Crete, an adventure emotionally and financially supported by her parents, demonstrating the freedom of movement her mother allowed (Dworkin to Sylvia, Harry, and Mark Dworkin, 31 Jan. 1966).

During her stay, she authored her first book, a collection of poetry called *Child*, for which she secured funding to print. As she was creating, she kept her family appraised that something very meaningful was coming their way soon, seemingly as excited as a mother would be with an impending birth. In one letter, she wrote, "I am in a high and wonderful mood, my Extraordinary Surprise is in the making" (Dworkin to Sylvia, Harry, and Mark Dworkin, 11 Feb. 1966). A month later she wrote, "The Extraordinary Surprise should be complete within two weeks, three at most. I hope you will be pleased" (Dworkin to Sylvia, Harry, and Mark Dworkin 16 Mar. 1966). And speaking of the delivery, she expressed her joy at the work that would soon be in their hands: "My surprise is ready, you will receive it shortly[;] I have published a collection of poems, 500 copies, a limited but very beautifully simply done edition I think. I hope with all of my heart that you are with me in this, and that you will feel my inexpressible joy in this birth. I am so proud and so happy" (Dworkin to Harry and Sylvia Dworkin, n.d. 1966). *Child* was dedicated to her parents and Mark, and although Dworkin was delighted, the collection raised some questions and concerns with her parents: The poems contained sexually graphic and disturbing content, with references to whores (6), ripped hymens, used-up sperm (9), and a "deathly sickly mother" (5). One poem in particular, "The Child Graves," told a first-person graphic and detailed story of a woman giving birth to a stillborn child in a dump, with erotic references between mother and child.

Dworkin's father remained silent on the provocative work, whereas Sylvia took on the emotional labour of offering Dworkin a critical perspective, focussing her attention on "The Child Graves." Penning a critique of her daughter's collection must have been difficult for Sylvia, who had, for months, read about her daughter's joy in birthing this creation. Needless to say, Dworkin was not pleased and told her mother, "I am sorry that you don't like the book," and then she proceeded to pen a multipage, single-spaced argumentative essay, replete with numerous rhetorical strategies aimed at defending her work (Andrea Dworkin to Sylvia Dworkin, 21 Apr. 1966). At the beginning and end of the letter, Dworkin declares that her retort was not an emotional one: "I am not angry or upset, I am responding simply because I suppose you want a response.... There is nothing emotional about it, as y[ou]r [letter] did not affect me emotionally" (Andrea Dworkin to Sylvia Dworkin, 21 Apr.

1966). Using dissociation, Dworkin overtly sought to distance herself from emotion, but these deliberate efforts suggest that she was indeed upset and that Sylvia perhaps evoked emotionality as a tool to question her arguments or decisions in the past.

Dworkin subsequently used appeals to accomplishment to invalidate her mother's criticisms. Drawing on an academic context—one that she repeatedly expressed suspicion of in her prior letters to her parents—she requested that Sylvia "accept the fact that modern poetry is complex and difficult, dependent on large academic knowledge" (Andrea Dworkin to Sylvia Dworkin, 21 Apr. 1966). She suggested that her mother did not have sufficient education to understand the value of her poetry: "No poem in the world is available to someone without a large background in poetry, someone who will live with a poem and study it for years if necessary" (Andrea Dworkin to Sylvia Dworkin, 21 Apr. 1966). Taking another, more aggressive jab at her mother—which again suggests her disappointment—Dworkin noted that when she studied Dante Alighieri, the course was for a year: "I am simply trying to say that if this poem, or any poem, excludes you from itself, it is not necessarily the fault of the poem" (Andrea Dworkin to Sylvia Dworkin, 21 Apr. 1966).

After undermining her mother's qualifications to render judgment on the collection through her lack of education, Dworkin next appealed to authority by drawing on the words of her Bennington College professor and poet, Francis Golffing. Modelling for her mother what she deemed a more appropriate response to her achievement, Dworkin stated that Golffing described "The Child Graves" as a "'masterpiece: brilliant, imaginative, powerfully affecting" (Andrea Dworkin to Sylvia Dworkin, 21 Apr. 1966). Advising her mother that even those who did not appreciate this particular poem were respectful of the project, Dworkin argued: "Stan and Phyllis Pogram don't like the [C]hild [G]raves in terms of what it conveys, but regard it with enough respect to have contributed to the cost of the printing" (Andrea Dworkin to Sylvia Dworkin, 21 Apr. 1966). Finally, she added her own perspective: "As for myself, I believe in the poetry.... That book is the accumulation of 3 years of arduous work, plus editing and proofreading which took over two months" (Andrea Dworkin to Sylvia Dworkin, 21 Apr. 1966).

Through this layering approach, Dworkin worked to recover her work from her mother's critique and to maintain their relationship,

telling her mother, "One does not ask for your approval[;] one asks for your love" (Andrea Dworkin to Sylvia Dworkin, 21 Apr. 1966). At her young age, Dworkin likely was not cognizant that her mother took the time and expended the energy to critique her work and give her feedback because she did in fact love her. Critique and love are not incompatible but often close companions; if someone takes the time to provide feedback, it is because they are invested in the person. Although there is no doubt that her mother's appraisal was difficult for Dworkin to digest, the very process of having to defend her work so vigorously and to think through such justifications and reasonings helped prepare her to successfully confront the adversity she would face in life, particularly the vociferous challenges and critiques she would encounter as a result of her radical, ground-breaking work. In various letters throughout their correspondence, we see evidence of Sylvia challenging Dworkin when she says things like: "This to mom: don't understand really why you would regret my maturity or ability to make decisions" (Andrea Dworkin to Harry and Sylvia Dworkin, 21 Dec. 1968) and "I really don't know what to do when I get a letter like that mom. I'm sorry you felt that outburst necessary" (Andrea Dworkin to Harry and Sylvia Dworkin, 16 Feb. 1973). This frank, if contentious, engagement and critique sharpened Dworkin as it created the space for her to learn how to defend her work and speak her truth, but it could have served as the basis for ending their relationship. Despite disagreement and argumentation, both Dworkin and her mother kept reaching out to each other; this relational dynamic—a dedication to truth and connection, despite debate and disagreement— can be seen in Dworkin's later interactional practices. For example, her private correspondence with such feminists as Gloria Steinem and Phyllis Chesler reflect this approach (Andrea Dworkin to Phyllis Chesler, 20 Jan. 1977; Andrea Dworkin to Gloria Steinem, 30 Mar. 1978).

A commitment to truth also permeated her approach to human rights and women's rights. Dworkin once said: "Writers get underneath ... the lies a society depends on to maintain the status quo, by becoming ruthless, pursuing the truth in the face of intimidation" (*Letters* 4). As the granddaughter of Russian and Hungarian Jewish immigrants, she "grew up taking hate and extermination very seriously," especially since her family experienced meaningful loss in the Holocaust (Dworkin, "Interview"). By her own admission, Dworkin "wasn't a religious zealot"

(*Heartbreak* 21). She even stridently rejected a subscription to the Beth Jacob Scroll sent by her mother when she was in college, calling it a "badly written, unintelligent piece of crap" and declaring, "I will not be bound by dogmas which limit consciousness or modes of activity" (Duberman 7; Dworkin to Sylvia, Harry, and Mark Dworkin, n.d. 1964). Yet this personal connection to, and other experiences with, antisemitism influenced her and her family's approach to human rights, and one of her best acclaimed books investigates the ways in which both women and Jews have been used as scapegoats by the societies in which they have lived (Dworkin, *Scapegoat*). Of their influence, Dworkin stated that her parents were both "horrified by US racism . . . [and] by all aspects of discrimination—black poverty, urban ghettos, menial labour, bad education, [and] the lack of respect whites had for blacks" (Dworkin, "Interview"). Martin Duberman reports that Sylvia even brought Dworkin to Harlem to gain a deeper appreciation of the poverty and struggle afflicting African Americans at the time (6). Despite her parents' mutual commitment to human dignity—during a period when such commitments were not pervasive—Dworkin identified her father as formative to her thoughts on human rights (Dworkin, "Interview").

Yet it was her mother who was foundational in her understanding of women's rights, which served as the cornerstone of her feminist practice. In an interview with Michael Moorcock, she reflected on her mother's radical stance on women's reproductive rights: "My mother was committed to [P]lanned [P]arenthood, to legal birth control (it was criminal then) and to legal abortion" (Dworkin, "Interview"). Dworkin later expanded on her mother's influence in her memoir as she reflected on how her identity was emerging as early as the sixth grade. As evidence of this, Dworkin pointed to two major themes. The first was her refusal to sing "Silent Night" with the rest of the Christians in her class, despite being punished by the school for her lack of conformity and by her fellow students with ridicule and expressions of antisemitism. This was, as Dworkin reports, her "first experience with a female collaborator" as a Jewish teacher was selected by the administration to compel her to sing with the rest of the class (Dworkin, *Heartbreak* 21). She would not, and decades later, she would still remember the teacher in stark terms as a "turncoat Jew, a pretty, gutless teacher" (21). While Dworkin was resisting conformity, which her parents affirmed, her young mind also was grappling with a second adult theme placed in her mind by her

mother; she was consumed with the fact that "abortion was illegal and women were dying," and she wondered "how could this be changed?" (23).

The fact that she was thinking about mature issues at such an early age was directly attributed to her mother: "It was my mother whose politics were represented by the abortion theme: she supported legal birth control and legal abortion long before these were respectable beliefs. I had learned these pro-woman positions from her, and I think of her every time I fight for a woman's reproductive rights or write a check [to a reproductive rights organization]" (Dworkin, *Heartbreak* 23-24). During her youth, Dworkin did not fully appreciate the forward thinking and boundary busting nature of her mother's stance. Looking back in her memoir, she was able to trace the seeds of Sylvia's influence and what she had taken for granted at the time: "Our arguments for ... abortion right now might be more politically sophisticated, but my mother had the heart and politics of a pioneer—only I didn't understand that. These were the reproductive politics I grew up with, and so I did not know that she had taught me what I presumed was fair and right" (24).

As Dworkin matured in her feminist politics, she turned her gaze towards her mother's role in her life and the role of mothers in Western culture more broadly. She admitted that as a young woman, she found that "mothers ... were the most expendable of people—no one had a good opinion of them, certainly not the great writers of the past, certainly not the exciting writers of the present" (Dworkin, *Our Blood* 5). The patriarchal influences that she had so readily imbibed—from Edward Albee to Philip Wylie to Sigmund Freud—made her think, at the time, that mothers in general and her mother in particular were "uninteresting ... small and provincial" (4-5). Masculinist artists had created a world that "robbed" women of their "full becoming" and offered "impoverished renderings of mothers and daughters" (9). Dworkin had uncritically absorbed these depictions, and her mother, astute as she was, recognized in their dialogues the way in which her daughter was viewing her. Sylvia confronted Dworkin: "You think I'm stupid" (qtd. in Dworkin, *Our Blood* 4). Dworkin realized that as a youth, she had, at times, diminished the value of her mother's perspective and had presumed she was intellectually superior to her (4-5). However, as she grew in her understanding of the world and women's role within it, she began to understand how central her mother was to her life: "This woman, my mother,

whether present or absent, was the center of my life in so many inexplicable, powerful, unchartable ways" (5). She began to respect and value anew what her mother offered: "I came to recognize that my mother was proud, strong, and honest ... [and] I had seen enough of the world and its troubles to know that pride, strength, and integrity were virtues to honour" (7). While she may not have fully recognized it, these are the very qualities that Dworkin would bring to her feminist theorizing and practice.

A Jewish Mother Undaunted: Standing Up and Giving Orders

Lehman, Kanarek, and Bronner argue that "Hallowed by some, excoriated by others—mothers have been depicted, on the one hand, as all that is good and sacred in the Jewish family, and on the other, and far more frequently, as overbearing, guilt-inducing and interfering" (1). These stereotypes prevent us from registering the nuances of being a Jewish mother in daily life, especially for someone like Sylvia, who was grappling with precarious health conditions while continuing to work and care for her children. As the daughter of Jewish immigrants of limited means, Sylvia was a realist who wanted to ensure her daughter's success and survival in the world. However, she did not have the privilege of being a helicopter mom, and she did not have the energy to engage in the intensive mothering regime. Instead, she prepared her daughter to be strong and bold by being honest and direct in her feedback, even if it meant putting their relationship at risk. She also gave Dworkin meaningful freedom of movement and choice while exposing her to adult topics. Although the seriousness of her health problems could have made Sylvia disappear completely, she fought to stay involved in her daughter's life as she provided her with a feminist and progressive role model. Neither the doting, calm-mannered, gentle, every-mother represented by Molly Goldberg, nor the calculating, cruel, domineering mother type imagined through the Bessie Berger stereotype, Sylvia was a strong, courageous woman who struggled with chronic health conditions that ruined the quality of her life, but she was determined to make her daughter feel her presence and receive her instruction.

Dworkin's relationship with her mother was complex, but it was instructive, and Dworkin wore her mother's teachings in meaningful

ways. Whether it was giving Dworkin permission to read adult-themed books or allowing her to be part of adult conversations regarding women's right to make choices regarding their bodies, Sylvia trusted young Dworkin with hard and heavy truths and the mature Dworkin did the same with her audiences. Just as Sylvia did not shield her daughter, Dworkin knowingly compelled her readers to confront the harshest realities of life. Of her approach, Dworkin once said: "I represent the morbid side of the women's movement. I deal with the shit, the real shit" (Dworkin, *Letters* 133). Sylvia also emphasized the importance of telling the truth. This was a principle that Dworkin admittedly carried with her throughout her life, and she would adhere to it regardless of whether it had the immediate impact she hoped.

In her memoir, Dworkin wrote, "You tell the truth and people can shit all over it ... but somehow once it's said it can't be unsaid; it stays living, somewhere, in someone's heart" (Dworkin, *Heartbreak* 65). In maintaining truth as a central ethic and encouraging Dworkin to stay connected to her Jewish roots and progressive values, Sylvia affirmed the mother as the moral centre of the family, which is central to representations of Jewish motherhood. Yet it was her father who offered her loving comfort, serving as the heart of the family—a role typically reserved for Jewish mothers. Instead, Sylvia took on the role of providing discipline and guidance, even when that meant she might create ripples in the sea of domestic tranquility and that Dworkin may resent her mother's perspective. But for Sylvia, just like for Dworkin later in her life, the principles she was advancing were the most important; they were the foundation, and the relationship would be built around them. Perhaps most importantly, Sylvia did not allow Dworkin to take anything for granted. This motivated her to learn, early on, how to articulate and defend her positions with vigour. It is because of boundary-busting mothers like Sylvia, who are not afraid to move children out of their comfort zones, that women gained such a champion in Andrea Dworkin, who spent her life moving people out of theirs.

Endnotes

1. Dworkin states that her maternal grandparents "came from someplace in Hungary" (*Our Blood* 2), but it is worth noting that ancestry. com suggests that they were born in Bulgaria.

Works Cited

Antler, Joyce. "A Bond of Sisterhood: Ethel Rosenberg, Molly Goldberg, and Radical Jewish Women of the 1950s." *Secret Agents: The Rosenberg Case, McCarthyism, and Fifties America*, edited by Marjorie Garber and Rebecca Walkowitz. Routledge, 1995, pp. 197-214.

Antler, Joyce. *You Never Call! You Never Write! A History of the Jewish Mother.* Oxford, 2007.

Bland, Edward. "Rheumatic Fever: The Way It Was." *Circulation*, vol. 76, 1987, pp. 1190-95.

Duberman, Martin. *Andrea Dworkin: The Feminist as Revolutionary.* The New Press, 2020.

Dworkin, Andrea. *Child.* Iraklion, Crete. Self-published, 1966.

Dworkin, Andrea. *Heartbreak: The Political Memoir of a Feminist Militant.* Perseus, 2002.

Dworkin, Andrea. Interview with Michael Moorcock. "Fighting Talk," *New Statesman & Society,* 21 April 1995, http://www.nostatusquo. com/ACLU/dworkin/MoorcockInterview.html. Accessed 15 July 2023.

Dworkin, Andrea. Letter to Gloria Steinem. 30 Mar. 1978. Box 13, Folder 4. MC 540 Papers of Andrea Dworkin, Schlesinger Library, Radcliffe, Boston. 21 Feb. 2018.

Dworkin, Andrea. Letter to Harry and Sylvia Dworkin. 21 Dec. 1968. Box 9, Folder 8. MC 540 Papers of Andrea Dworkin. Schlesinger Library, Radcliffe, Boston. 20 Jan. 2017.

Dworkin, Andrea. Letter to Harry and Sylvia Dworkin. 16 Feb. 1973. Box 9, Folder 13. MC 540 Papers of Andrea Dworkin. Schlesinger Library, Radcliffe, Boston. 20 Jan. 2017.

Dworkin, Andrea. Letter to Harry and Sylvia Dworkin. 15 June 1978. Box 9, Folder 14. MC 540 Papers of Andrea Dworkin. Schlesinger Library, Radcliffe, Boston. 20 Jan. 2017.

Dworkin, Andrea. Letter to Harry and Sylvia Dworkin. 28 May 1969. Box 9, Folder 9. MC 540 Papers of Andrea Dworkin. Schlesinger Library, Radcliffe, Boston. 20 Jan. 2017.

Dworkin, Andrea. Letter to Harry and Sylvia Dworkin. 8 Nov. 1965. Box 9, Folder 6. MC 540 Papers of Andrea Dworkin. Schlesinger Library, Radcliffe, Boston. 20 Jan. 2017.

Dworkin, Andrea. Letter to Harry and Sylvia Dworkin. 18 Sept. 1972. Box 9, Folder 12. MC 540 Papers of Andrea Dworkin. Schlesinger Library, Radcliffe, Boston. 20 Jan. 2017.

Dworkin, Andrea. Letter to Phyllis Chesler. 20 Jan. 1977. Box 12, Folder 6. MC 540 Papers of Andrea Dworkin. Schlesinger Library, Radcliffe, Boston. 20 Feb. 2018.

Dworkin, Andrea. Letter to Sylvia Dworkin. 21 Apr. 1966. Box 9, Folder 7. MC 540 Papers of Andrea Dworkin. Schlesinger Library, Radcliffe, Boston. 20 Jan. 2017.

Dworkin, Andrea. Letter to Sylvia, Harry, and Mark Dworkin. 11 Feb. 1966. Box 9, Folder 7. MC 540 Papers of Andrea Dworkin. Schlesinger Library, Radcliffe Boston. 20 Jan. 2017.

Dworkin, Andrea. Letter to Sylvia, Harry, and Mark Dworkin. 31 Jan. 1966. Box 9, Folder 7. MC 540 Papers of Andrea Dworkin. Schlesinger Library, Radcliffe, Boston. 20 Jan. 2017.

Dworkin, Andrea. Letter to Sylvia, Harry, and Mark Dworkin. 16 Mar. 1966. Box 9, Folder 7. MC 540 Papers of Andrea Dworkin. Schlesinger Library, Radcliffe, Boston. 20 Jan. 2017.

Dworkin, Andrea. Letter to Sylvia, Harry, and Mark Dworkin. N.d. 1964. Box 9, Folder 5. MC 540 Papers of Andrea Dworkin. Schlesinger Library, Radcliffe, Boston. 20 Jan. 2017.

Dworkin, Andrea. *Letters from a War Zone.* Lawrence Hill Books, 1993.

Dworkin, Andrea. *Our Blood: Prophecies and Discourses on Sexual Politics.* Harper and Row, 1976.

Dworkin, Andrea. *Scapegoat: The Jews, Israel, and Women's Liberation.* The Free Press, 2000.

Jewish Women's Archive. "Gertrude Berg's 'The Goldbergs' Premieres on Television." *JWA,* jwa.org/thisweek/jan/10/1949/gertrude-berg. Accessed on 15 July 2023.

Howe, Irving. *World of Our Fathers.* Harcourt, Brace, and Jovanovich, 1976, p. 171.

Lehman, Marjorie, Kanarek, Jane, and Simon Bronner. *Mothers in the Jewish Cultural Imagination.* Littman Library of Jewish Civilization, 2017.

Michman, Dan. "Jews." *The Oxford Handbook of Holocaust Studies,* edited by Peter Hayes and John Roth, Oxford University Press, 2010, pp.

185-202.

Oyler, Lauren. "The Radical Style of Andrea Dworkin." *The New Yorker*, 25 March 2019, https://www.newyorker.com/magazine/2019/04/01/the-radical-style-of-andrea-dworkin. Accessed 15 July 2023.

Prinz, Jessica. "Jewish Mothers: Types, Stereotypes, and Countertypes." *Mommy Angst: Motherhood in Popular Culture*, edited by Ann Hall and Mardia Bishop. ABC-Clio, 2009, pp. 197-226.

Raymond, Janice, and H. Patricia Hynes. "Andrea Dworkin: Teller of Hard Truths." Truthdig.com, 17 July 2019, www.truthdig.com/articles/andrea-dworkin-teller-of-hard-truths/. Accessed 15 July 2023.

A message from the breach,
a critical sensibility,
a liminal space between life and death.
Not dying but becoming,
and making sense—
exactly what I needed.

Story Thirteen

Mothering with Cancer: Between Life and Death in Contemporary US Literature, Film, and Culture[1]

Suzanne M. Edwards

for HF

There are two kinds of mothers: living and dead. We dying mothers are usually counted among the dead. There is only the sparsest cultural lexicon for a mother with an incurable, progressive, and ultimately terminal illness like the one I have been living with for the last twelve years.

This chapter is a message from that breach, where I have lived long enough to develop an eye for the cultural patterns that render mothers living with progressive and incurable disease invisible. That critical sensibility is a necessary strategy for living and mothering in-between life and death. In contemporary United States (US) film, television, and literature, mothers most often either die as a narrative predicate for their children's burgeoning independence or survive a life-threatening diagnosis as a way of bringing their family closer together. But there is no iconography for a mother who lives knowing that her disease will kill her sooner rather than later. Most cinematic and literary narratives arc towards a mother's death or her recovery; they rarely leave her, and by extension audiences, in between life and death.[2] Even as the dying mother is mostly absent from public discourse, there are more and more of us on the ground. Ten years ago, in 2010, an estimated 2.85 million

children in the US had a parent with cancer, when my own children suddenly counted among their number (Weaver et al.). With the development of treatments that prolong survival but do not offer a cure, that number has likely increased over the last decade. A study from 2016 estimates that 10 per cent of children worldwide live with a parent who endures chronic illness, including cancer (Razaz et al.).

Weaving together personal narrative and literary analysis, this chapter reads between the lines that separate the growing numbers of mothers living with progressive disease from normative ideals about motherhood that rely on futurity. This methodological approach is inspired by S. Lochlann Jain's *Malignant*, which argues that "understandings of cancer reflect back on the cultures that have defined it" (14) and foregrounds how cancer is not just a disease but also a "set of relationships—economic, sentimental, medical, personal, ethical, institutional, statistical" (4). For me, one of the relationships intertwined with cancer is that between mother and child. I argue that the elision, and sometimes the moral condemnation, of dying mothers both derives from and protects the belief that a mother's unchanging, stable presence anchors a child's healthy development. In exploring this normative ideal and the erasures on which it depends, my aim is ameliorative. The sharp line that so often separates living and deceased mothers in books, film, and television has material consequences for dying mothers and their families. Furthermore, it has a psychic cost for everyone, whether living with progressive disease or not, in that it implicitly venerates a hierarchical relationship between a mother unaffected by physical change and a rapidly growing child. Deconstructing the barrier between maternity and mortality, I argue, reconfigures caregiving relationships as sites of nonhierarchical interdependency, which is important for anyone who is raising children. Yet this is not a chapter about what dying mothers can teach the living. On the contrary, it questions why mothers with progressive terminal illness are often so cast as object lessons for healthy mothers, in a denial of our shared humanity.

Because it is grounded in my personal experiences, this chapter focusses on mothers with advanced, presumptively incurable, cancer. I do not share my experiences as a mother with cancer because I think they are representative of anyone else's; I include them because they constitute a significant part of my expertise on the topic, including the limitations of that knowledge. The specific contours of cancer treatment and

the prevalence of cancer as metaphor in US politics mean that the experiences of mothers living with other progressive illnesses, such as multiple sclerosis and ALS, may overlap with mine in some ways and diverge in others. Even mothers who share a cancer diagnosis endure varied treatment regimes, side effects, and courses of disease progression. If they could read this piece, some of my friends with cancer who have died would laugh at me for characterizing myself as dying. I am not in a hospice. My performance status—a standard measure of how well cancer patients can manage daily activities, from basic self-care to housekeeping and working—is not radically different than it was before my diagnosis. Yet the knowledge of my prognosis and physical reminders of the palliative (as opposed to curative) treatments I have suffered (three eight-hour surgeries, two six-month rounds of chemotherapy, four years of debilitating infusions of an experimental drug, and six years of hormone blockers) shape each one of those daily activities. By analyzing my own experiences alongside memoirs of other contemporary US mothers living with incurable cancer and fictional representations of dead and dying mothers, I map some of the shared exclusions and possibilities that shape the intersections of progressive disease and motherhood.[3]

I. The Living and the Dead: The Case Against Dying Mothers

I first learned about my cancer diagnosis when I was intubated in the ICU after a placental abruption and emergency caesarian section that nearly killed me.[4] For months afterwards, I was convinced it would have been better if I had died on the operating table. Lingering on that thought, I obsessed about a moment just before the surgery, before anyone knew I had cancer. Over the heads of a dozen efficient medical professionals and a glistening ocean of blood, I looked at my spouse and felt a transcendent calm. To this day, I do not know whether that moment of peace was a privileged person's foolish belief in her charmed invulnerability or a glimpse of how it feels to die. After I learned of my diagnosis, I perseverated on the idea that my newborn and my three-year-old would remember me only as a shadowy figure, sick in bed, before I disappeared from their lives. I woke up in the middle of the night to google my chances of survival (50 per cent chance of living five years

and 20 per cent chance of living ten) and then doublechecked that my baby's astrological sign was not Cancer, which would have been a cruel cosmic reminder of how my fate had defined their life (Baldwin et al.). It seemed like a maternal failure that I had dodged a quick death from blood loss only to wake up in the middle of a slow death from cancer that would be worse for everyone involved.

Most ill-fated mothers are gracious enough to die expeditiously off-stage, where they sidestep the category confusions that come along with dying as a long process rather than a sudden event. For these dead mothers and their children, there is only the searing shock that clarifies the boundary between the living and the dead. In *Finding Nemo*, the plucky clownfish's mother is swallowed whole, we assume, as the screen fades to black. In *Bambi*, the fawn realizes that his mother has been killed when the stag simply says, "Your mother can't be with you anymore." If I had died abruptly, my children, lacking any memories of me, would have gone on to their adventures with less grief. This, anyway, is the lie that Disney offers us. Without memories of their own, my kids could pore over photographs in which my hair was long and my smile broad. They would have had the gift of knowing only a mother uncontaminated by cancer.

Today, more than a decade later, still alive and still incurable, I now know that those thoughts, which at the time seemed indisputable, reflected postpartum depression, postdiagnosis grief, and entrenched ableism. When cancer (or any other trauma) radically disrupts plans, seaming together past and future versions of the self amid a wobbly present is painstaking work. Kate Bowler, a mother and religion scholar with stage IV colon cancer, calls this "the cost of living in the in-between" (149). For literary critic Susan Gubar, who also lives with ovarian cancer, the gut punch of diagnosis and treatment induces a "posthumous existence," a term she borrows from the poet John Keats; the corpse's oxymoronic sensorium is tied to the formerly living flesh only by willful faith (165). S. Lochlann Jain, who was diagnosed with breast cancer as a young adult, uses the term "living in prognosis" to capture "the moment one becomes someone who thinks differently about a future, a death, and a life" and underscore the uncertainty underneath the implied triumph of "survivor" (224). Living in prognosis is a liminal state in which the uncertainties of a serious diagnosis color both future and past. For me, the rupture of diagnosis has now long

passed, and I no longer struggle to reconcile a sense of self grounded in health with the realities of disease. Everything I did and everything I was before that Thanksgiving night in 2011 has been redefined by the illness I now know was always coming. Treatment and tumor growth are part of the futures I now envision, and I know that there will be more recalibrations to come—when my current treatment fails, when I am hospitalized for a bowel obstruction, and when it becomes clear that there are no more treatment options. When my fifteen-year-old talks about the piece she is obsessed with playing someday, the Sibelius violin concerto, I picture myself perhaps in the audience, perhaps in the hospital, or perhaps as dust in the spotlight. I feel far less pain about such futures now that I see them as consistent with the story of my life.

For parents living in prognosis, this imaginative self-redefinition is made harder by the fact that normative parenting is a future-oriented identity. Being a good parent means shepherding a dependent young person into their comparatively autonomous adulthood with emotional and financial support. This developmental emphasis positions a parent with chronic illness—a parent in decline—as inadequate. By needing care ourselves, we may be unable to model independent selfhood, and by dying before our children's maturity, we may fail to see our duty of care through.[5] While in treatment, we consume family resources, money, and time that would otherwise be devoted to our kids. My conviction that motherhood and incurable cancer were incompatible was not only an effect of depression, although it surely was that. It was also an effect of a cultural landscape that, in defining parenting as future-oriented, forces the two apart. Kate Bowler writes that she could barely process the news that she had metastatic cancer; when she finally is able to speak, it is about just that incompatibility: "I have a son. It's just that I have a son" (6). After her diagnosis with stage IV colon cancer, Julie Yip-Williams is consumed with thoughts of "not being there" for her daughters and not seeing the kinds of women that they "would become one day" (20). "My babies," she writes, "became someone else's children" (21). Certainly, anticipatory grief about the pain one's children will endure is primal. Nina Riggs, a mother with metastatic breast cancer, explains that her two sons' "very existence is the one dark piece I cannot get right within all of this.... I cannot figure out how to let go of mothering them" (215). Yet in my own experience and in these cancer memoirs, cultural values that make mothering and dying incompatible

amplify that irreducible pain: If I am a mother, then I must be there for my child into the future, and if I cannot be there for my child, then I must not be a mother.

That syllogism, freighted with the cultural values that associate illness with moral failing, harms mothers with incurable disease as well as the children who will learn to read (or to resist reading) our deaths as a parental failing. The potent intersection between moralizing about disease and about motherhood defined my own experience long before I even had a diagnosis; it was the backdrop for my belief that it would have been better to die than to mother with cancer. When doctors spotted something on my ovary during a routine ultrasound twelve weeks into my pregnancy, they debated the best course of action. A CT scan was out of the question; radiation posed too great a risk to the fetus, especially since the scan—by itself—would be inconclusive. Only surgery could definitively determine whether the mass they had seen on the ultrasound was benign or malignant, but surgery would also put the pregnancy at risk. Every doctor, save one, recommended against surgery because the odds of cancer were so low. When I asked that lone doctor (who did turn out to be right about the cancer) to compare the risk to me and the risk to the baby I still hoped to have, he answered, "Maybe you should think about the child you already have." He was trying to convey the medical advice that if I did have cancer, earlier diagnosis and treatment would significantly improve my prognosis. But he framed that advice in terms of my imminent shortcomings as a mother, if I did indeed have cancer: how much worse for me to subject two children rather than one to a dying mother, how much worse for me to leave my surviving spouse with two children, how much worse for me to think of the child I wanted rather than what the child I already had would want—for me to have a better chance at survival than for her to have a sibling. He implied that it is a terrible failure for a mother to be diagnosed with advanced, incurable disease. This doctor would no doubt disagree with how I translate his rhetorical logic. Yet just as he is a doctor of maternal-fetal medicine, I am a doctor of literature; just as he reads blood tests and scans, I read language for the shadows beneath its surfaces.

I do not blame that doctor; he merely sought to persuade me by alluding to an entire cultural grammar from advertisements, film, and literature that portrays women with cancer as insufficiently attentive to their children's wellbeing. Maria Edgeworth's *Belinda*, a nineteenth-

century domestic novel that I loved as a college student, offers a particularly clear example. In this "moral tale," as Edgeworth calls it, Lady Delacour is an apathetic wife and mother whose glamorous exterior hides deep unhappiness. Underneath her party frocks, she is dying from breast cancer. In Edgeworth's preliminary plot sketch for the novel, Lady Delacour declares to her horrified young protegée, "You shall know how I myself caused this cancer" (481). Her decaying breast, she explains, is both cause and effect of her unfitness for motherhood. After her first child was stillborn and her second child starved to death at her breast, Lady Delacour sent her third child to be raised by someone else. A reunification scene with that child emphasizes that breast cancer is a symptom of failed affection. When the girl presses "close to her mother's bosom," Lady Delacour "scream[s] and pushe[s] her daughter away," her wound inflamed by the embrace (173). Edgeworth originally planned for Lady Delacour to die from her disease, an appropriate punishment for her maternal neglect. Revising that initial plan, Edgeworth instead gives Lady Delacour a chance at redemption. Transformed into a better mother, Lady Delacour learns that her supposed cancer had merely been a bruise. The circular moral reasoning linking disease and motherhood could not be clearer: A sick mother is a bad mother, and a bad mother is a sick one. Being a more loving and attentive mother can save your life.

Belinda's sentimental moralizing may read to us today as obviously over the top, but it is closer than we might realize to tropes that define motherhood and cancer in the twenty-first century US. On my social media feeds, other moms in my suburban neighbourhood promote activewear and nutritional supplements that have made their lives better. With before-and-after photos, they sell products and recruit more saleswomen for multilevel marketing schemes. They promise that these wellness-focussed products make it possible both to earn more money and to have more time to spend with their kids. Get healthy, get wealthy, and you will be a better parent. We breathe in the associations between health and motherhood like air, not noticing until the oxygen gets thin. But such logic is not benign. In 2011, Alaina Giordano was denied primary custody of her children, in part because she was living with metastatic breast cancer. In her order, the judge cited the fact that "the course of [Ms. Giordano's] disease is unknown" (qtd. in Hutchison). Another strike against Giordano: She was unemployed. The judge's ruling cited a forensic psychologist's blunter claim: "[Children] divide

their world into the cancer world and a free of cancer world. Children want a normal childhood, and it is not normal with an ill parent" (qtd. in Hutchison).[6] The formulation implies that it is the parent's job to keep children in the "free-of-cancer world" to affirm the norm that a mother's absence is preferable to her dying presence.

But the norm and not the reality of dying is the problem here. Progressive disease complicates the all-or-nothing dichotomy that divides the mother who is everything from the mother who is gone. A good mother either survives because she cares so much for her children, or she dies suddenly because she puts her child's needs above her own. Bambi's mom takes a bullet for her baby. In J. K. Rowling's *Harry Potter* series, Lily Potter's sudden, violent death saves her infant son from the same fate and magically protects her son from harm into his adolescence. Her self-sacrifice allows her, in effect, to continue mothering him. My own mother used to tell me: "I would throw myself in front of a truck for you. That's how much I love you." The mother dying from cancer risks exposing maternal limitations rather than the superhuman love required to will her own death to save her child. And so, the dying mother, who neither saves nor sacrifices herself for the sake of her child, fails at motherhood. Yet here we are. Here I am.

II. Living Dying

Because mothering in the contemporary US is organized around futurity, to be dying in ordinary scenes of parenting like attending a parent-teacher conference, sitting in the audience at a school concert, or standing on the sidelines at a birthday party is to feel acutely displaced. One key to living with cancer is never getting ahead of yourself, never looking beyond the next scan. Nina Riggs's memoir cites her oncologist's advice about "staying in the present with this stuff, not trying to extrapolate into the future" (242). We may celebrate cancer patients for giving us "a gentle reminder to cherish each day," as the blurb from *Entertainment Weekly* quoted on the back of Riggs's book does. But, at the same time, such present-ness is incompatible with normative mothering in the contemporary US. Most of the cultural narratives there are for doing dying right as the mother of young children prescribe futurity—specifically provisioning an affective and financial inheritance for the kids—to deflect grief and to keep anyone from lingering too long

in a tenuous present.

Parenting rituals and conversation circulate around what will happen in the future and especially the nostalgia for the present the parent will later come to enjoy. Anyone in the throes of intensive motherhood has heard the phrase, "The days are long, but the years are short." It is an example of what Lauren Berlant calls "cruel optimism," a continued affective investment in whatever's wearing you out today premised on a future when things will be better. Keep going with the unending labour of caring for a small child because someday you will look back on how fleeting it was. It is a phrase that lands quite differently for a dying mother. The years are indeed short, and for some of us, there will be no retrospective wonder. Scenes organized around such future nostalgia prompt the dying mother to reflect—often uncomfortably—on our attachments in the present. I do not think it is a coincidence that so many of the settings when Yip-Williams feels despair are the ones when she is among other parents. Accompanying her daughter to a birthday party, Yip-Williams wants to scream at the other parents: "*I have fucking Stage IV colon cancer! Do you have any fucking clue?*" (92, emphasis in original). Settings like birthday parties are painful, I think, because they do not admit mortality. A dying mother's presence would create a scene, even if she did not yell expletives. My kids never cared whether I wore a wig at home, where they often enjoyed rubbing my bald head, but they often asked me to wear one to events where other families would be present. Even though a wig can be tortuous in an overheated gymnasium-turned-auditorium, I obliged because I also did not want to be too conspicuous—or to have another parent make my tears an object of their self-serving pity. In my daughter's choir, the end-of-year concert always ends with the graduating seniors singing the opening verse of a song by themselves; the younger kids then join in on the remaining verses. Each year, every child moves closer towards the moment when they will sing alone and unaccompanied. By the time they step to the front of the group to take their turn, there is an acute temporal effect, as though no time has passed at all—the years are short. On my better days, I can find it comforting that even if I die before I hear my kid do her own thing, I will have viscerally anticipated it more times than I dared hope. But most of the time, it is a reminder that the tradition itself constructs parents as spectators for their children's entire lives, and that is not a scene where I belong.

Dying mothers often accommodate themselves to the relentless futurity of normative motherhood—a form of "compensatory mothering" that Claudia Malacrida identifies as characteristic of disabled mothers in general. Disabled mothers often strive to conform to ableist notions of motherhood by disguising embodied differences and developing adaptive strategies (Malacrida 109). For mothers with terminal illness, managing a child's future compensates for the failure of not being there herself. One version of this compensatory mothering, evident in recent cancer memoirs, includes arranging domestic space to provide for children's development and enduring happiness. For example, Yip-Williams completely remodels her apartment, as "the single greatest physical and tangible legacy [she] could leave for [her] children and husband" (180). Even if she will not be there to manage day-to-day domestic tasks, the physical space itself will be her avatar—a presence in her children's lives that "could be passed down from generation to generation" (180). For Riggs, "finding the perfect living-room couch" starts to seem like "the most important thing [she's] ever done" (212). Just the right leather couch, which will remain after Riggs has died, is one way she will continue to care for her children into the future. In a moving passage, she speaks of her desire for "high-quality leather, something earthy and animal and real. A surface that knows something of what it was to be alive, that warms to our touch and cools in our absence.... Something that will hold us through everything that lies ahead" (215).

Writing letters for a child to read as they grow is another compensatory practice that allows the dying mother to approximate normative motherhood's relentless futurity. This is both a literary trope, commonplace in fiction and nonfiction accounts of mothers with terminal illness, and a recommended therapeutic practice. My own counsellor, trained specifically to work with cancer patients, encouraged me to write such letters to my own kids to assuage both my own present despair and their future grief. In "Pretending the Bed is a Raft," a short story by Nanci Kincaid, a twenty-three-year-old mother with incurable ovarian cancer makes a list of "things to do before I die," including "tape record birthday messages for my kids up until they turn 21" (204). In *Our Friend*, the 2019 film based on Matthew Teague's essay for *Esquire*, the mother dying of ovarian cancer includes letters on her bucket list: "I'd like to write some letters to the girls, for certain milestones in their lives like their first boyfriend, and their wedding day, and first baby, in case they

want to hear my advice or want to feel me." Lauren Grodstein's 2017 *Our Short History* frames the novel itself as a message that a mother with stage IV ovarian cancer leaves for her six-year-old son to read when he becomes a young adult: "Learn more about me. And that way, even though you won't always be with me, I will always, at least a little, be with you" (7). Through this literary trope and material practice, the dead mother can remain a stable presence in her children's lives. Her voice anchors each birthday and major life event organized around reproductive heteronormativity (e.g., dating, marriage, and becoming a parent), collapsing generational time. This compensatory mothering reconciles death with the futurity that defines normative motherhood. To project herself into the future, the dying mother speaks from the rhetorical position of already being dead; she is always alive, always dead, but never dying. To secure continuity between the child's past and future, the dying mother elides disease progression and invokes her own unchanging constancy in life and in death.[7]

The mother who heroically hides her terminal diagnosis so as not to ruin her children's lives most clearly expresses the cultural logic by which dying—and not being dead *per se*—is a terrible thing to do to your kids. *Our Short History* describes faking health as what a dying mother does for love. Karen "fake[s] being hungry" and leaves her wig on even while she sleeps so that her son will think she is doing well (21, 98). In the 1998 movie *Stepmom*, Jackie (played by Susan Sarandon) does not tell anyone about her incurable lymphoma because her kids already have too much going on with their parents' recent divorce. Just when Jackie is finally about to reveal her diagnosis, her ex-husband informs her that he is going to get remarried to his significantly younger girlfriend, Isabelle (played by Julia Roberts). When he remembers that she also has news, she demurs: "I think we have quite enough to deal with your news." In the 2003 film, *My Life Without Me*, twenty-three-year-old Ann hides her diagnosis of terminal ovarian cancer from her husband and children. She protects her family and herself by refusing all treatment, suffering her illness alone, and arranging their futures without their knowledge. From her family's perspective, her slow decline from progressive disease will appear as a sudden death.

A replacement mother, handpicked by the dying mother, promises a stable maternal presence who will ensure the children's continued healthy development. Karen, of Grodstein's *Our Short History*, will leave

her son's care to the sister who taught her how to be a mother. In *My Life Without Me*, the logic of maternal continuity is even blunter; the replacement wife and mother that Ann chooses for her husband and children, after a trial babysitting run, is the next-door neighbour—who is also named Ann. Although Jackie in *Stepmom* never would have chosen career-driven, spontaneous Isabelle as a mother for her children, she nevertheless manages to make her into a satisfactory replacement. As the two hash out their differences, Jackie puts it this way: "I have their past. And you can have their future." This form of compensatory mothering depends on the fantasy that a seamless transition to a substitute mother will dampen children's grief. In these works, securing a replacement mother is another form of self-sacrifice—an exquisite pain the dying mother swallows for the good of her children. This heroic example has the power to make other women into better mothers. Jackie's self-sacrifice inspires Isabelle to quit her job so that she can prioritize picking up the kids. In *Our Short History*, Karen allows her son's father, who abandoned her while she was pregnant, to build a meaningful relationship with their child. She tells him: "I love [my son] too much to keep him from you. More than I love myself. So he gets you. That's what he wants. I want him to have what he wants. There's no time left for more fighting" (334). Even though this decision hurts her (as does quitting her job), both are what her son needs. As Karen writes in her letter to the future version of her son, "You are my happy ending" (17).

These strategies of compensatory mothering reconcile dying to normative motherhood. Although *Stepmom*, *My Life Without Me*, and *Our Short History* might seem to offer narrative examples of dying mothers, they in fact reinforce the incompatibility of dying and motherhood. A dying mother can be a protagonist only by hiding her illness from her children, by arranging for a mother who will take her place, and by living posthumously through letters her children will read in the future. These compensatory strategies effectively assimilate the terminally ill mother to the dead mother who sacrifices herself for her children's sake. They are not written for those of us with terminal disease. Instead, they offer a limit case that defines idealized, self-effacing maternal love tailored to the living; the audience for *Stepmom* might cry at Jackie's death, but they are encouraged to identify with Isabelle's transformation. These narratives offer an affective payoff addressed to the healthy, able-bodied mother negotiating her own complex feelings about raising a child who

will one day leave her. Grodstein is explicit about this in an interview published as an appendix to *Our Short History*. The book, she says, was inspired in part by a relative's impending death from ovarian cancer and by something "more mundane, but even more powerful": "I wanted my son to know how much I love him.... One day I hope he reads the book and knows that I could never have written about Karen's love for Jake if I didn't love him so desperately" (345-46). In the novel, Karen's healthy sister confesses that she's "not ready to let [her oldest child] go," a sentiment that Karen recognizes: "We fell asleep pondering the condition of being mothers, which was, of course, the condition of helping people you love most in the world leave you" (207). The dying mother's story becomes a proxy for the grief a healthy mother feels at her child's growing independence.

Mothers with terminal illness are accustomed to divergent responses, as people either cathect to our slow-burn tragedies or brightly deny the realities of chronic, progressive disease. Our stories become inspirational tearjerkers for the living. Yip-Williams's *The Unwinding of the Miracle*, Riggs's *The Bright Hour*, and Bowler's *Everything Happens for a Reason* were all *New York Times* bestsellers. The *New York Times Book Review* blurb on the back of *The Bright Hour* reads, "You can read a multitude of books about how to die, but Riggs, a dying woman, will teach you how to live." As inspiration, we are all about ensuring others' futurity, a form of dehumanization that we often encounter in everyday conversation. People say, "I could never do what you're doing." One medical student, watching me nurse my infant in the weeks before chemotherapy would force me to stop, said what many were thinking: "I wouldn't want to trade places with you; that's for sure." Apparently opposite, both those who find us inspirational and those who claim distance from us refuse the material realities of living with and dying from incurable disease. On the one hand, the dying mother is reducible to insight or wisdom she has to offer the healthy mother; and, on the other hand, the embodied reality of chronic illness and dying... nobody wants that.

These affective scenes and the model of motherhood they sustain generate not just the compensatory practices that the dying mother adopts but also the social resources available to her. These phenomena are interlocked and mutually reinforcing. Many services for kids who have a parent with cancer trade on the idea that a parent's diagnosis ruins childhood. For instance, Camp Kesem, a free nationwide summer

camp serving youth six to eighteen who have a parent, living or dead, with cancer. This five-day program, which serves more than ten thousand children annually at sites in forty-four states, is designed as a "safe and welcoming environment to have fun and rediscover their childhood" ("Camp Kesem"). My two children have both attended Camp Kesem, and they love it. What kid would not appreciate full-time fun and the devoted attention of volunteer college students? But, as their dying parent, I am also ambivalent about its message that youth do not truly experience either childhood or fun if they have a parent with cancer in their home. For my kids, who cannot remember me before cancer or without ongoing treatment, I wonder whether Camp Kesem causes harm by positioning me as a drag on the cancer-free life they ought to be living. Other programs to support families in which a parent is dying fund trips or special experiences that will become a sustaining memory: a week at a beach house, a trip to Disney World, tickets to a Broadway show.[8] The Jack and Jill Late Stage Cancer Foundation, for example, creates "strong memories of special times together" for kids with a parent dying of cancer. These memories, they explain, "become an annuity—the legacy, a measurable return on investment" ("Jack and Jill"). This economic formulation erroneously imagines that disease- and dying-related memories can and will somehow be separate from a profitable legacy of "special times together." For my kids, expressions of sentimentality or plans for "special times" often make them more fearful that I am about to die. My older child especially— an inveterate consumer of YA romances that make imminent death into love stories (John Green's *The Fault in Our Stars* or the unbearably literal *Sick Kids in Love* by Hannah Moskowitz)—knows that in narratives of terminal illness, a brief reprieve from chronic, progressive illness, such as a trip to Amsterdam or a festive Christmas party, only heightens the pathos of an impending decline.

In order to offer healthy mothers imaginative identification with life-and-death feelings from a safe distance, these narratives of dying mothers never admit the material needs that parents with progressive disease face. In *Our Short History*, single-mother Karen never worries about money, health insurance, or childcare. When the nanny is on vacation and Karen ends up hospitalized unexpectedly, her sister Allie drops everything to fly across the country and take care of Karen's son. Allie and her husband, a high-level corporate executive, have no worries

about the cost of raising Jake after Karen's death. Ann, in *My Life Without Me*, comes from a working-class background and lives with her husband and two children in a mobile home on her mother's property, but class does not otherwise figure into this portrait of a dying mother. She does not really need health insurance because she refuses treatment for her illness. She is not worried about childcare because both her mother and the neighbour she identifies as her husband's next wife fill the gaps. She does not have Karen's vast wealth, but she has enough money for the items on her bucket list: a Sears portrait of the family and a proper outfit for her funeral.

To bring to light these material needs—far less fun to fund than a family trip to Orlando—raises the spectre of communal responsibility to the disabled, sick, and dying and thus ruins the affective fantasy that defines dying mothers in contemporary cultural imaginaries. A dear friend of mine with advanced ovarian cancer kept working full time until days before her death. As the primary wage earner in her home, her labour provided health insurance not only for her but also for her children and her spouse. Even though she qualified for disability, the COBRA payments that would maintain their insurance over the twenty-four-month waiting period for Medicare were more than she could afford on disability benefits. Often, the needs of the dying mother are ordinary, such as childcare that will accommodate the vagaries of an overwhelmed medical system and an unpredictable disease. When I arrive at the cancer centre only to learn that my oncologist is two hours behind schedule, my spouse and I work the phones from the waiting room to locate someone who can meet the kids after school. Arranging childcare on the fly, while wondering what the latest CT scan will show, is a very particular hell. Matthew Teague writes about the overwhelming challenges of simultaneously caring for his dying wife and their young children. He changes oozing wound dressings; he drives his kids around; he titrates medication to balance his wife's pain relief and cognitive function; he supervises homework sessions; he orders home medical supplies; he pays the bills. All of this is a rather different picture than the one we get in sentimental films and books about dying mothers. Even memoirs by dying mothers tend to be written by those with ample financial resources (enough to renovate an apartment or buy a couch) and support from family and friends—privileges that describe my experience as well.

To acknowledge the material, practical, and embodied needs of terminally ill parents and their children gives lie to the normative motherhood expressed through a dying mother's investments in a future she will never see. Stories about dying mothers who provision enduring stability for their children through domestic, emotional, financial, and educational resources offer an alibi for a social landscape that will offer less compassion and little material support. In them, the stability children need is a mother's individual responsibility, not a community obligation; if she is a good enough mother, nothing—not even death— will stop her.

III. #Stillalivebitches

One of my cancer friends, a mother with the same diagnosis I have—all the way down to the genetic mutation driving our tumors—ended her social media posts with a witty hashtag: #stillalivebitches. Her inspired phrase evokes the self-talk that mitigates dehumanizing days and hours in chemo suites, waiting rooms, and on bathroom floors. While I was getting acupuncture for chemotherapy-induced nerve damage, I would often silently remind myself: "I am a person, and I am alive." Yet the hashtag's note of surprise—as though the forgotten patient has just jumped out from the crypt—also captures the necessity of reminding others that even with an advanced cancer diagnosis, we are, in fact, still alive. In *Our Friend*, the mother dying of ovarian cancer says, "People don't look at me when they talk to me anymore." Finally, the hashtag points towards its own obsolescence, the day when it will no longer apply. As I have been arguing in this chapter, the dying mother is subject to erasure, and the strategies for compensatory mothering that appear in cancer memoirs and fiction about mothers with cancer typically shore up those erasures by hiding diagnoses or symptoms from children, projecting future versions of ourselves in letters, and cultivating domestic spaces through which we will manifest after our deaths as stable presence for our families. #Stillalivebitches resists assimilation to norms that relentlessly deny mortality.

By sharing her terminal diagnosis and physical symptoms of disease with her children, a mother does not rob them of childhood. Rather, disease and dying simply become a part of their childhood. In Kincaid's short story, "Pretending the Bed is a Raft," Belinda—who is dying of

ovarian cancer—continues to care for her three children as she grows sicker. The children enjoy her "new laziness": "Her lying around the trailer in her pajamas until noon. Taking long afternoon naps pretending the bed was a raft and the floor was an ocean full of sharks. Playing cards for hours" (226).[9] There is no sharp distinction between the cancer world and the world free of cancer or between a healthy mother and a dying mother. As part of a domestic scene, Belinda's bed is not freighted with onrushing tragedy, but nor does it deny that Belinda is dying. It is where her children were conceived, where they are growing, and where she is dying. Lamar, her youngest child, is "learning his numbers" (226). This detail underscores the continuity between the mother Belinda was before cancer, when she presumably taught her older daughters to count, and the mother that she is with cancer, still administering those lessons. In *The Bright Hour*, children's questions about chemo punctuate imaginative play, as Riggs's younger son pretends to be a fennec fox. Later, Riggs takes her sons with her to radiation, thinking that it will be a fun, science-focussed family field trip. Unsettled to see the floor open up beneath the radiation table, one son describes the visit as "completely terrifying," and the other wishes he "hadn't seen it." Riggs jokes, "Whoops! I guess I just damaged everyone for life a little" (187). This scene voices every dying mother's fear that she is traumatizing her children. But with a metaphor that describes the radiation technology as a "Tony Stark-designed doorway to hell," Riggs also deftly connects it with any child's exposure to images for which they are not developmentally ready (186). And by the next morning, everyone is "bumbling through" the "regular routine" again, with the kids wishing Riggs good luck at her appointment (187). When my younger child, Charlie, was one, I often wore scarves to keep my hairless head warm. Squealing, Charlie would snatch cloth napkins from a shelf in the kitchen and cover everyone's head—their older sister's, their dad's, their own, the cats', and their stuffed animals'. Cancer is not always or only a disorienting disruption, although there are excruciating moments when it is; mostly, it is part of the life I share with my children and my spouse.

As cancer weaves into the games we, as mothers, play with our children, the knowledge we cultivate in conversation with them, the real and imagined fears our children share with us, and the relationships we have with them, it also challenges cultural norms in which a good

mother bears one-sided responsibility for physical and emotional care-giving. At one point, Yip-Williams talks herself out of the belief that it would be better for her to die than to parent with cancer by "rediscov-ering the magic and wonder of our powerful children and letting them help us walk through our darkest hours" (23). When Riggs's son finds her crying and asks why, she tells him the truth even though she's "not at all sure this is what you're supposed to say to your nine-year-old": "The idea of dying ... and how much I love you" (247). "Jeez," he says, "That's pretty heavy-duty stuff," and he advises her to go play the drum set in his room because that is what he does to feel better when he is "all sad and mad" (247). For Riggs, who grieves her own mother's death from cancer at the same time she gets her own diagnosis of metastatic breast cancer, mutual care defines the parent-child relationship. And like her mother, Riggs keeps returning to the final lines of a poem that she had written years earlier, about a trip the two of them took together: "You reached out to me for balance / even though we weren't speaking / and a minute later I had to do the same" (qtd. in *The Bright Hour*, 82).

When I suffered debilitating, unpredictable migraines from an ex-perimental cancer drug, my younger child would pop up next to my pillow with their prized blankie and fold it up under my cheek; my older daughter would bring in the book we had been reading together, and she would read it to me. They did for me exactly what I had done for them when they had strep throat or a cold. For a dying parent to let a child help (and not just for show)—to "let" them walk alongside us and bal-ance their grief as we balance ours—departs radically from the mater-nal ideal we see in narratives like *Our Short History* and *Stepmom*. What if it was not a question of letting but encouraging or inviting? Taking care and giving care can be shared among all members of the family, dismantling stark distinctions between those who provide aid (whether physical, financial, or emotional) and those who receive it. In *Examined Life*, Judith Butler and disability scholar and activist Sunaura Taylor explore the convergences between the social construction of gender and of disability to argue for the importance of rethinking the human as a site of interdependency (see also Minaki). For Butler, interdependency as opposed to individuality is a crucial building block for a politics that will "minimize the unlivability of lives" (67). Redefining the moth-er-child relationship, usually idealized as a mother's endless capacity to absorb a child's physical and emotional dependence, is critical for

moving towards that political vision.

When a parent's dying—at least in the long, slow phase where I find myself—becomes inseparable from childhood, it normalizes change across the lifecycle, once again unsettling the conventional hierarchy between a stable, unchanging mother and a child who is developing at a rapid pace. Over pizza and rosé, I described this chapter to a friend while our kids fought with foam swords in the backyard. She sat quiet for a long time, and she finally said, "I feel like you're overlooking what's irreplaceable and special about a mother's relationship with her children; you're denying the grief and the pain, the fact that a mother's death is the worst thing that can happen to a child." That stung, even though she was not trying to be cruel, because it suggested both that I am responsible for the "worst thing" and that I am denying that pain. I asked her, "When your kids are fearful about your mortality, what do you tell them?" And she replied, "I tell them that I'm not going to die for a very, very long time," and to soften it, she said, "I think of you every time I say that." (I hear: I wouldn't want to trade places with you.) But it occurs to me now to ask whether I am the only one denying grief.

When my children come to me with their fears about death, I sit with both the child's grief and my own. As they get older and understand more, they keep relearning that my cancer has not been and will not be cured. I have delivered the news of my diagnosis and prognosis more times than I can count, and each time it lands differently on them—and on me in relation to them. And the next morning, Charlie still ferrets out clean-enough clothes from the hamper, Matilda still calls her grandmother while she walks the recalcitrant dog, and everybody still heads out the door to school and work. The impulse to protect our own children from contemplating our deaths is continuous with the impulse to refuse our own mortality. I do not know when I am going to die, but I do know that both my kids and I will be in different places then, and we have practised enough to know that when it happens, it will be both a devastating shock and completely ordinary.

It is likely—we now know—that I only became a mother after cancer started killing me. My presence and absence in my kids' lives are fundamentally linked and even sometimes simultaneous—when surgical side effects send me running for the bathroom while we are in the middle of an urgent conversation-demonstration about how wolf parents discipline their cubs with affectionate nips. (In this scenario, I am the

cub.) Ten years of living with (and slowly dying from) cancer have convinced me that children who are constantly negotiating their own abrupt shifts in identity can, in fact, benefit from a mother who models selfhood as a process of change and adaptation rather than stasis. As Suleika Jaouad writes about her own journey to come to terms with a leukemia diagnosis as a young adult: "The idea of striving for some beautiful, perfect state of wellness? It mires us in eternal dissatisfaction, a goal forever out of reach. To be well is to learn to accept whatever body and mind I currently have" (274). Or as Riggs puts it when she wonders how her children will remember her, "It's hard: I am not done becoming me. I am still in the works" (297). That is what I am trying to model for my children, and dying is part of that becoming. This is not to say that living with cancer has made me a better mother: there is no upside to cancer, and I am not. But from here I can glimpse what I might not have noticed otherwise—that to be a good mother does not require stasis, to be a sun securing a child's orbit. Instead, I am a neighbouring planet, and my kids and I are spinning on our own cockeyed axes, passing through light and dark, perceiving different galactic vistas, and shouting at each other across the vacuum as our unmapped trajectories move closer and further from one another.

Endnotes

1. I am grateful to Mary C. Foltz, Rita Jones, Michael Kramp, and Alyssa Volker for their thoughtful comments on earlier versions of this chapter. I also thank the editors of this volume, Michelann Parr and BettyAnn Martin, for their suggestions as well as Larry Snyder, who kept the kids busy enough for me to write during a pandemic.

2. The paucity of representations of dying mothers connects with limited cultural representations of disabled mothers more broadly. See, for instance, Samantha Walsh, who discusses the effects of a "predominant image of mothering ... done by an able bodied woman" (28).

3. Of course, parents of all genders live with chronic disease and so, too, do parents of all genders do the feminized care work historically assigned to mothers. When I refer to motherhood in this chapter, I refer to dominant cultural constructions of an idealized feminine parent—a role that men, women, and nonbinary people alike may

aspire to, reject, and/or seek to redefine. The representations of dying parents that I discuss in this chapter, like representations of parents in general, most often adhere to binary gender categories.

4. For a more detailed narrative of my diagnosis and how it connects with reproductive justice movements, see Edwards.

5. For analysis of misogynist and ableist beliefs that disabled mothers inappropriately place children in caregiving roles, see Minaki, Prilleltensky, and Garland-Thompson.

6. On disability discrimination against mothers in custody cases, see Callow.

7. In practice, writing these letters is far more challenging than movies make it out to be. Paul Kalanithi, author of *When Breath Becomes Air*, considers writing letters for his infant daughter to read after his death: "But what would they say? I don't know what this girl will be like when she is fifteen; I don't even know if she'll take to the nickname we've given her" (199). Although such letters are meant to testify to an enduring intimacy between parent and child, they can in practice end up intensifying its loss (Segal).

8. There are numerous examples of these charitable groups, modelled on the Make-A-Wish Foundation programs available for kids with life-threatening illnesses. For instance, there is the Family Lives On Foundation, which facilitates traditions for celebration and grieving a parent's death. The Memories of Love Foundation funds family trips to Orlando for visits to Disney World and/or Universal Studios.

9. *My Life Without Me*, which I discuss above, is adapted from this short story with a major difference. Whereas Ann, the film's protagonist, does not share her diagnosis with her family, Belinda (as she is named in the short story) does.

Works Cited

Baldwin, Lauren A., et al. "Ten-Year Relative Survival for Ovarian Cancer." *Obstetrics and Gynecology*, vol. 120, no. 3, pp. 612-18.

Berlant, Lauren. *Cruel Optimism*. Duke University Press, 2011.

Bowler, Kate. *Everything Happens for a Reason: And Other Lies I've Loved*. Random House, 2018.

Butler, Judith. *Notes Toward a Performative Theory of Assembly.* Harvard University Press, 2018.

Callow, Ella. "Disabled Mothers: Misadventures and Motherhood in the American Courts." *Disabled Mothers: Stories and Scholarship by and about Mothers with Disabilities,* edited by Gloria Filax and Dena Taylor, Demeter Press, 2014, pp. 277-94.

"Camp Kesem: About Us." *Camp Kesem Website,* www.campkesem.org/about-kesem. Accessed 16 July 2023.

Edgeworth, Maria. *Belinda,* edited by Kathryn J. Kirkpatrick for World's Classics, Oxford University Press, 1994.

Edwards, Suzanne. "What 'Health of the mother' Means." *Salon,* 24 Oct. 2012, https://www.salon.com/2012/10/24/what_health_of_the_mother_means/. Accessed 16 July 2023.

Examined Life. Directed by Astra Taylor. Zeitgeist Films, 2008.

Garland-Thompson, Rosemarie. *Extraordinary Bodies: Figuring Physical Disability in American Culture and Literature.* Columbia University Press, 1997.

Grodstein, Lauren. *Our Short History.* Algonquin Books of Chapel Hill, 2017.

Gubar, Susan. *Memoir of a Debulked Woman: Enduring Ovarian Cancer.* W. W. Norton, 2012.

Hutchison, Courtney. "Judge Cites Mom's Breast Cancer in Denying Custody of Children," *ABC News,* 6 May 2011, https://abcnews.go.com/Health/BreastCancerCenter/north-carolina-mom-breast-cancer-loses-custody/story?id=13546870. Accessed 16 July 2023.

"Jack and Jill Late Stage Cancer Foundation: FAQs." *Jack and Jill Late Stage Cancer Foundation Website,* www.jajf.org/foundation/faqs. Accessed 16 July 2023.

Jain, S. Lochlann. *Malignant: How Cancer Becomes Us.* University of California Press, 2013.

Jaouad, Suleika. *Between Two Kingdoms: What Almost Dying Taught Me about Living.* Penguin Random House, 2021.

Kalanithi, Paul. *When Breath Becomes Air.* Random House, 2016.

Malacrida, Claudia. "Performing Motherhood in a Disablist World: Dilemmas of Motherhood, Femininity and Disability." *International*

Journal of Qualitative Studies in Education, vol. 22, no. 1, 2009, pp. 99-117.

Minaki, Christina. "Scrutinizing and Resisting Oppressive Assumptions about Disabled Parents." *Disabled Mothers: Stories and Scholarship by and about Mothers with Disabilities*, edited by Gloria Filax and Dena Taylor, Demeter Press, 2014, pp. 31-47.

My Life Without Me. Directed by Isabel Coixet. Sony Pictures Classics, 2003.

Prilleltensky, Ora. "My Child Is Not My Carer: Mothers with Physical Disabilities and the Well-Being of Children." *Disability and Society*, vol. 19, no. 3, 2004, pp. 209-23.

Kincaid, Nanci. *Pretending the Bed Is a Raft*. Algonquin Books of Chapel Hill, 1997.

Razaz, Neda, et al. "Children of Chronically Ill Parents: Relationship between Parental Multiple Sclerosis and Childhood Developmental Health." *Multiple Sclerosis*, vol. 22, no. 11, 2016, pp. 1452-62.

Riggs, Nina. *The Bright Hour: A Memoir of Living and Dying*. Simon and Schuster, 2017.

Segal, David. "Letter Day Saint." *This American Life* 401, 19 Feb. 2010, https://www.thisamericanlife.org/401/parent-trap/act-one-0. Accessed 16 July 2023.

Our Friend. Directed by Gabriela Cowperthwaite. Black Bear Pictures, 2019.

Stepmom. Directed by Chris Columbus. Columbia Pictures, 1998.

Teague, Matthew. "The Friend." *Esquire*, May 2015, https://www.es-quire.com/lifestyle/a34905/matthew-teague-wife-cancer-essay/. Accessed 16 July 2023.

Walsh, Samantha. "'Where Do Babies Come From?' Meeting Joanne and Kyle: A Reflection on Mothering, Disability and Identity." *Disabled Mothers: Stories and Scholarship by and about Mothers with Disabilities*, edited by Gloria Filax and Dena Taylor, Demeter Press, 2014, pp. 21-29.

Weaver, Kathryn E., et al. "Parental Cancer and the Family: A Population-Based Estimate of the Number of US Cancer Survivors Residing with Their Minor Children." *Cancer*, vol. 116, no. 18, 2010, pp. 4395-4401.

Yip-Williams, Julie. *The Unwinding of the Miracle: A Memoir of Life, Death, and Everything That Comes After.* Random House, 2020.

Threads of Continuity

Michelann Parr

Thirteen unique voices were offered in this collection. As each tale came our way, we noted the differences in the details but great similarity in the process and the insights. We found threads that wove themselves in and out, and all around, ultimately forming a collective and cohesive story.

A little surprised, we looked back to our call for papers, searching for some hint that we may have unduly guided the writing or suggested that we were looking for some particular insight.

We found that we had not.

In our original call, we asked: Why do we colour inside the lines? Why do we encourage and praise our children for doing so? How and why do we affirm and respect the boundaries and impositions of social condition, the memos we have been issued about how to become successful women and how to build strong families, careers, and faiths? What are the implications of this conditioning for those who willingly mother outside the lines, those who blaze their own trails and stretch boundaries?

We were interested in exploring how and why mothers transgress normative motherhood, reclaim their experience of parenting and womanhood, and rewrite possibilities for future generations of mothers. We were in search of stories that would resonate with other women's experience, offer the possibility of maternal wellbeing, and ground a sense of self-awareness through critical, reflexive, and empathetic engagement. Ideally, we hoped for a mindful distinction between the stories we construct and those that are constructed for us (Clandinin, Caine, and Lessard; Clandinin and Connelly).

Consistent with our themes of mothering outside the lines and boundary-busting mamas, we intentionally left our list of topics and genres open ended. We invited creative storying (in the form of, for example, diary, memoir, letter, poetry, and fiction) of mothers and other mothers (aunts, sisters, mothers, friends, grandmothers) whose lives and maternal practice challenged the cultural construction of maternity. We also sought social and cultural explorations of the personal and political implications of maternal trailblazers' lives and choices; scholarly and academic investigations of the lives of existing/fictional maternal trailblazers; theoretical, philosophical, and interdisciplinary explorations of boundary-busting mamas; critiques and discussion of media and/or artistic representations and explorations; as well as cross-cultural reflections on narratives of lived transgressions of maternal boundaries.

We could not possibly have anticipated the threads of continuity that bound individual stories together so seamlessly and continuously and that weaved together a collective whole that took on a shape of its own and is far greater than the sum of its parts.

Where one thread ended, another picked up. And we came to understand that although each tale had a limit and boundary of its own, when woven together, they revealed what it means to mother outside the lines. Our authors gave real life and literary examples of what it means to bust boundaries set for us, by us, and with us, both internally and externally. We came to understand that sometimes it is the littlest of things—the taken for granted, the invisible, the unspoken, and even the unintended—that make the greatest impact on our ability to mother outside the lines and create open futures and possibilities for both ourselves and those we mother.

The longer we stayed with the stories, the more we realized that their threads of continuity were life sustaining for self, for other, and for the maternal collective. When we encounter tales of honesty, struggle, joy, ambiguity, insight, and playfulness, each with their own way of being, language, and details, we find that we are not quite so isolated and not quite so alone. Real lives, hope, and dreams reside in these tales and beckon us to come closer.

We who mother are the same, except in the details.

We are acquiring the courage to express our vision, the strength to set our limits, and the willingness to take responsibility for ourselves, others, and all our relations in a new way (Murdock).

We need these stories.

We need each other.

Together, we are stronger, more resilient, and ready to rise as a matricentric feminist collective—a veritable kaleidoscope of being and becoming in life and in writing.

Being and Becoming: A Tale That Never Ends

It is not common to have postwriting reflections in a book, particularly an academic book, and yet here we are circling back with no clear beginning or ending—pushing the boundaries yet again. Transformed by the tales we had encountered and inspired by the threads that bind, we reached out to our authors almost on the eve of submission for review. We were curious to know where they were at, what they were thinking after writing their story, and what they had learned throughout the process. Our original thought was to preface each story with these reflective interludes, but the closer we got to publication, and with a little provocation from our reviewers, we realized that perhaps what we envisioned as a teaser might in fact get in our readers' way by offering the end insight before they even entered the story. We offer our authors' postwriting reflective pieces in first person to retain each storyteller's unique voice, their memory of their individual journeys, and to show that this work of mothering—this way of being and becoming—is never finished and always evolving.

Reflecting on Becoming at the Edge of Our Internal Boundaries

Michelann

For as long as I can remember, I have struggled with silence; I suspect that this was passed from one generation to the next. Writing this piece afforded me an opportunity to really dig into what silence means within the context of motherhood, the patriarchy, my becoming, and my being. Through this writing, I came to understand both the costs and benefits of silence in my experience of motherhood. I began this piece not really knowing where I was going or what I was writing, but resting in the stillness of silence and staying with the process, I discovered deep within

myself the healing and forgiveness that I needed. I came to realize that I was exactly where I needed to be and accepted the privilege of my prolonged journey in, with, through, and still... in silence. I know now that had I forced a structure or a shape, I would likely still be sitting in front of a blank page. Knowing that this is just the beginning, I take up a new challenge—that of sharing my silence and finding creative ways to ensure that my children and grandchildren know when to choose silence and when to choose voice.

Tanya

Prior to "My (Paren)theses," I had not written a poem in twenty years, since entering my undergraduate degree. This poem continues to live with me. Different feelings and struggles become foregrounded each time I return to it. This poem and I play with the sometimes seemingly paradoxical existence of my parenting and professional theses. I now see my ongoing dialogues with this poem as a way of storying and unpacking the struggles, ambiguity, (non)sense, and (un)becomings of standing in the tragic gap of reality and imagined possibilities as I imagine and enact my response abilities within my caring and social justice work. I was encouraged to share this work by other PhD student-mothers, and I hope that it serves to capture and nurture the complex feelings of—and (in)form speculative hope for more just worlds in/through—mothering and caring.

Jennifer

During the process of writing about my family's experience, I was able to process even more thoroughly my thoughts and emotions. This project allowed me to ask more questions of my son, to discuss memories with him, and to compare each of our truths within a shared story and experience. I found that committing words to the page about my experience made it more real; this choice of record keeping has allowed for better understanding, reflection, and perspective. I also hope that this writing will help other mothers, families, and trans individuals as they navigate their own transitions and complicated feelings and reactions.

Kate

This short, meditative piece is part of a larger work in progress about my experience of my mother's struggle with early onset Alzheimer's disease. My piece in this collection marks the start of a larger attempt to

demarcate where the blurred lines between my mother and myself have been forcefully cleaved by the illness, mapping the lonely place I inhabit in the face of my mother's dementia.

Drisana

My aspirations are a collective sojourn: I wish to be a possibility example for others like myself, who create scholarship and submit our ways of knowing to live in the archives as evidence that we were here and had something to say. In the same way that my notebooks and digital note-pads are filled with things that others have said, I want others to know that we can achieve self-definition and wellbeing with steadfast practice while contending with a reality where we must contend with barriers to overcome and the effects of oppression—where we are never only students in inquiry, where we are never only dreaming, and where we are never not vulnerable. We need each other, and one way that we find each other is through our written testimonies.

Lessons Learned by Honouring Our Boundary-Busting Foremothers

BettyAnn

Relationships are messy. Tension is the discomfort that moves us to understand—to make meaning of connection. I wrote this chapter because I wanted to heal that tension in relation to my mother. Through the opportunity to reflect, I have recovered our relationship in ways that have even surprised me. I realize now that relationships continue, well beyond ending, if we allow ourselves to embrace the possibilities for peace made possible through the gentle handling of memory. I now recognize my mother as a trailblazer and visionary—an awareness I wish I had been conscious of in her living years.

Darlene

The last year has been a journey of self-reflection and resetting of priorities. I had been planning this retirement in my mind, thinking I was not yet ready. My career had defined me, alongside the joy of being a mother. With a health scare behind me, I started to prepare by carving out time for self-care, which was something I was never good at, always

looking at it as a guilty pleasure. I gave myself permission to make appointments with myself. Yoga brought physical healing and meditation into my life. Eating a healthier diet and regular exercise started to become a more consistent part of my schedule. And when retirement kicked in, new opportunities trickled in, and I found new joy. I never thought I would be invited to contribute to this collection of experience, and I am honoured. Life happens for a reason.

Susan

Writing this chapter was a rare gift in what has been to date the most difficult chapter in my life. In revisiting the song and the stories that inspired it through this writing, I felt strengthened by the fierce independence and determination of my mother and grandmother in the face of war, loss, and love. The process of writing has allowed not only me to suffer with them but also for them to suffer with me as the story continues to evolve. I discovered that we all suffer in some way, whether we are aware of it or not.

Zoe

Writing this chapter, I came to understand that it did not take big actions for my mother to mother outside the lines; small choices, made every single day, built to something bigger and better than my mother ever could have imagined. As a daughter, I am proud. As a witness, I am honoured to see what my mother did. As an aspiring future mother, I have learned. But as a writer, I realize that my mother gave me the tools necessary to tell her deserving story, and if I am really being honest, most of that probably came from her, too.

Natasha

The writing of this chapter allowed me to set aside my lens as a child and daughter and contemplate my mother's experiences as a single-lone mother; in doing so, I came to truly appreciate all that my mother had gifted me. I have come to fully appreciate that both my mother and myself have—knowingly and unknowingly—mothered outside the lines of the patriarchy to immense gratification, satisfaction, and joy. Our motherhood experiences point to the great resilience, strength, and joy that comes from mother-led families.

Insights Gained by Paying Homage to Popular Culture Boundary-Busting Mamas

Andrea

That it takes acute psychological tensions, shocking surprise elements—kidnapped, phantom, and abused babies—and confusing plotlines and twist endings shows how hidden the extreme difficulties of early motherhood have become in patriarchal motherhood and how necessary it is to expose and extricate them.

Valerie

Although I still admire the tenacity, strength, and fearlessness that Dworkin exhibited, I now have a new admiration for, and fascination with, the often overlooked and quiet role of boundary-busting mothers—mothers who are not afraid to question and contest—in cultivating the leadership for the next generation and providing daughters with the power to persevere in the most difficult of circumstances.

Suzanne

Since I first wrote this piece, I have faced a second cancer recurrence as well as a third debilitating surgery and fresh round of treatment. Each rediagnosis, treatment failure, or escalation of symptoms finds me renegotiating motherhood alongside my children, as we all make sense of the relationship between my changing capacities and theirs. This chapter is what I needed to read and could not find when I was first diagnosed with chronic, progressive disease. With my most recent recurrence, I re-read it to remind myself how to mother meaningfully in a world that would have either healed or martyred me.

Parting Thoughts

As we near the end of this collective journey, we realize that as editors, we received all that we asked for and more—more than we possibly could have anticipated. It was exactly what we needed to support us in our quest to blaze trails, to bust boundaries, to mother outside the lines, and, most importantly, to heal ourselves and other mothers:

We are Humans-Mothers-Workers-Creators-Activists[1]:

We who recover. We who make a way. We who recognize the need to live mindfully. We who are self-grounding. We who lean into the (dis)continuity, (in)stability, (un)certainty, ambivalence, ambiguity, and paradox that is motherhood. We who stay in the discomfort. We who grow through resistance. We who are resilient, empowered, ready. We who know comfort through struggle, joy through pain, love through indifference. We who know that these feelings are not uniquely ours. We who are enlightened. We who are endarkened. We who push through outdated and tired narratives that tell us who we are. We who know this too shall pass. We who are compassionate and love deeply. We who belong. We who are makers of love and life. We who nurture. We who grow. We who are learning. We who take only what we need. We who let go. We who do not let go. We who are not afraid to fail. We who share, knowing that together we are better. We who know when to be silent and when to speak up. We who are rule makers, boundary busters, and trend setters. We who honour maternal legacies and more knowledgeable maternal others. We who know that the little things count. We who prioritize rest. We who reset. We who critique, interrogate, and write new beginnings. We who stand alone; we who rise together. We who brave the wilderness. We who stay. We who story. We who are conscious. We who hope.

Endnotes

1. For the idea and structure of this poetic rendering, we offer inspirational credit to Drisana McDaniel, this collection.

Works Cited

Clandinin, D. Jean, and F. Michael Connelly. "Personal Experience Methods." *Handbook of Qualitative Research,* edited by N. K. Denzin and Y. S. Lincoln, Sage, 1994, pp. 413-427.

Clandinin, D. Jean, and Jerry Rosiek. "Mapping a Landscape of Narrative Inquiry: Borderland Spaces and Tensions." *Handbook of Narrative Inquiry: Mapping a Methodology,* edited by D. Jean Clandinin, Sage, 2007, pp. 35-75.

Murdock, Maureen. *The Heroine's Journey: Woman's Quest for Wholeness.* Shambhala, 2020.

Notes on Contributors

Suzanne M. Edwards is associate professor of English and Women, Gender, and Sexuality Studies at Lehigh University, where she has been teaching for the last fifteen years. In addition to numerous scholarly articles, she is the author of *The Afterlives of Rape in Medieval English Literature* (Palgrave, 2016), a study of how medieval writers conceptualized rape survival and its implications for contemporary discourses of survival. Most recently, Suzanne's research has focused on author Gloria Naylor's interest in the Middle Ages, and she is codirector of the Gloria Naylor Archive Project, which seeks to make Gloria Naylor's collected papers accessible to scholars, students, and fans of Naylor's work. This project, funded by the National Endowment for the Humanities and featured in the *Recovery Hub for American Women Writers* showcase, is available at wordpress.lehigh.edu/naylorarchive/. As a scholar and educator, Suzanne is committed to public-facing scholarship, and she has published short pieces with *Slate* and *The Washington Post*.

Tanya L'Heureux (she/her) is an adoptive mother, family caregiver, PhD student, and critical dietitian with immense privilege through being a cisgender, heterosexual, middle-class, thin, and white Canadian. She is pursuing her PhD in Kinesiology and Health Studies at Queen's University. Her practice and study interests, emerging from over fifteen years as a registered dietitian, involve understanding and transforming everyday dietetic practices through embodiments, addressing social injustice, and critically examining the politics of care. She strives to use her desire for lifelong learning, heart, and art to guide her personal-professional journey of living a more trauma-informed, socially just, and critically nurturing existence as a mother and caregiver.

BettyAnn Martin is a narrative scholar interested in the reconstruction of experience through story and the manner in which creative engagement with memory transforms individual consciousness. She rediscovered the therapeutic aspects of storytelling and writing while completing her PhD in educational sustainability from Nipissing University. In addition to several peer-reviewed articles and book chapters, recent publications include *Writing*

Mothers: Narrative Acts of Care, Redemption, and Transformation (2020) and *Taking the Village Online: Mothers, Motherhood, and Social Media* (2016). Through her own experience of mothering and through a growing literature theorizing motherhood, BettyAnn continues to research and write about motherhood and its implications for identity and healing. She currently resides in Brantford Ontario. Contact: bannmartin@hotmail.com

Drisana McDaniel (she/her) is a mother-worker-activist and a race equity and justice facilitator. Her teaching addresses social injustice, racialized dimensions of trauma, resilience, and capacity and connecting across differences to experience healing and integrity. Through her practice "the alchemy of now," Drisana attends to the nitty-gritty of our individual and collective experiences from an embodied, historical, social, and psychospiritual perspective. She envisions transformational justice as the fruit of contemplation and action. As a worker-owner of the Transformative Teaching Collective, she supports organizations and groups by designing and facilitating workshops and gatherings that focus on conflict resolution, social justice education, empathy, the practice of nonviolence, healing, and collaboration. She has a passion for curating events to facilitate radical interconnectedness and is most hopeful about what can happen when we explore our connection to each other and the earth. Drisana lives with her two daughters in Summerville, South Carolina, and she has an adult son who lives in Atlanta.

Mairi McDermott (she/her) is a cis-het, white, able-bodied mother, educator, creator, ever curious learner who dreams of better worlds. An associate professor in Curriculum and Learning at the Werklund School of Education, University of Calgary, her body of research bends towards social justice as an act of speculative fiction; living in the "what if things were otherwise" realm. Through engagement with questions of (student) voice, anti-racism in education, critical-feminist-embodied pedagogies, power, and (re)storying our lives, she is interested in naming how systems, structures, and relations of oppression work so that we might yet bring forth m/otherworlds.

Jennifer Mehlenbacher (she/her) is a mother, wife, and liberal thinker living in a small western New York college town. She received her MS degree in early childhood education. After teaching for seven years, in two states, in all grade levels K-5, she decided to stay home with her children until they were in school. For the past fifteen years, she has been working for a nonprofit organization. She is the branch coordinator for her company in the county in which she lives. She registers, inspects, and provides trainings for family providers and school age based childcare programs and their staff as well as providing programming for the children in their care. She has given back to

her community by being on the local school board for eight years, five of which she served as its president. She also volunteers at the local hospice house caring for terminally ill residents and gives her time to other local causes and events. Her many hobbies include training and running half marathons (she's only half crazy!), completing needlepoint projects as gifts for friends and family, baking cookies to be sent as care packages to loved ones, and completing books for her monthly book club meetings. Jenn resides in Geneseo, NY, and has been married to her high school sweetheart and best friend for over twenty-seven years. She is the proud mom of two extraordinary human beings. Her son is a social worker for foster care children and lives with his fiancé, who identifies as nonbinary, in the Adirondacks. Her daughter is attending college in Rochester, NY, with the aspiration to become an ASL interpreter. Both of her children aspire to help others in their careers and to make the world a better place. She hopes to grow up one day to be just like them!

Andrea O'Reilly, PhD, is full professor in the School of Gender, Sexuality and Women's Studies at York University, founder/editor-in-chief of the *Journal of the Motherhood Initiative* and publisher of Demeter Press. She is coeditor/editor of thirty plus books including *Normative Motherhood: Regulations, Representations, and Reclamations* (2023), *Coming into Being: Mothers on Finding and Realizing Feminism* (2023), *Mothers, Mothering, and COVID-19: Dispatches from a Pandemic* (2021), *Maternal Theory, The 2nd Edition* (2021), *Monstrous Mothers; Troubling Tropes* (2021), *Maternal Regret: Resistances, Renunciations, and Reflections* (2022), She is author of three monographs *Matricentric Feminism: Theory, Activism, and Practice, The 2nd Edition* (2021). She is twice the recipient of York University's "Professor of the Year Award" for teaching excellence and is the 2019 recipient of the Status of Women and Equity Award of Distinction from OCUFA (Ontario Confederation of University Faculty Associations). She has received more than 1.5 million dollars in grant funding for her research projects including two current ones: "Older Young Mothers in Canada" and "Mothers and Returning to 'Normal': The Impact of the Pandemic on Mothering and Families."

Zoe Oliveira is a twenty-year-old creative writing student at the Ontario College of Art & Design University (OCADU) and is studying to become a creative fiction author. Her summers are spent engaging with children and youth of all ages and backgrounds at her full-time senior staff position at a Dundas summer camp, where she hopes to inspire the same wonder and everyday magic that she was raised in. She grew up in a Portuguese Canadian family in Brantford, Ontario, where she continues to spend time with loved ones, study, read, write, and enjoy impromptu singing and dancing sessions in her mother's kitchen.

Valerie Palmer-Mehta is a feminist rhetorical researcher who is invested in how we communicate and assign meaning and value to gender, which she sees as intersectional. She is particularly interested in how all things related to the feminine have been maligned, misappropriated, or otherwise undervalued in Western cultures. Narratives and experiences of motherhood are a vital dimension of the feminine that are simultaneously minimized and meticulously controlled yet exquisitely powerful and irrepressible. As a stepmother and othermother, but not a biological mother, she has found the narratives and expectations of motherhood swirling around her mystifying, intriguing, and consternating. She has a passion for unpacking, questioning, and investigating how motherhood as a cultural construct and lived experience is navigated, subverted, and reconceptualized so that we can live and make sense of our lives in ways that are truly meaningful to us.

Michelann Parr is first and foremost, a cisgender woman, a mother, a daughter, a privileged white settler, and an educator. She is the proud mother of three children who range in age from thirty-three to thirty-seven, one of whom would identify her as a radical feminist. She has two grandchildren who benefit from her later-years wisdom. Michelann is full professor in the Schulich School of Education at Nipissing University. Her favourite courses include *Proactive and Inclusive Classroom Management, Educational Sustainability,* and *Doctoral Seminar,* in which she weaves in her views on sustainable care, education, living, loving, and of course interrogating assumptions of all sorts! Her primary research interests include narrative forms of inquiry, autoethnography, identity as lifework, sustainability as relationship with self, other, and all our relations, and family engagement through community partnerships. Recent and upcoming edited collections include *Writing Mothers: Narrative Acts of Care, Redemption, and Solidarity; Tales of Boundary-Busting Mamas,* and *What the Pain of Mothers Must Never Expose.* Michelann lives in North Bay, ON, happily just a few blocks from her grandchildren on one side and her parents on the other.

Susan Picard is a farm kid, mother, widow, educator, musician, researcher, and community activist. Her various work experiences (including lumber piler, social worker, crisis counsellor, teacher, farmers' market manager, gifted education specialist, and musician) have provided her with unique vantage points and openings from which to engage with others in the world. Over the years, her reflections, observations, and questions have been captured in hundreds of songs, some of which led her to pursue a PhD in educating for sustainability. Grounded in songs, her doctoral journey utilized appreciative inquiry to explore the application of Dabrowski's theory of positive disintegration in educational settings as a means of reenvisioning how

we approach and support inclusion. Susan and her daughters live in Victoria, BC. Wisdom and joyfulness come from finding our way through.

Kate Rossiter is an associate professor in the Department of Health Studies at Wilfrid Laurier University. Her scholarly areas of expertise include the history of institutionalization and developmental disability in Canada, critical theories of the body and embodiment, theories of social violence and care work, and the social determinants of health. She lives in Brantford with her family.

Natasha Steer (she/her) is an intersectional feminist, single-lone mother, and educator. She became a mother at the age of nineteen, and at the age of twenty-one, she enrolled at York University, where she completed her Bachelor of Arts in English Literature and her Bachelor of Education. Natasha lived and taught abroad in China for four years and upon her return attended the University of Toronto, where she completed her M.Ed in social justice education and resumed teaching. Natasha is the author of *Great Lakes to Great Walls: Reflections of a Single Mom on Young Motherhood and Living Overseas* (2016) and the co-author of *What Are the Ties that Bind? Mothering and Friendship across Difference and Distance.* Her passions include advocacy, reading, writing, and travel.

Darlene Tetzlaff (she/her) is the proud mother of three adult children. She has navigated the challenges of being a mother and as a professional accountant working in various financial and leadership roles in the health care and automotive sectors. At the beginning of her career, she encountered the difficulties of earning the respect of peers in a male dominated automotive industry. With a solid work ethic, supportive mentors and credible output she was able to earn that respect and see a more progressive inclusion of females in finance roles over time. Opportunities for advancement came from colleagues and leaders that noticed, even though it was not necessarily in her own master plan. Her career was filled with learning and proving to herself and others she was worthy. She valued inclusiveness and collaboration among stakeholders and saw herself as a business partner. Always balancing the unlikely blend of heart and financial accountability into her work, the lines of motherhood and a career were often blurred. There was very little time for self discovery. Recently retired after 40 years, she sees this time ahead as a gift, an opportunity to renew self and relationships, reflect and rediscover her passions. She treasures this opportunity to spend time with family and her mother who continues to live independently nearby at the age of ninety-six. Darlene lives with her husband in Chatham-Kent, Ontario, and she has two adult daughters and one son.

Deepest appreciation to
Demeter's monthly Donors

DEMETER

Daughters
Tatjana Takseva
Debbie Byrd
Fiona Green
Tanya Cassidy
Vicki Noble
Myrel Chernick

Sisters
Amber Kinser
Nicole Willey

Grandmother
Tina Powell